& SOUL

ART & SOUL

To Eliza, Danielle and Kiki, who are all daily inspirations for coloring outside the lines. And to the next generation of great leaders with souls of artists.
—Robin L. Bronk

To my lovely wife Fazia, who was at my side every step of the way, making certain everyone looked their best and had a great time on these shoots. For that and everything else, I love you, baby...
—Brian Smith

ART & SOUL

STARS UNITE TO CELEBRATE AND SUPPORT THE ARTS

PHOTOGRAPHED BY BRIAN **SMITH** | EDITED BY ROBIN L. **BRONK**

To Christine

HAPPY HOLIDAYS 2011!

Brian Smith

IN ORDER OF APPEARANCE

ANNE **HATHAWAY**

SAMUEL L. **JACKSON**

KERRY **WASHINGTON**

PATRICIA **ARQUETTE**

SPIKE **LEE**

ADRIAN **GRENIER**

KELSEY **GRAMMER**

DAVID HYDE **PIERCE**

ALYSSA **MILANO**

TIM **DALY**

HARRY **BELAFONTE**

ZOOEY **DESCHANEL**

ALFRE **WOODARD**

ADRIEN **BRODY**

STEVEN **WEBER**

TAYE **DIGGS**

DULÉ **HILL**

TARAJI P. **HENSON**

MATTHEW **MODINE**

DANA **DELANY**

HECTOR **ELIZONDO**

JOHN **ORTIZ**

JOHN **TURTURRO**

MARLON **WAYANS**

JESSE **WILLIAMS**

ELISE **NEAL**

ANTONIO **SABATO JR.**

OLIVER **PLATT**

ALFRED **MOLINA**

HILL **HARPER**

BEN **VEREEN**

CCH **POUNDER**

TOM **FONTANA**

TICHINA **ARNOLD**

J. **ALEXANDER**

MARY **MURPHY**

JASON **RITTER**

MEKHI **PHIFER**

MO'NIQUE

JOEL **SCHUMACHER**

TONY **BENNETT**

FISHER **STEVENS**

JUDITH **LIGHT**

CHAZZ **PALMINTERI**

RICHARD **SCHIFF**

ADAM **BUSCH**

DANIEL **STERN**

NIA **VARDALOS**

KATHY **NAJIMY**

RICHARD **BELZER**

LYNN **WHITFIELD**

STEPHEN **COLLINS**

KATE **MARA**

AMANDA **PEET**

OMAR **EPPS**

ANITA **BRIEM**

ALAN **CUMMING**

KATHRYN **ERBE**

MELISSA **LEO**

JAMES **DENTON**

ANDREA **BOWEN**

GLORIA **REUBEN**

AMY **BRENNEMAN**

PETER **GALLAGHER**

MELISSA **MANCHESTER**

CATHERINE **DENT**

ELLEN **HOLLMAN**

FRANCES **FISHER**

JAMIE **KENNEDY**

PAULA **ABDUL**

MASI **OKA**

PORTIA **DOUBLEDAY**

JAMES KYSON **LEE**

RACHAEL LEIGH **COOK**

LINUS **ROACHE**

STEPHANIE **MARCH**

DEBI **MAZAR**

BENJI **SCHWIMMER**

JEFFREY **ROSS**

BARRY **BOSTWICK**

IAN **GOMEZ**

WENDIE **MALICK**

ADHIR **KALYAN**

GILLES **MARINI**

TAMALA **JONES**

HARRY **HAMLIN**

NOUREEN **DeWULF**

LAURA **SILVERMAN**

ELLEN **BURSTYN**

EDDIE **GRIFFIN**

CAMRYN **MANHEIM**

SIEDAH **GARRETT**

JASON **ACUÑA**

QUINTON **AARON**

DENNIS **HAYSBERT**

RICK **YUNE**

TY **BURRELL**

RICHARD **KIND**

PATRICK **FISCHLER**

TOM **ARNOLD**

DEMIÁN **BICHIR**

AARON **STATON**

VIK **SAHAY**

PABLO **SCHREIBER**

JOSH **RADNOR**

MATTHEW **SETTLE**

CHERYL **HINES**

CHRIS **BOTTI**

COREY **REYNOLDS**

THOMAS IAN **NICHOLAS**

AARON **PAUL**

RICKI **LAKE**

OLIVIA **D'ABO**

EVAN **HANDLER**

MALIN **AKERMAN**

JOE **MANTEGNA**

MICHAEL **SHANNON**

ANDY **SERKIS**

JUSTIN **BARTHA**

PHILLIP **BLOCH**

ROBERT **DAVI**

BRIAN J. **WHITE**

ELLIOTT **ERWITT**

Foreword by ROBIN **BRONK**

More than two decades ago, a group of activists—who happened to also be actors—went to Capitol Hill to help save the National Endowment for the Arts from extinction. In the winter of 1986, Christopher Reeve, Ron Silver, Susan Sarandon, Alec Baldwin and Stephen Collins boarded an Amtrak train from New York City to Washington, D.C.—using that ride to plan their strategy to convince policymakers that public funding for the arts was neither a Republican nor a Democratic Party issue, but something that no American citizen could or should live without. They arrived in Washington, D.C.'s Union Station armed with the facts and figures to prove, without a doubt, the efficacy of supporting the arts. Chris, Ron, Susan, Alec and Stephen were, indeed, instrumental in saving the National Endowment for the Arts.

Like all good activists, they didn't stop after they won that first battle. They went on to found The Creative Coalition.

The Creative Coalition, the national, nonpartisan, nonprofit organization for leaders in the arts and entertainment industry, uses the power and spotlight of those arenas to support issues of social importance. For the past 22 years, the number-one-priority issue for The Creative Coalition has been public funding for the arts in America.

When I began this book, I asked participants to pinpoint a moment in time that changed their lives. While everyone had his or her own individual and poignant anecdote, the common thread woven throughout everyone's story was that someone or something fostered the artistic sensibility in each of them.

Today, it is so important to remember the totality of what the arts bring to our citizenry. In these times of economic crisis, it seems only rational that we should look back at our history to review what works to secure a strong economic legacy for future generations.

When faced with a collapsing economy, President Franklin Roosevelt tried to put Americans in all lines of work back on the job. Instead of singling out artists as somehow frivolous and unimportant to our nation's economy, he instituted a litany of programs designed to put federal funds into the arts, employing America's creative talent and leaving a cultural legacy that still endures today.

The high point of this commitment was the Works Progress Administration's Federal One program, which put thousands of Americans to work in the arts. The government program was a lifeline for Jackson Pollock, Mark Rothko, Orson Welles, Burt Lancaster, Sidney Lumet, Ralph Ellison, Richard Wright, Studs Terkel, John Cheever, Saul Bellow and thousands of other artists across the country.

These programs created much-needed jobs in the immediate term, but they did much more. They fostered great talents that otherwise might have been lost. The works of the many great artists supported by the government in the 1930s still benefit us today. Those artists' contributions to our culture endure, and their successful careers resulted in employment for many others in the years that followed.

Today, however, many of our leaders apparently have forgotten this lesson of our not-so-distant past. Faced with an economic downturn of staggering proportions, some attack any help for the arts as wasteful, ignoring the millions of Americans who earn their livings and support their families through their artistic endeavors and arts-related enterprises.

Beyond the finances, though, investing in the arts during these tough times can ensure that America doesn't lose a generation of creative talent to our temporary economic woes. Somewhere in America today, there are individuals with the potential of Orson Welles and the artistic gifts of Mark Rothko.

Look deep into the souls of those artists who are portrayed in these pages. They truly represent a great American legacy.

Thank you to Michael Frankfurt, Tim Daly and Dana Delany for allowing me to earn a living doing something that I love. My deepest gratitude and appreciation to my partner in creating this book, Brian Smith. And to the most inspirational artists I know—Eliza, Danielle and Kiki.

<div align="right">

—ROBIN L. **BRONK**
CEO
The Creative Coalition

</div>

A few words from BRIAN **SMITH**

If you want to reach straight to the heart of a famous Hollywood star, just ask them about the arts. You'll likely witness an amazing transformation as their thoughts transport them back to their first school play, when their biggest stage was shared with school assemblies and their entourage and stretch limo were their friends in the back of their mom's minivan.

This book is not about their latest movie or the agendas of a magazine, their agent or studio. It is much simpler than that. This project is plainly and simply about the arts. It's about what the arts mean to them and the promise the arts hold for future generations.

I've been blessed with more than my share of great projects, yet this is one of the most memorable shoots of a 30-year career. I owe a huge debt of gratitude to Sony's Kayla Lindquist for dropping this dream project in my lap and for coming up with the concept of having celebrities write in a notebook what the arts mean to them, thus providing the text that accompanies each photograph and quite possibly creating the coolest yearbook...ever...

Working with our partners from The Creative Coalition over the past two years, Robin Bronk, Barb Horvath, Briana Mulherin, Dennis, Risa and Liv, we all became close as family. It was wonderful to witness the great work they do in support of the arts. This book salutes their commitment.

Little did any of us suspect that what was planned as a three-day shoot during Oscars Week 2009 would grow into the project you see here. From the very start, this project was truly something special. Everything just clicked. TCC president Tim Daly was the very first portrait of this shoot. Normally it takes a while to hit a rhythm on a shoot, but after shooting a dozen

frames I stepped over to the monitor with Tim to see how things looked and up popped the photo of him that you see in this book. It was just frame 10 of this project, yet everyone in the room knew that we'd hit on something wonderful.

Memorable moments quickly followed as Lynn Whitfield and Tichina Arnold both channeled Eartha Kitt in their photos, our jaws dropped when we all saw the brilliant way Zooey Deschanel used a flowchart to explain the arts, and yes, ladies, James Denton does just walk into a room and look that suave...

We followed our Los Angeles shoots with three more days in New York that began with a dream day starting with a shoot of Anne Hathaway. Lovely Anne Hathaway, so wonderful to photograph. Somehow Anne is even nicer in person than you could possibly imagine. Thanks for the cupcakes, Anne. On a normal day, life couldn't possibly get any better than cupcakes with Anne Hathaway, but this was a shoot with few "normal" days. So after saying goodbye to Anne, we headed uptown to Tony Bennett's Central Park apartment to photograph the icon. It was the perfect ending to the perfect day.

Every May, The Creative Coalition members travel to Washington, D.C., to lobby for arts funding on Capitol Hill. In 2009, we took an early version of this book, donated by Blurb, to Capitol Hill and the White House with TCC members including Barry Levinson, Tim Daly, Dana Delany, Matthew Modine, Tom Fontana, Matt Settle, Linus Roache, Rachael Leigh Cook, Alfre Woodard and Kerry Washington. I had no idea that Alfre and Kerry would soon be doing a bit of friendly lobbying for me. But at the Sundance Film Festival the following January, I approached Samuel L. Jackson to explain the project. He quickly cut me off, saying he'd seen the prints I'd given Alfre and Kerry, and

wondered how anyone could do a book about the arts that didn't include Samuel L. Jackson. Well, Sam, you're absolutely right and this one does...

Peer pressure can be a wonderful thing. After a dozen frames, Kelsey Grammer asked if I had what I needed. I replied, "I suppose...though we got a lot more out of David Hyde Pierce." The sheepish look on Kelsey's face is his reaction to being upstaged by his *Frasier'* costar. Speaking of former costars. Tim Daly was shooting a PSA in the studio next to me when Steven Weber came in for his shoot, so at the end of Steven's shoot, I dragged Tim in for my own personal *Wings* reunion.

We took advantage of every opportunity to expand the project, stealing a bit of New York studio time from another shoot for a chance to photograph Harry Belafonte and Matthew Modine. Harry proved he's still every bit the chick magnet, as every single woman on the shoot lined up for a picture with him. Any conceptions you might have of pampered Hollywood celebrities would be shattered if you saw my pal Matthew ride up to our studio on his bike.

Three more trips to Los Angeles followed. On the first, Richard Schiff had so much fun, he stuck around for our shoots of Dulé Hill, Rachael Leigh Cook and Catherine Dent, and then started calling up friends for our shoot, including his golfing buddy Peter Gallagher. I began to wonder if there was anyone in Hollywood who wasn't within "Schiff Degrees of Separation."

In May 2010 this project was previewed with an exhibition of the photographs and live performances by some of these stars at the Library of Congress. This also provided an opportunity to round out this book with portraits of Omar Epps impeccably dressed straight off his red-eye from Los Angeles, and Spike Lee,

Patricia Arquette, Gloria Reuben and Marlon Wayans shot in the greenroom backstage which turned into LaGuardia High School reunion with best friends Omar and Marlon joined by Adrian Grenier and Steven Weber. If you need a great blueprint for a school for the arts, look no further than LaGuardia High, the famed School for the Arts in New York City, whose alumni in this book also include Adrien Brody, Tichina Arnold and Melissa Manchester.

It's my great pleasure to close this book with a portrait of Elliott Erwitt, an artist who inspired my career. My thanks to Elliott for his kindness and support.

This book is dedicated to every teacher who ever opened a child's eyes and imagination to the possibilities of the arts and to the artists whose art transforms countries into civilizations.

—BRIAN **SMITH**

An act of
creation is
an act of
hope.
Art gave me
my heart.

ANNE **HATHAWAY** / ACTRESS

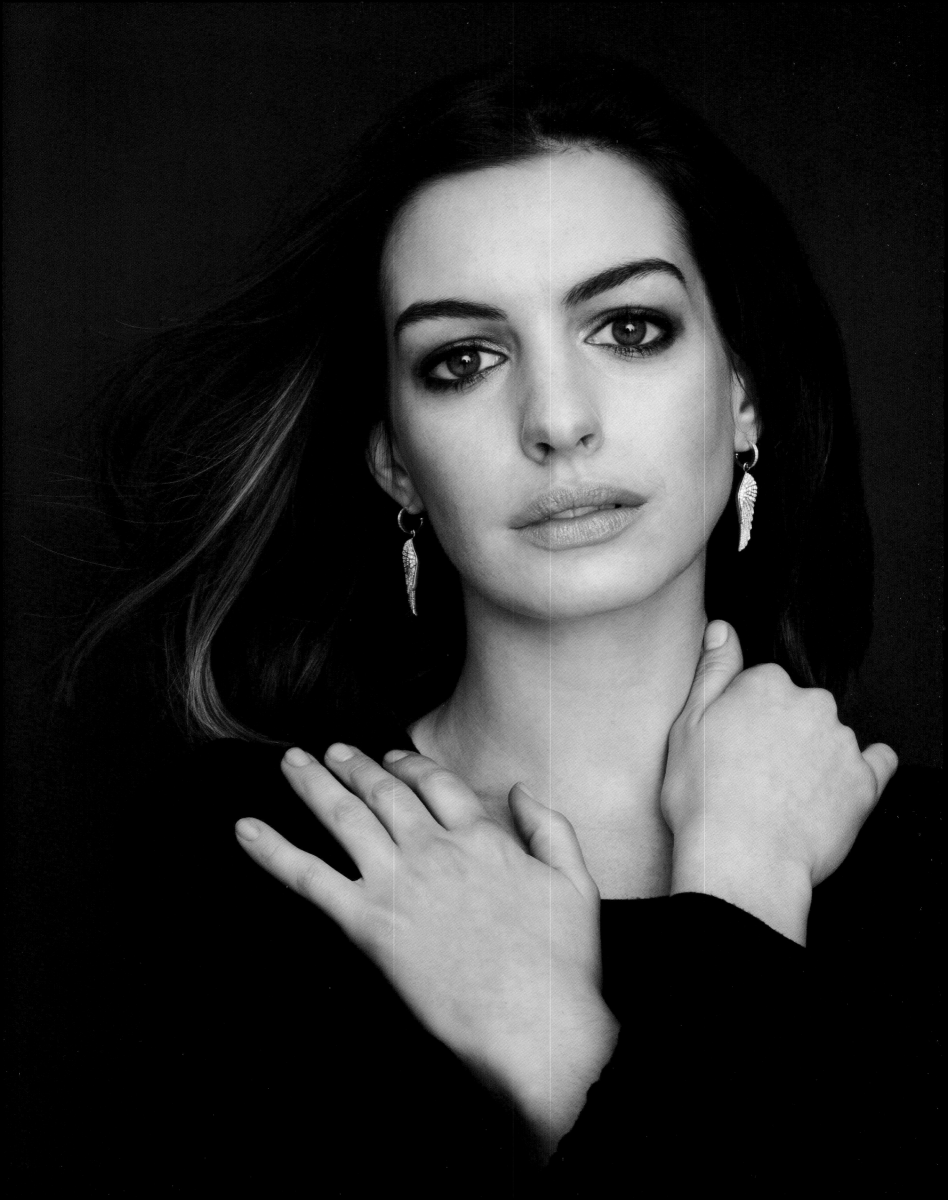

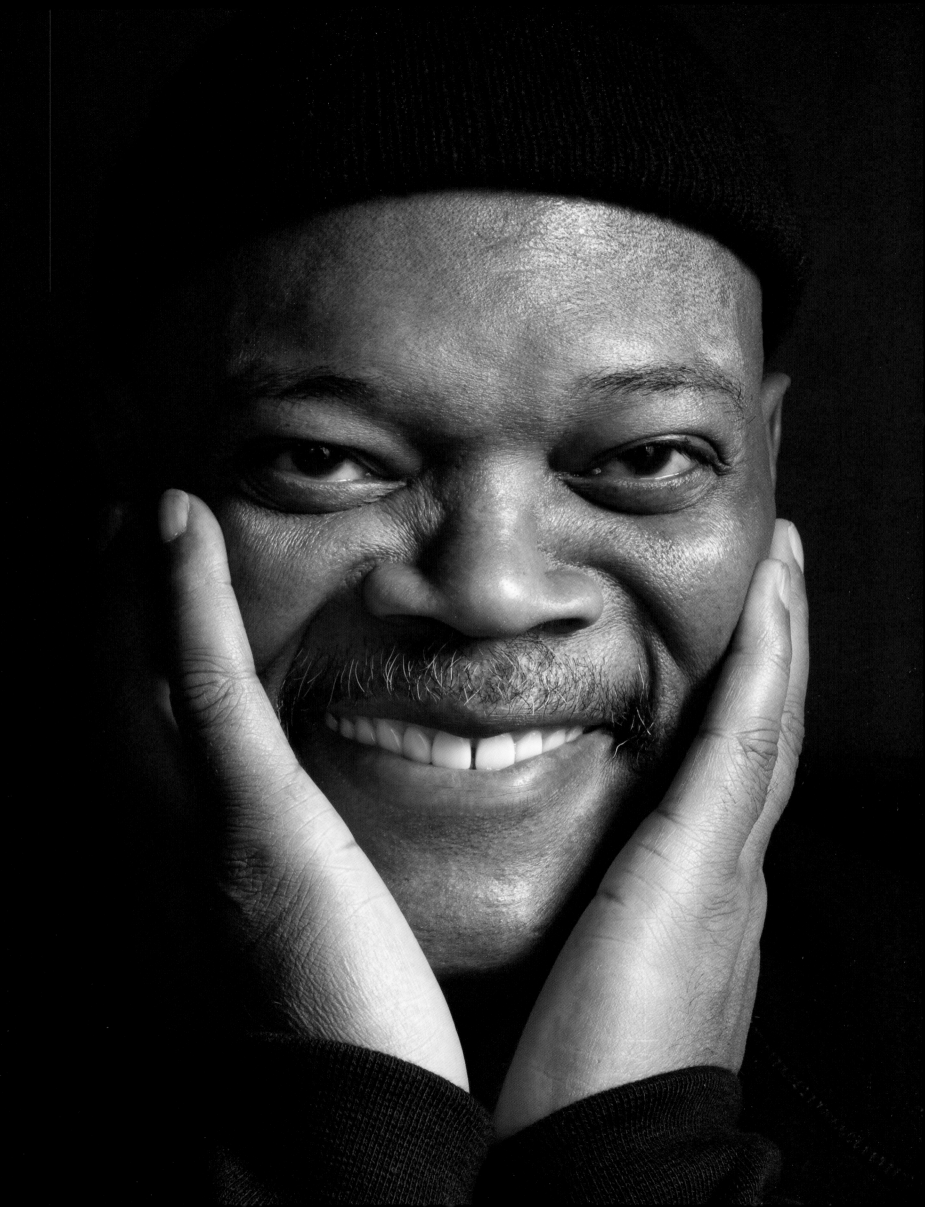

ART IS THE
MASTER,
I
AM ITS
SLAVE!

[signature: Samuel L. Jackson]

SAMUEL L. **JACKSON** / ACTOR

I am who I am because of the Arts!! ♡

We must keep them, honor them, cherish them, celebrate them.

Artfully yours :)

KW

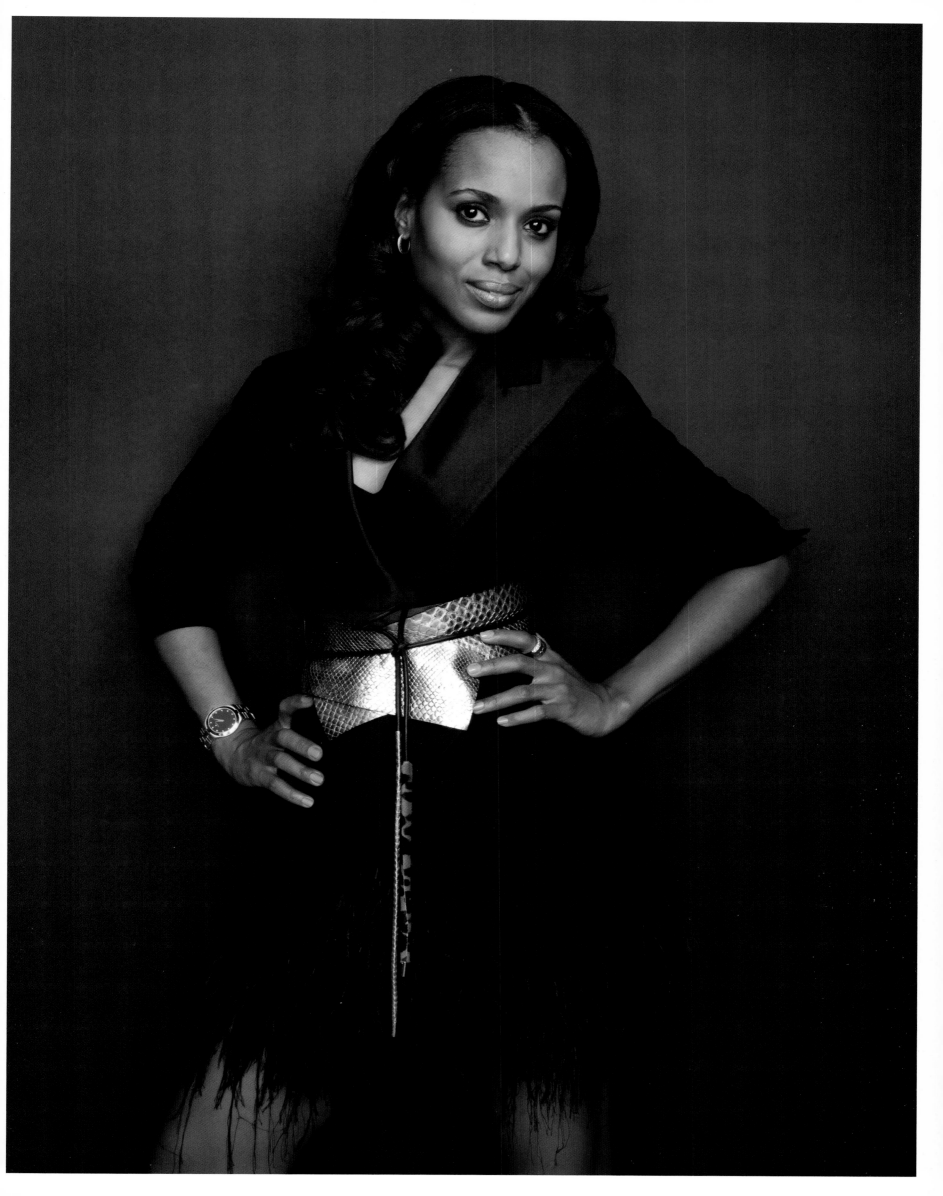

When a single mother is raising 3 children alone art supplies are not in the budget. She has no time to teach her children about Norman Rockwell or Andy Warhol or Miro.

Children need art to express who they are. How they feel. Why we are here on Earth. How they are Special. Children need art! Art heals.

Art is Not A Luxury!

Art is a Necessity!

Patricia Arquette

PATRICIA **ARQUETTE** / ACTRESS

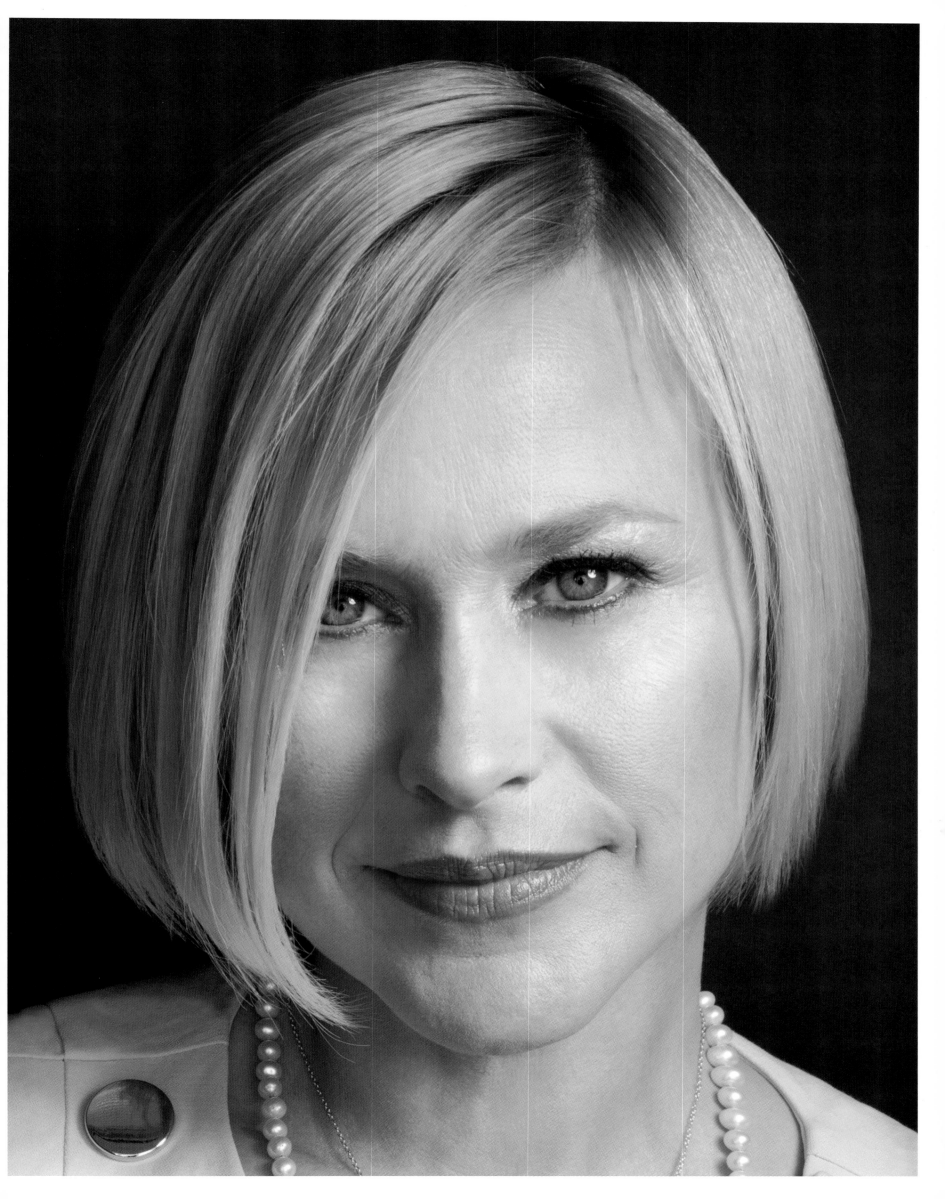

ART
is
LOVE

spike lee filmmaker Republic of Brooklyn, N.Y.

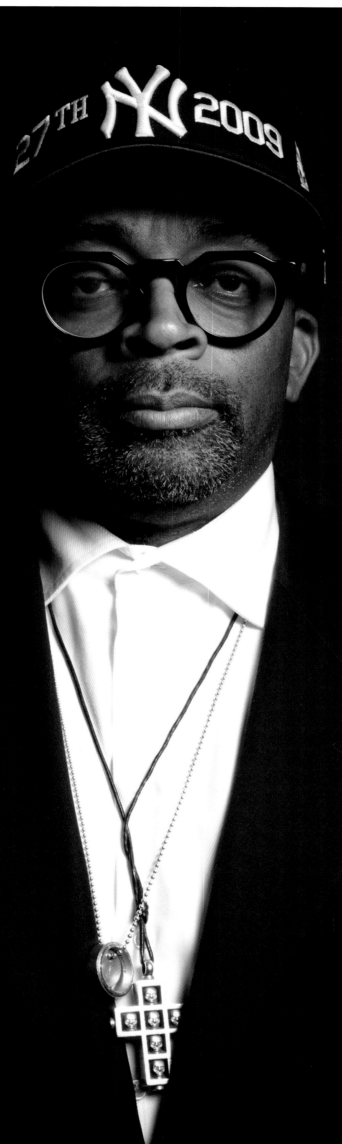

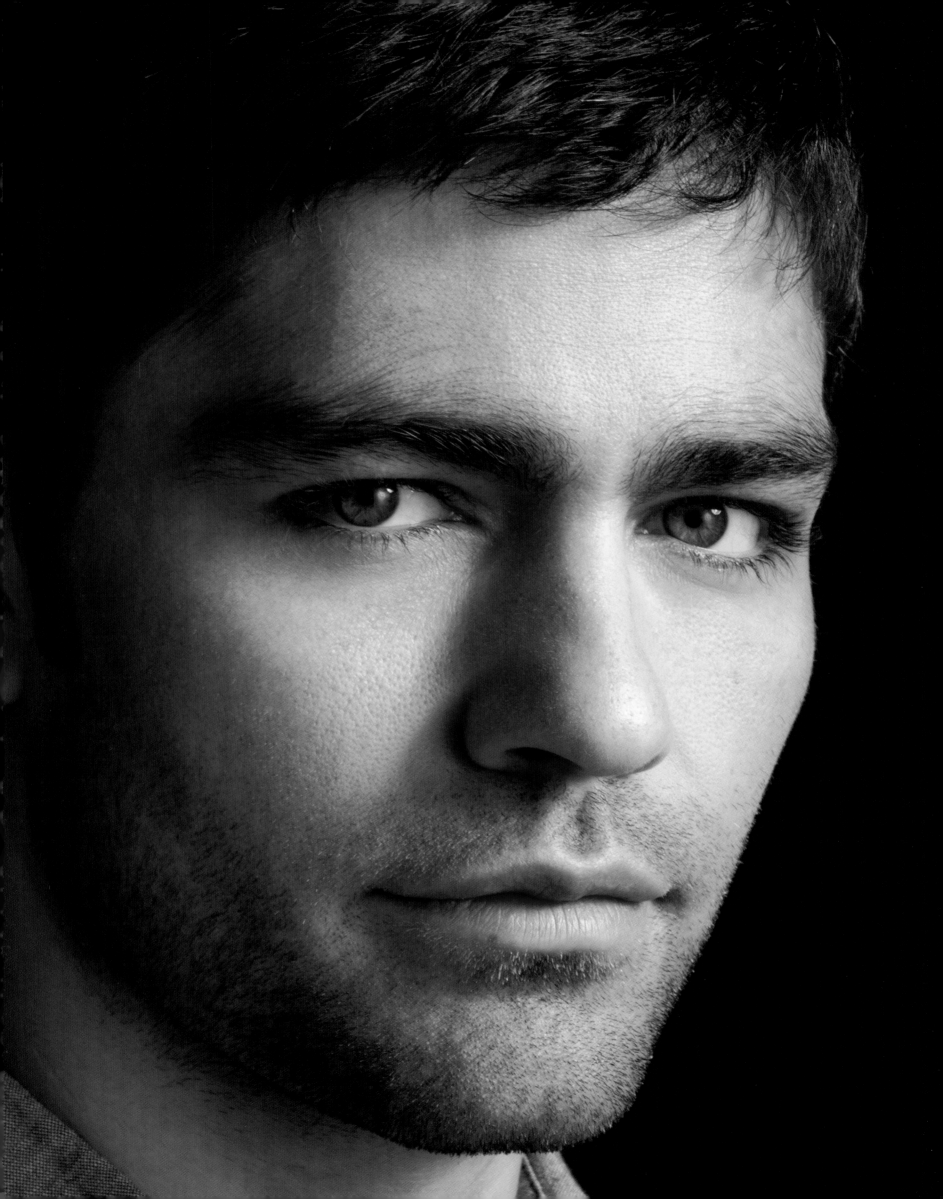

Art is
Fart
without The
"F"
— Adrian Grenier

ADRIAN **GRENIER** / ACTOR / MUSICIAN / FILM MAKER

Art questions.

Kelsey Grammer

KELSEY **GRAMMER** / ACTOR

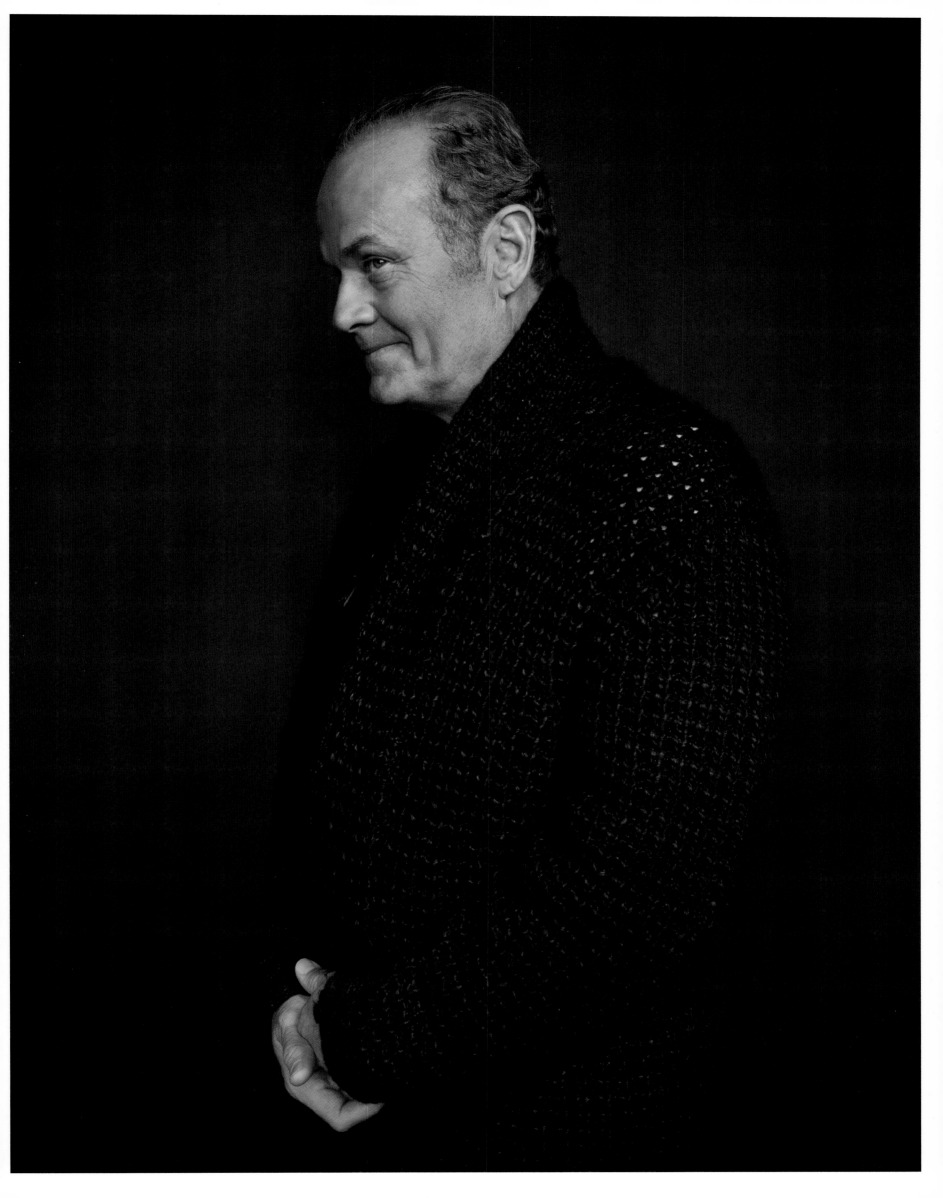

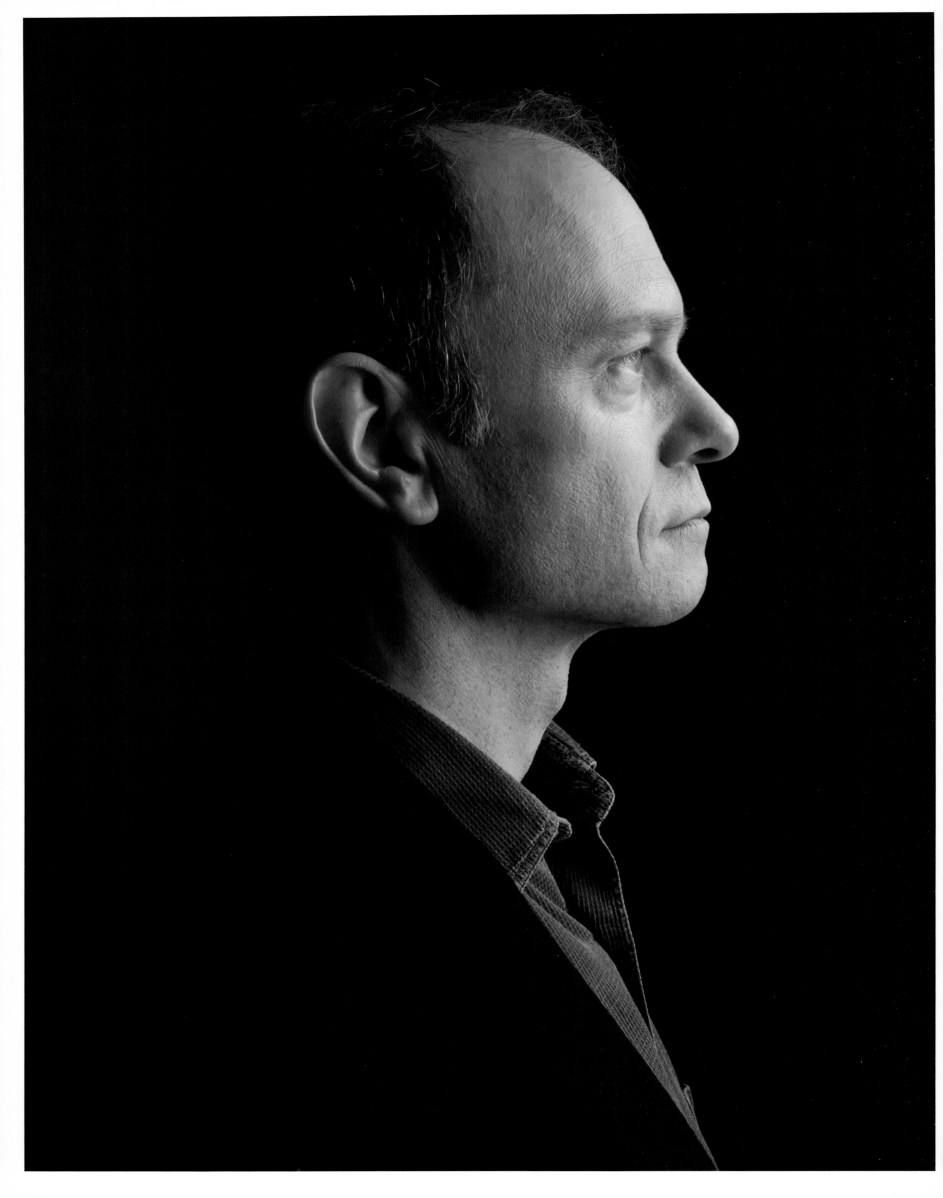

The arts tell us
who we were,
who we are,
and who we could be.
they have the power
to heal us, to bring us
together, to show us the way.

(oh, and they make us
laugh.)

David Hyde Pierce

To Create
To dream
To Laugh
To Touch

To dip your head below
the marsh and take notice...
Of even the tiniest of details.

Alyssa Milano

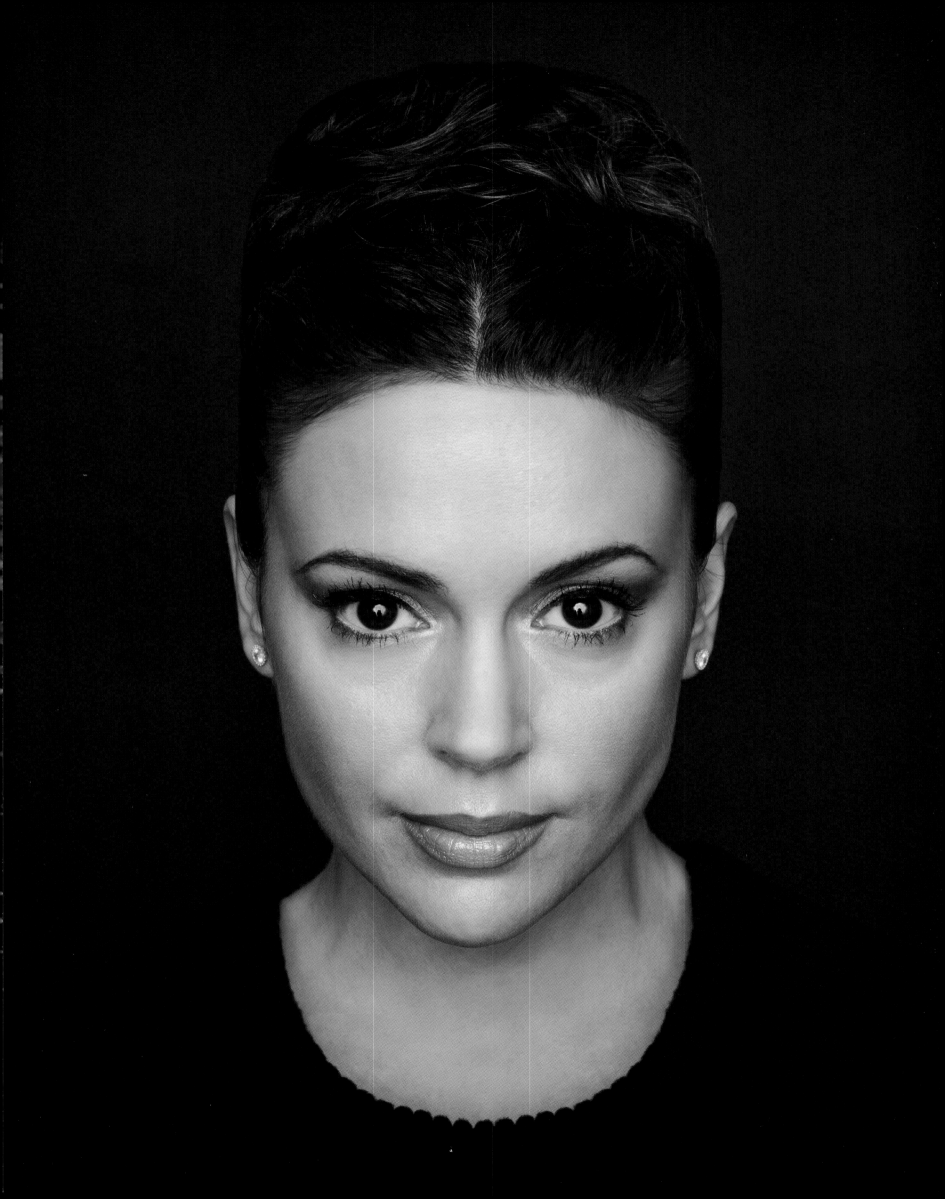

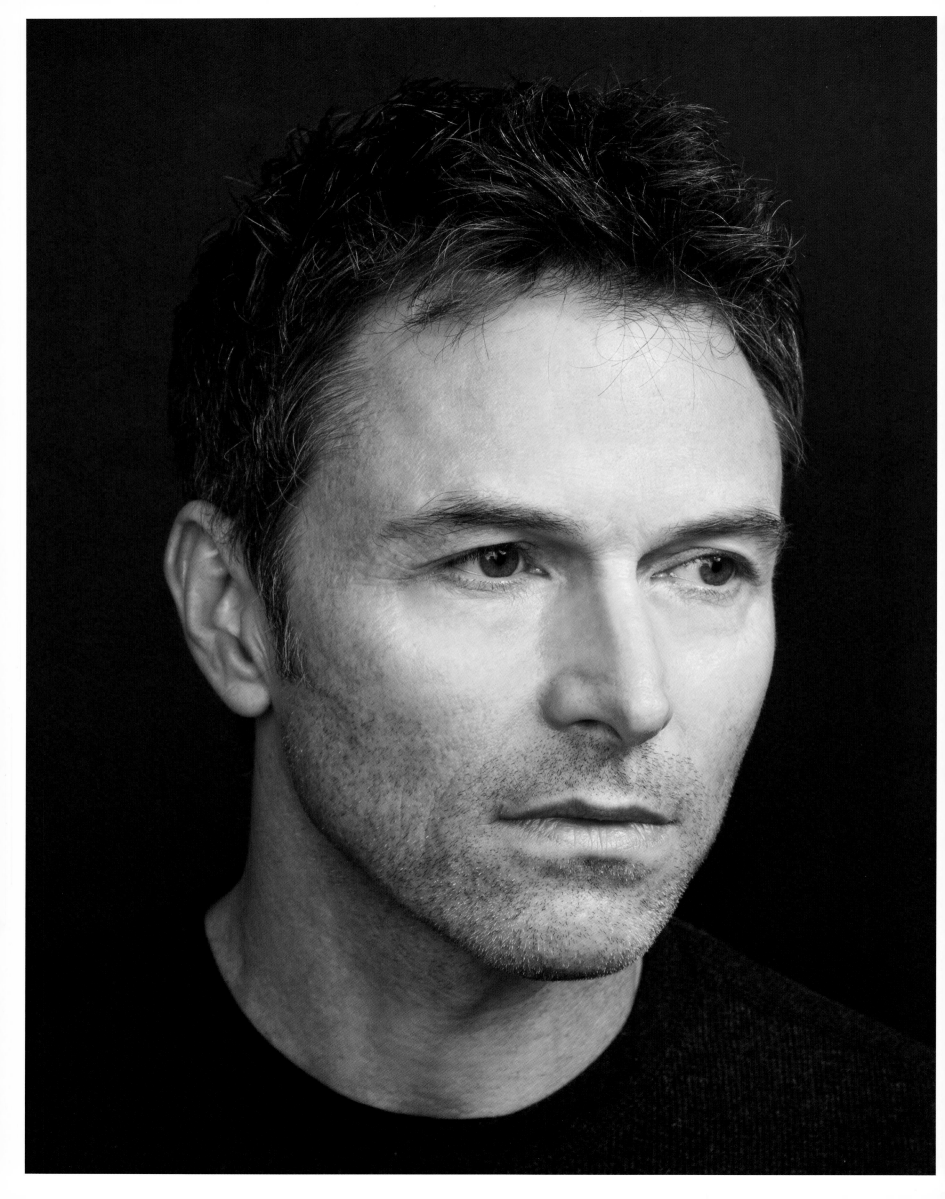

I AM ALWAYS ASTOUNDED WHEN POLITICIANS TRY TO DE-LINK ARTS FROM OUR EVERYDAY LIVES AND OUR ECONOMY. EVERYTHING WE SEE: EVERYTHING WE WEAR: EVERY TOOL WE USE: EVERY CHAIR: EVERY AUTOMOBILE: EVERY TV SHOW: EVERY MOVIE: EVERY OFFICE is CONCEIVED OF BY A CREATIVE MIND AND ACHIEVED BY ARTISTS AND ENGINEERS. ART is ALL AROUND US. IT's EVERYWHERE. OUR CREATIVITY NEEDS TO BE NURTURED AND SUPPORTED NOT JUST TO ENTERTAIN US AND BRING BEAUTY INTO OUR LIVES BUT TO KEEP US COMPETITIVE IN DESIGN, TECHNOLOGY AND ECONOMICALLY. MUSIC, PAINTING, THEATRE, FILM, DANCE, ARCHITECTURE, DESIGN. IT'S NOT EXTRA... IT'S WHO WE ARE.

TIM **DALY** / ACTOR

Art in showing life as it
is.

Gives the artist the
opportunity to show
life as it should be.

Peace.

Harry Belafonte

HARRY **BELAFONTE** / SINGER / ACTOR

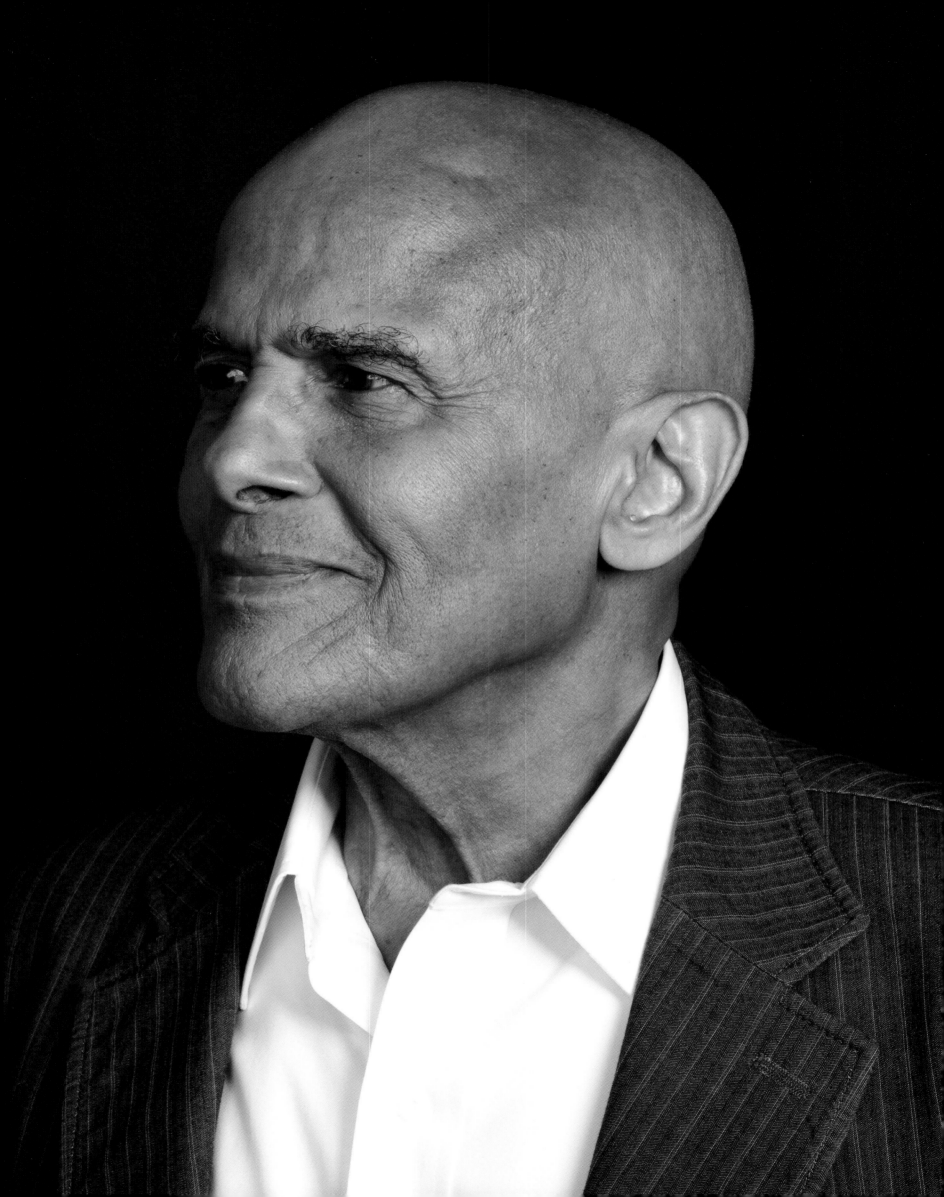

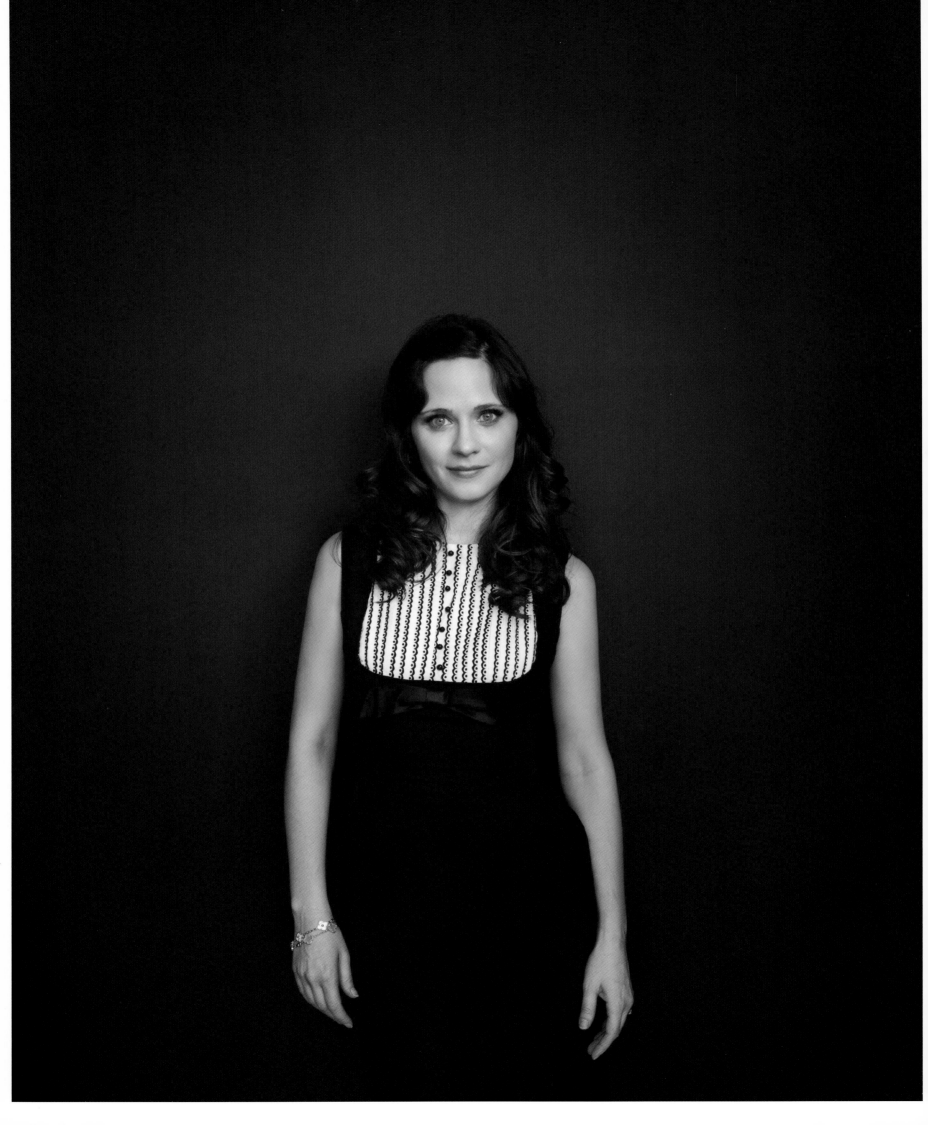

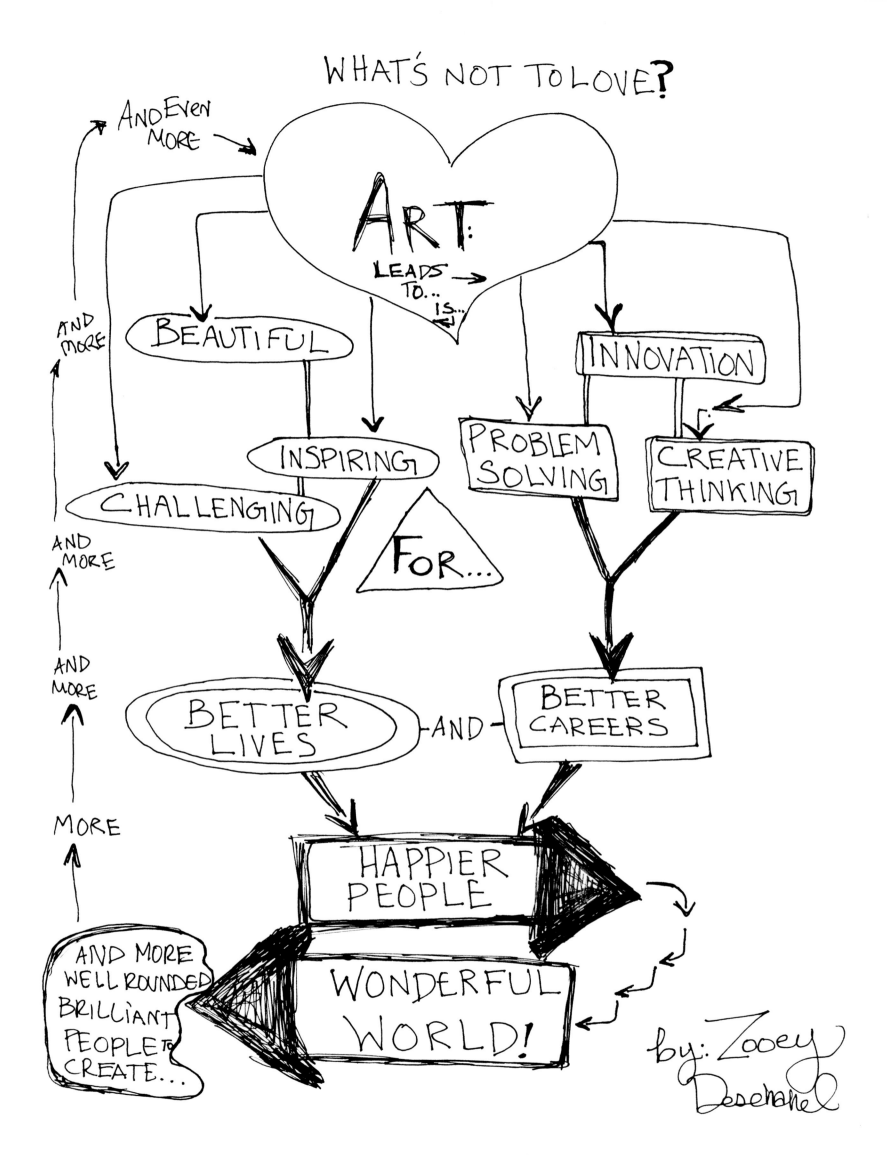

ZOOEY **DESCHANEL** / ACTRESS / MUSICIAN / SINGER

When I was very little I was moved, deeply, by art. I didn't understand why but deep alive connection coursed thru my body standing in front of a painting at Philbrook Art Center or squatting next 2 Native American Sculpture at Gilcrease Museum in The Osage Hills. Watching the dance, hear-feeling the orchestra, The gutbucket Thump of a band. I have always been deeply moved in the middle of art. I think of every expression of it as living. When I discovered at 4 That I could take off and whirl and stick my hands in and make it too — I felt a connection to life and 2 other people here + those gone That gives power to me, joy to me, reason 4 b N 2 ME. Why feed your young, Why tell the stories of life b4 them, Why teach them how 2 make $$ or cross the street safely — if you do not give them access 2 Art — feed them art — let The Art? 4 That is meal, nutricious, sustain life. Alfre

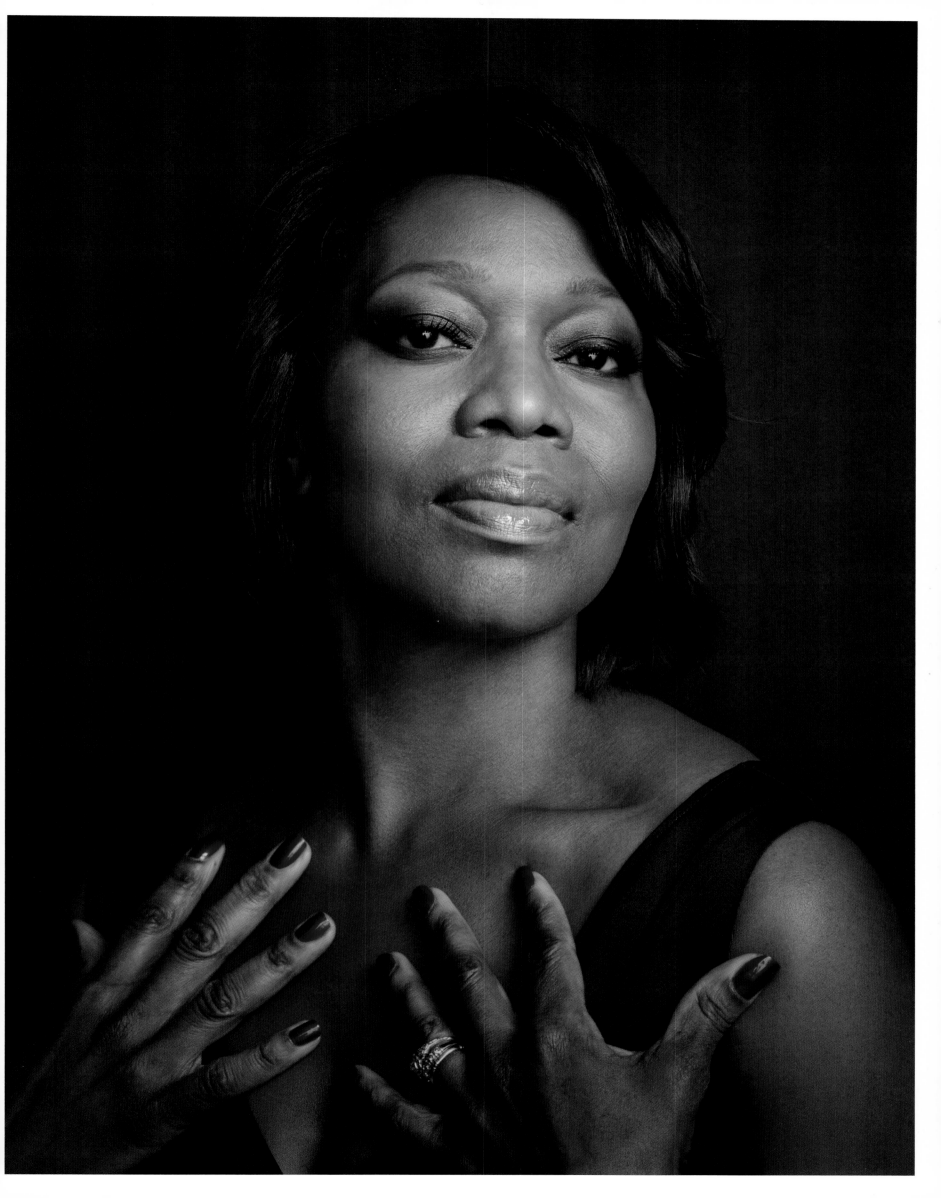

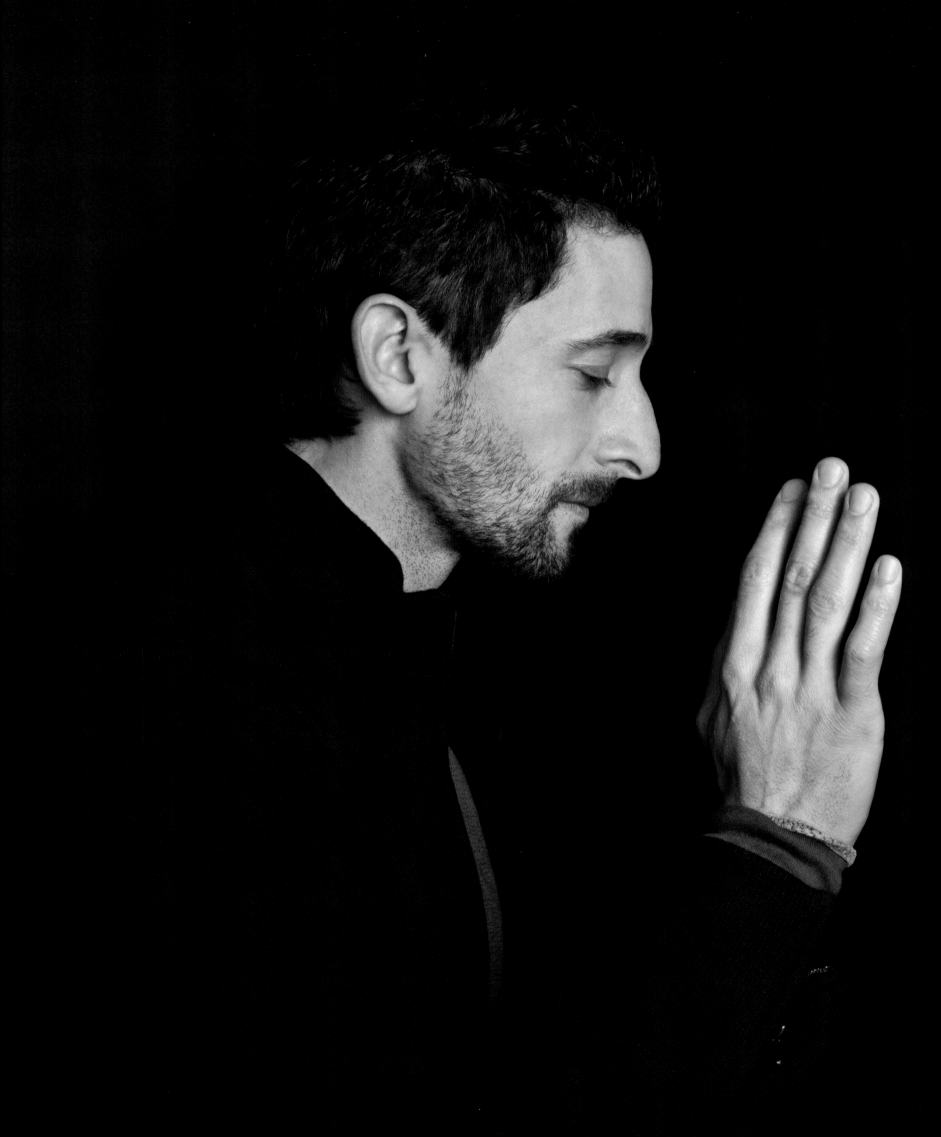

¿ WITHOUT ART
WHERE WOULD
WE BE...

ADRIEN BRODY

Every great thinker, statesperson, philosopher, inventor, innovator has depended on art to complete his or her vision. Without it, the world is a sterile, corporatized environment; without it, people are slaves to consumerism, hollow, their potential unrealized. And also, art is great for seeing lots of nude people.

Steven Weber

STEVEN **WEBER** / ACTOR

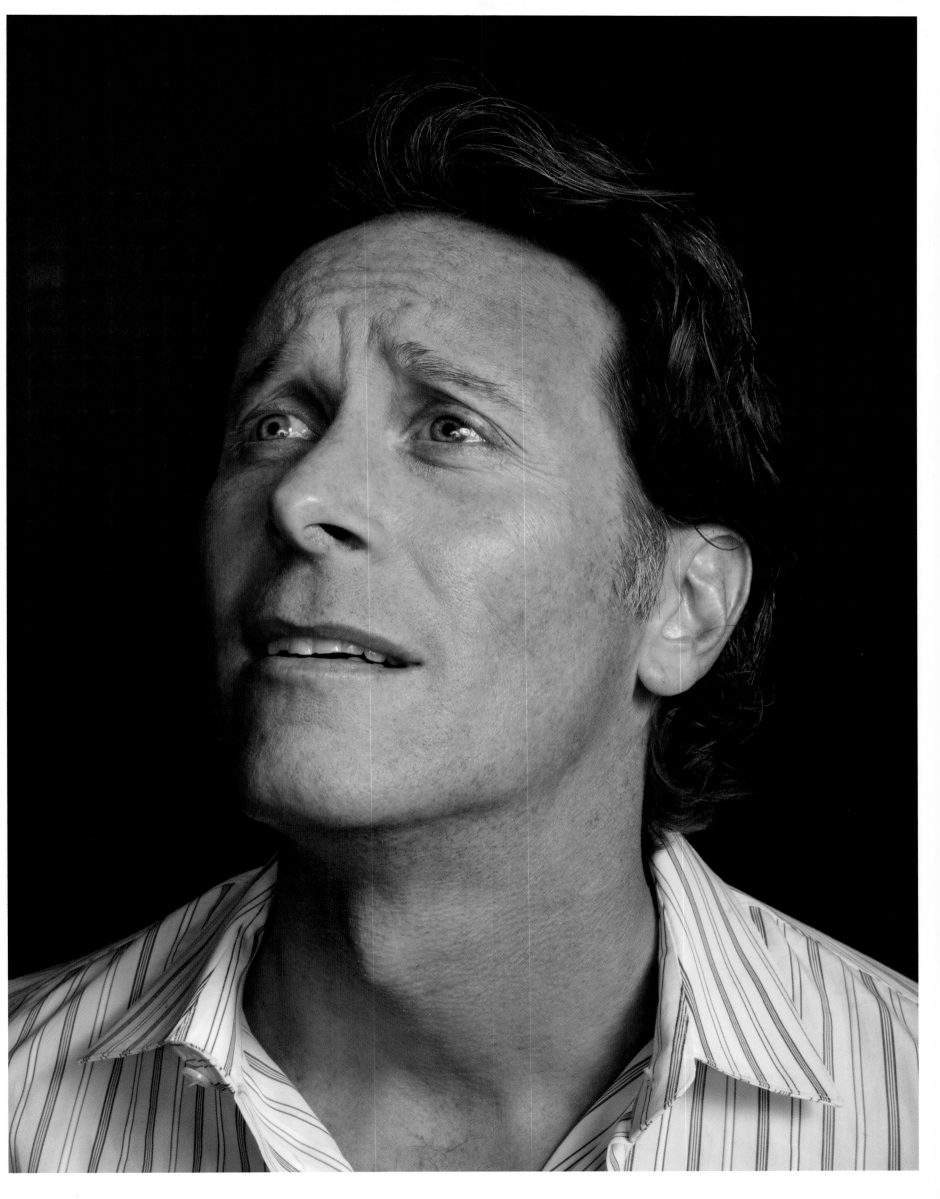

AS A KID I STRUGGLED WITH BEING
ACCEPTED SOCIALLY & HAD ISSUES
WITH SELF CONFIDENCE.
 THROUGH SINGING, ACTING AND
 DANCING I FOUND AN AMAZING
SENSE OF COMMUNITY & RESPECT FOR
MYSELF AND OTHERS.

 THE ARTS GAVE ME
 AN IDENTITY.

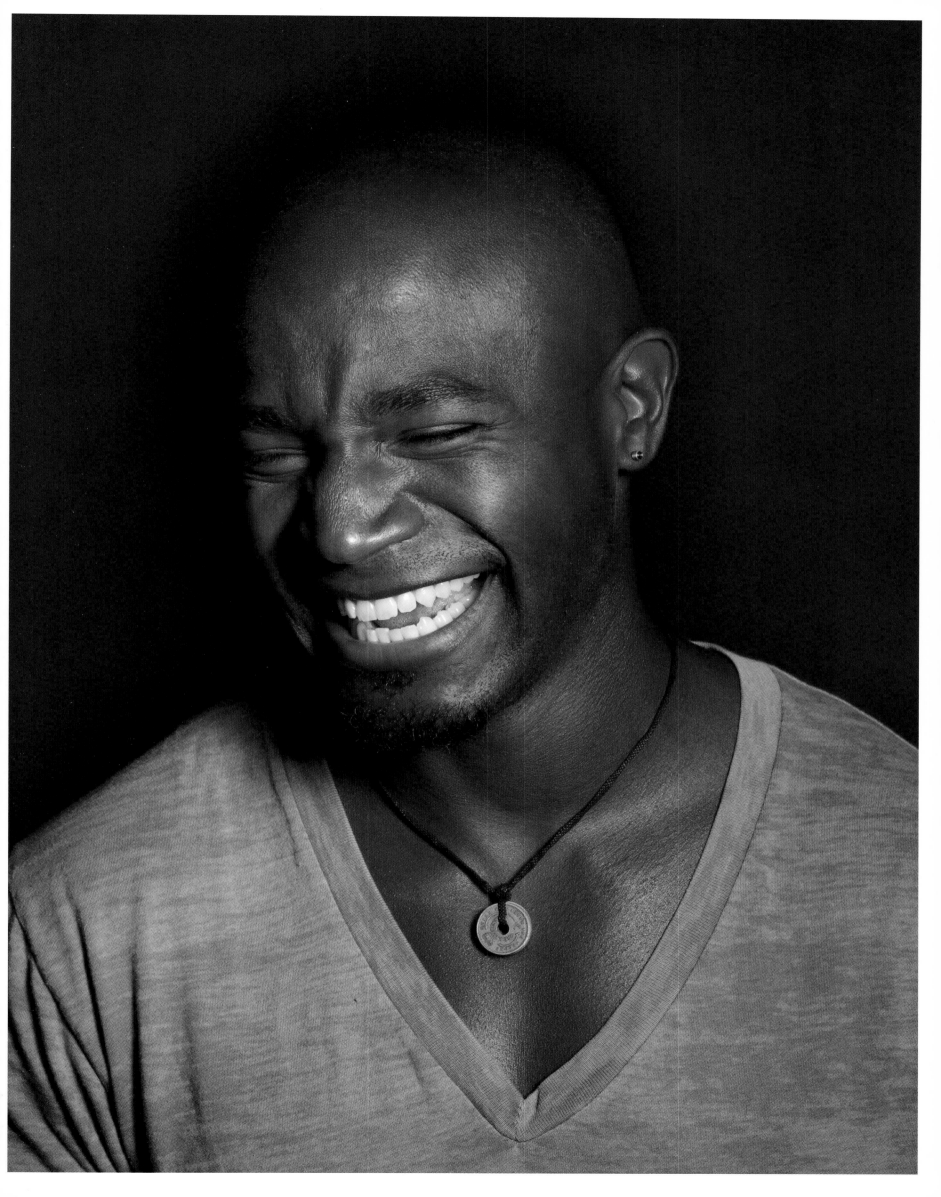

ART. ACT. TAP.

When has Art _not_ been in my life. 1 month before I was born my Mom was still dancing ballet. 1 month after I was born she was back dancing again.

I started dancing at the age of 3 and thanks to Jennifer Hill, Marie Wildey, Henry LeTang, Harold Nichols and Gregory Hines I have been acting and tapping ever since.

Without the Arts my life would have gone in a completely different direction. All I can say is

thank God 4 the Arts!

Dulé Hill

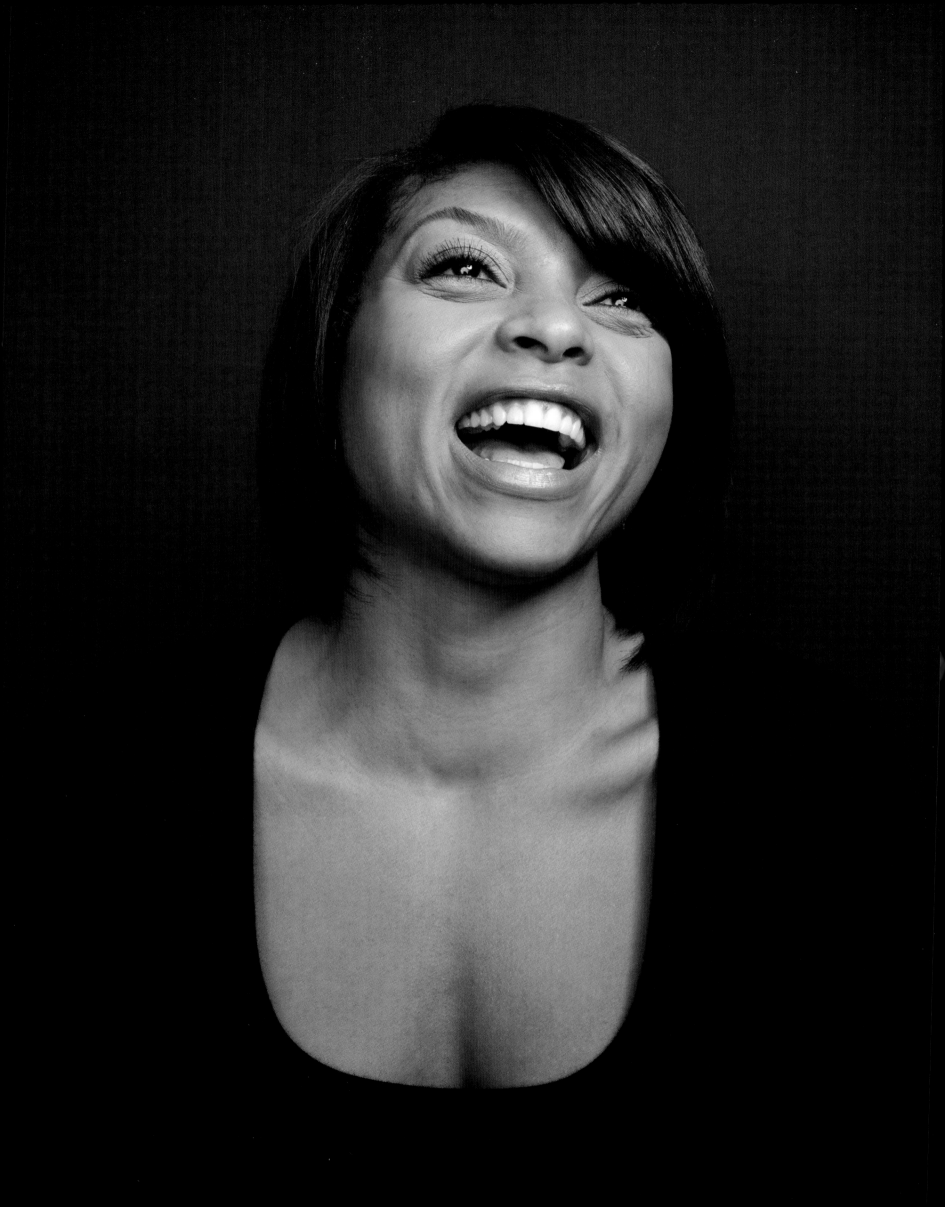

I grew up in S.E. Washington DC. As a teenager I always looked forward to the summer work program for teens. There was an arts program called Street Theater and that's when I learned to not only dream but that's where I fell in love with acting. I want this program back because it saved my life!

Thank God
4 the Arts

Taraji P. Henson

TARAJI P. **HENSON** / ACTRESS

art! what is it? art is
useless. and thats what
makes it so interesting
and use-full...

you cant eat it - yet it
feeds us...

imgine the world without
art. ~

no great architecture,
no great literature,
no science fiction to
inspire inventors and
scientists...
no music...
no paintings...
no poetry...
no clever chefs that make
food clever. ~
no philosophy...
a whole bunch of no's
and nothings.

I like art and artists. so there

7.17.09

Matthew Modine

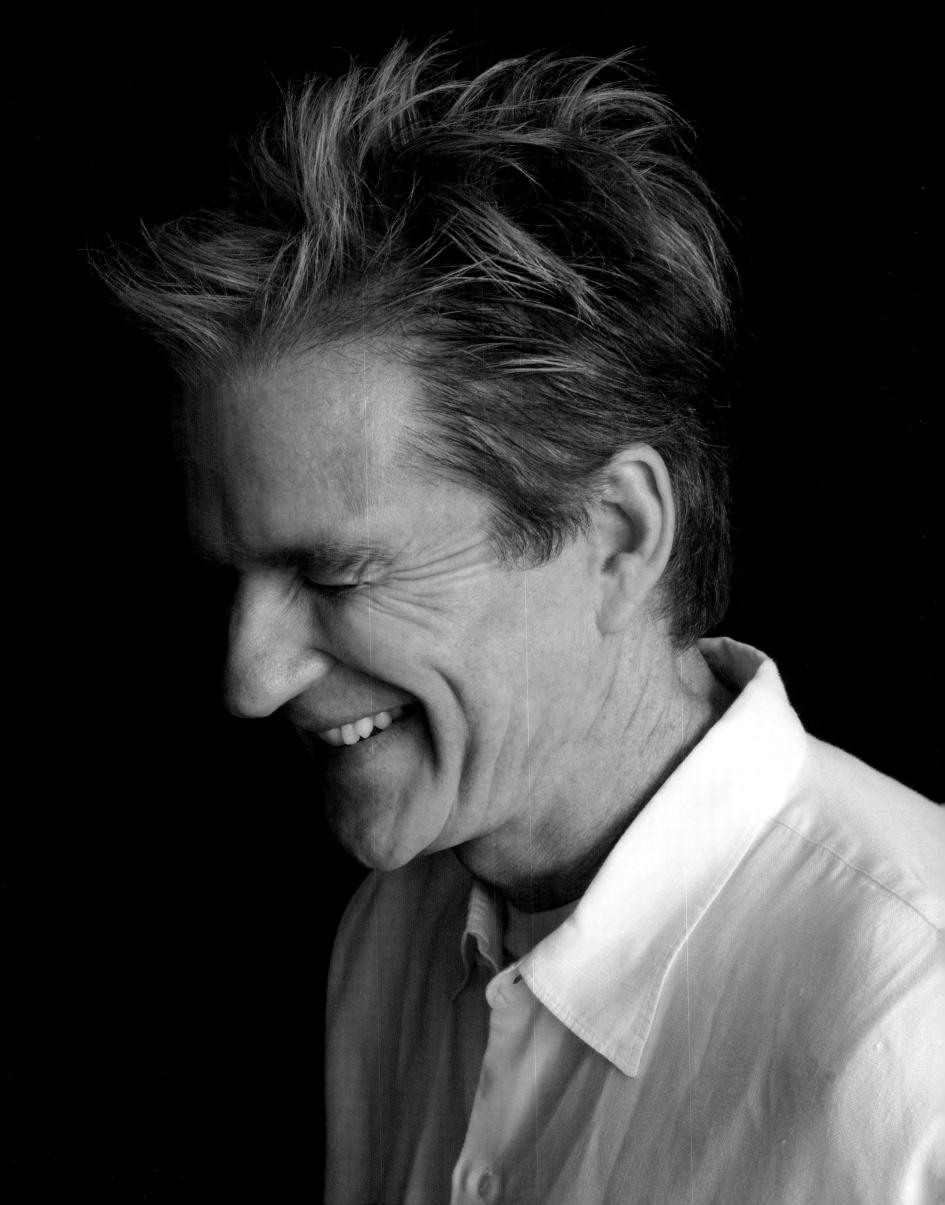

When I was 8 I saw
my 1st Broadway show.
My public school music
teacher took me. It was
"Oliver" directed by Peter
Coe. I was mesmerized.
I learned every song.
15 years later I was
on Broadway in "A Life"
directed by Peter Coe.
Dreams really do come
true.
 Dana Delany.

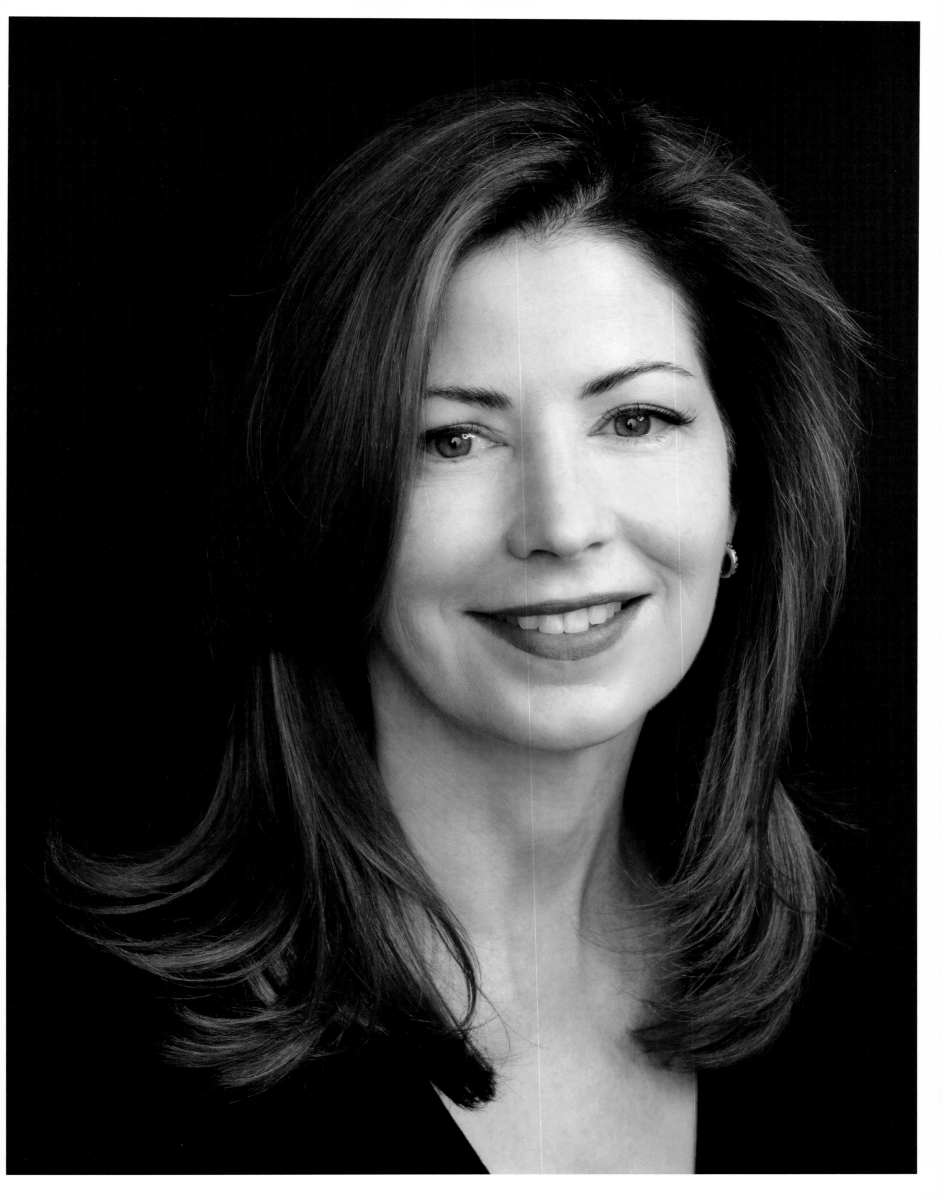

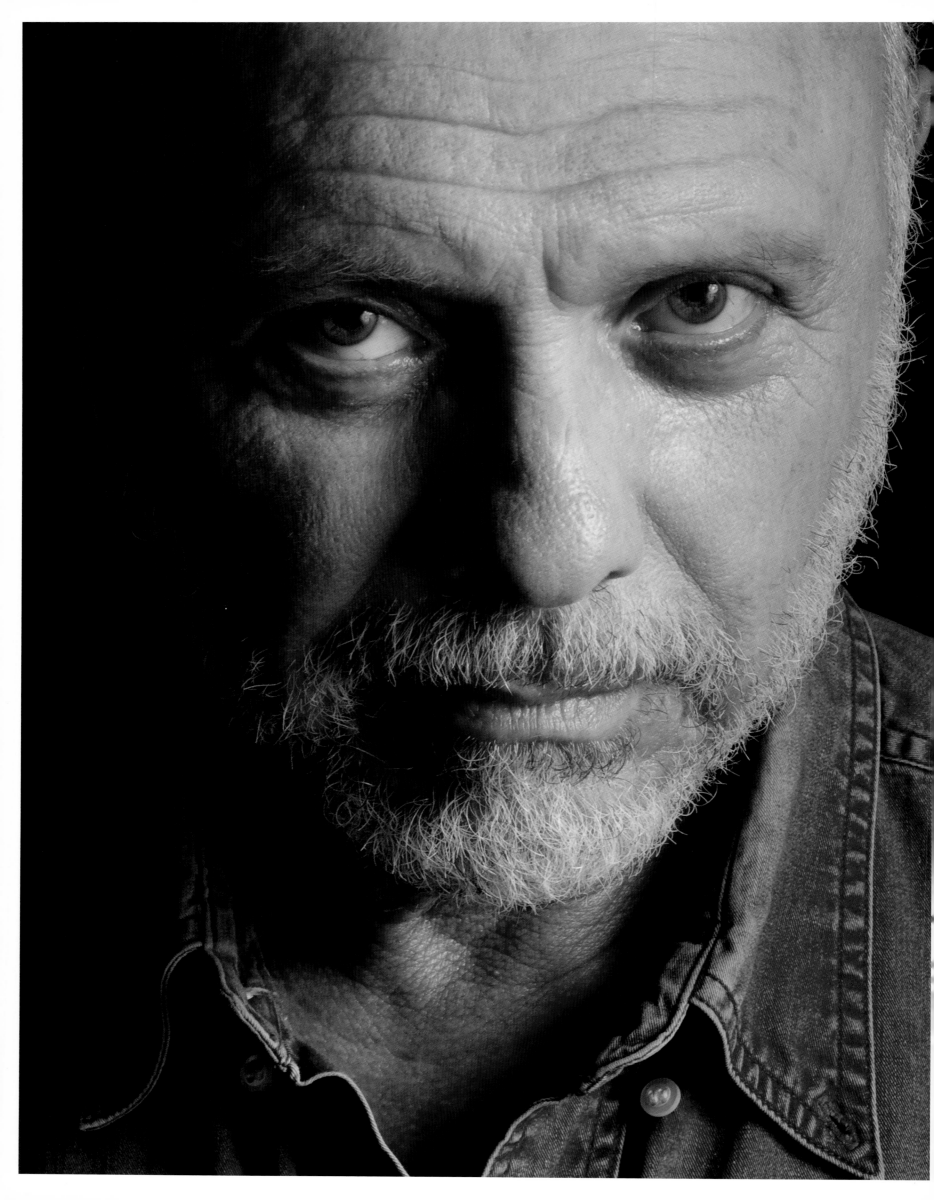

Our common genetic impulse is our inexpressible to express and reinvent ourselves through art. Restrain that impulse, thwart it in any way by prevailing powers or ideology and you will have a people deluded by its own certainty and thus easily controlled. ART can save the person and therefore, civilization.

Peace on you,

Hector Elizondo

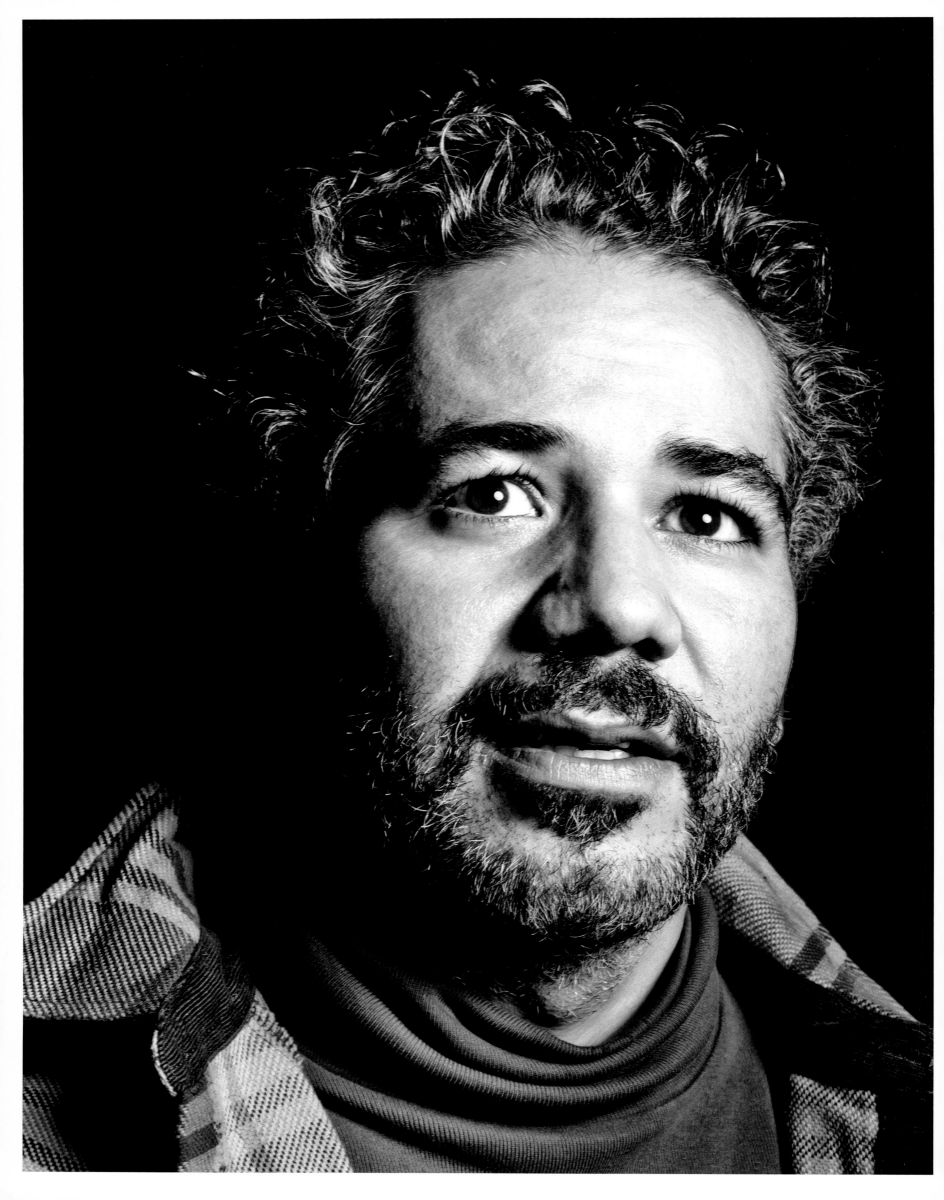

It, the moment of colliding head on with ART, was purely a matter of not only survival but of celebrating those stories, those faces, that need to be shared.

It gave me a reason to wake up. To go thru my day with purpose. and I AM forever indebted to the cause that give me LIFE! _(signature)_

JOHN **ORTIZ** / ACTOR

Art bridges cultures, races, religions
It takes us places we have never
been.
It helps make sense of the world.
It can entertain, teach & civilize.
Art makes us human.

JOHN **TURTURRO** / ACTOR

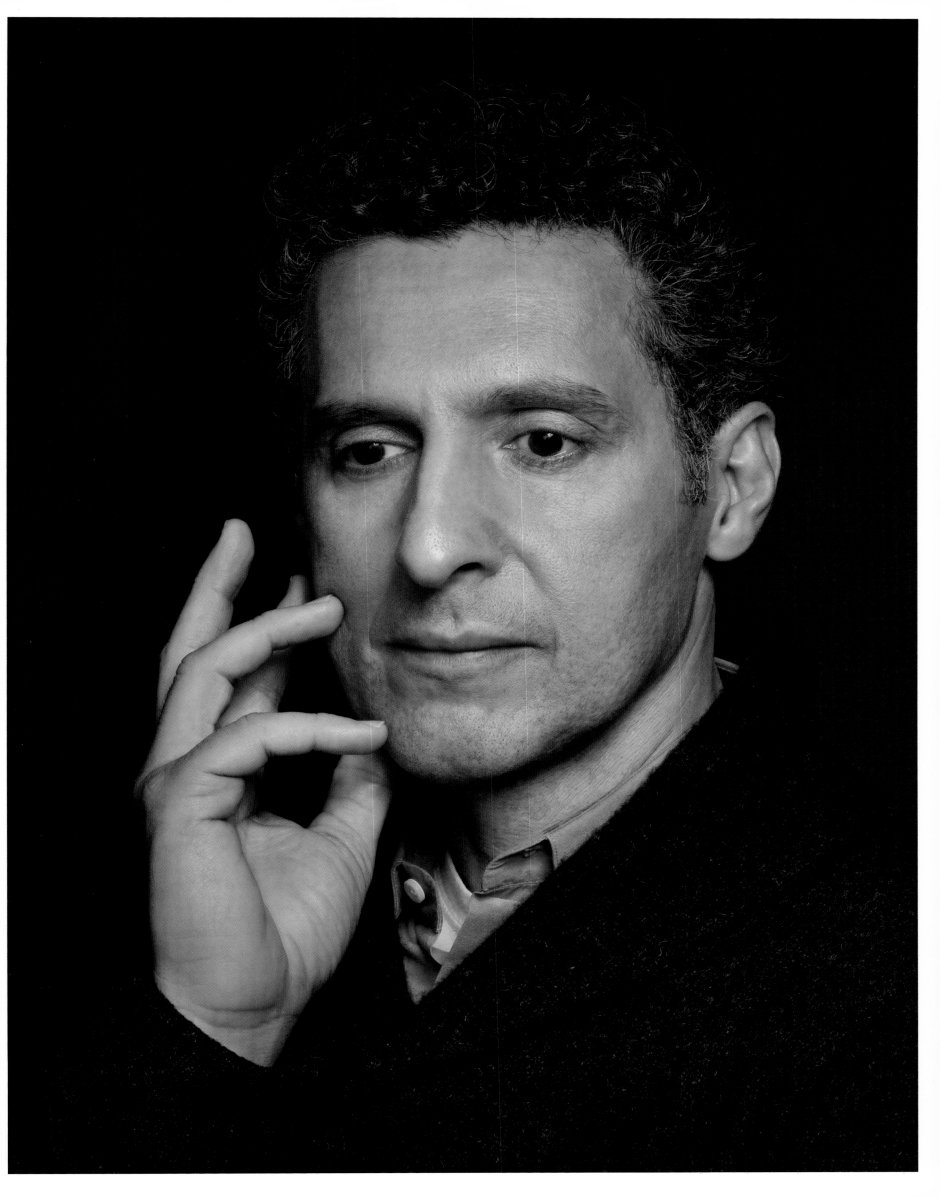

MARLON
WAYANS.

when I was seven years old
I fell in love with
the most beautiful thing I
ever met ... Acting.
The art of expression has
given my heart a permanent
smile. I live my life
pursuing a dream. To
make the unbelievable believable
how God has blessed me.
This love has kept me
faithful, honest, passionate,
happy & peaceful. Growing
up in the projects of
NYC where the was trouble
on every corner, I was
fortunate to have the arts
to keep me distracted & out
of trouble. I pray every
child can & will have the
arts in their lives. Once you
find that inner child it
never leaves you.
Please support the arts
The Greatest Love I ever had

MARLON **WAYANS** / ACTOR / COMEDIAN

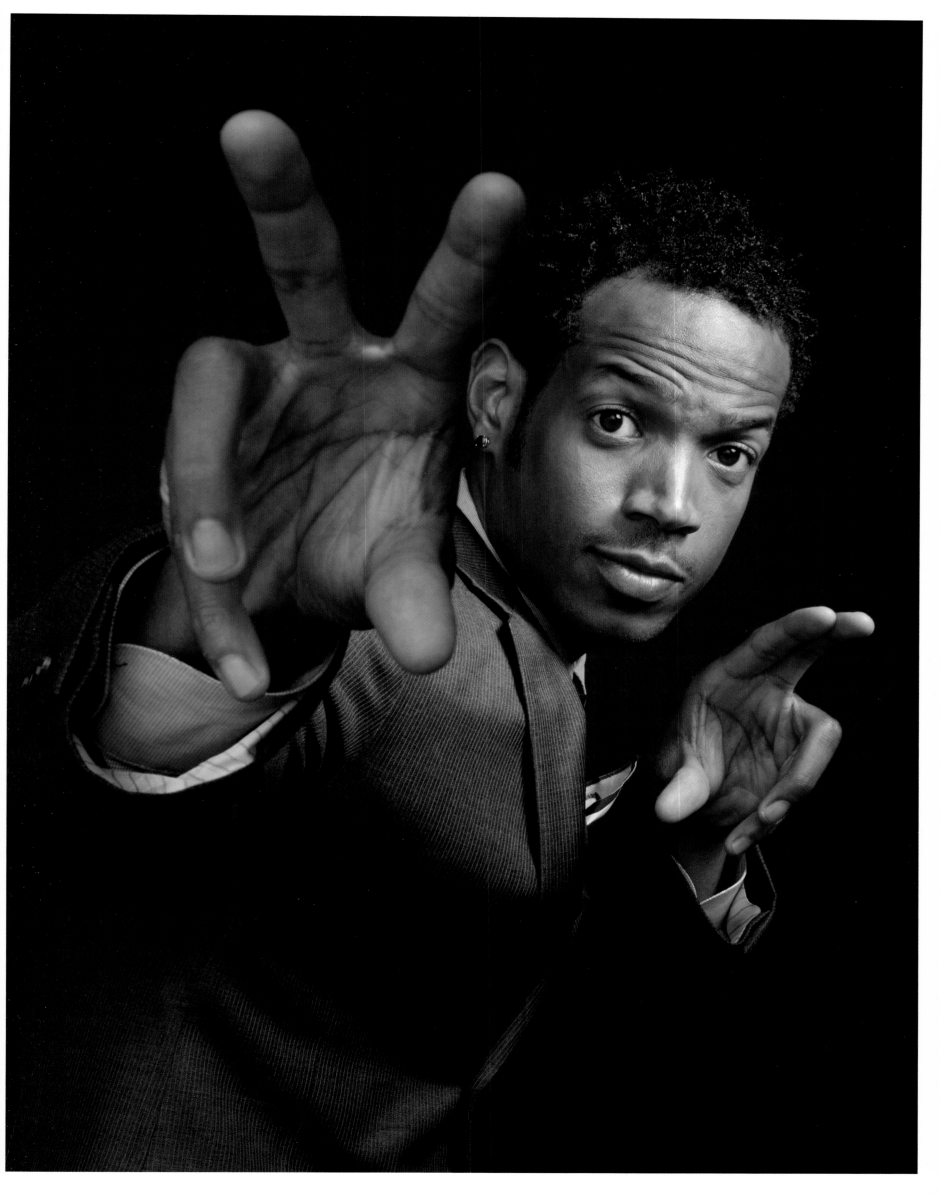

ARt fosteRs CREATiViTy, which Engages, eneRGizes, and inspires us to <u>TRY</u>, without fear.

Education is about prepaRedness. our schools have an opportunity to Lead future Generations of CREATIVE THiNKeRS. Now.

ARt → CREATiViTy → everything we Love.

JESSE **WILLIAMS** / ACTOR

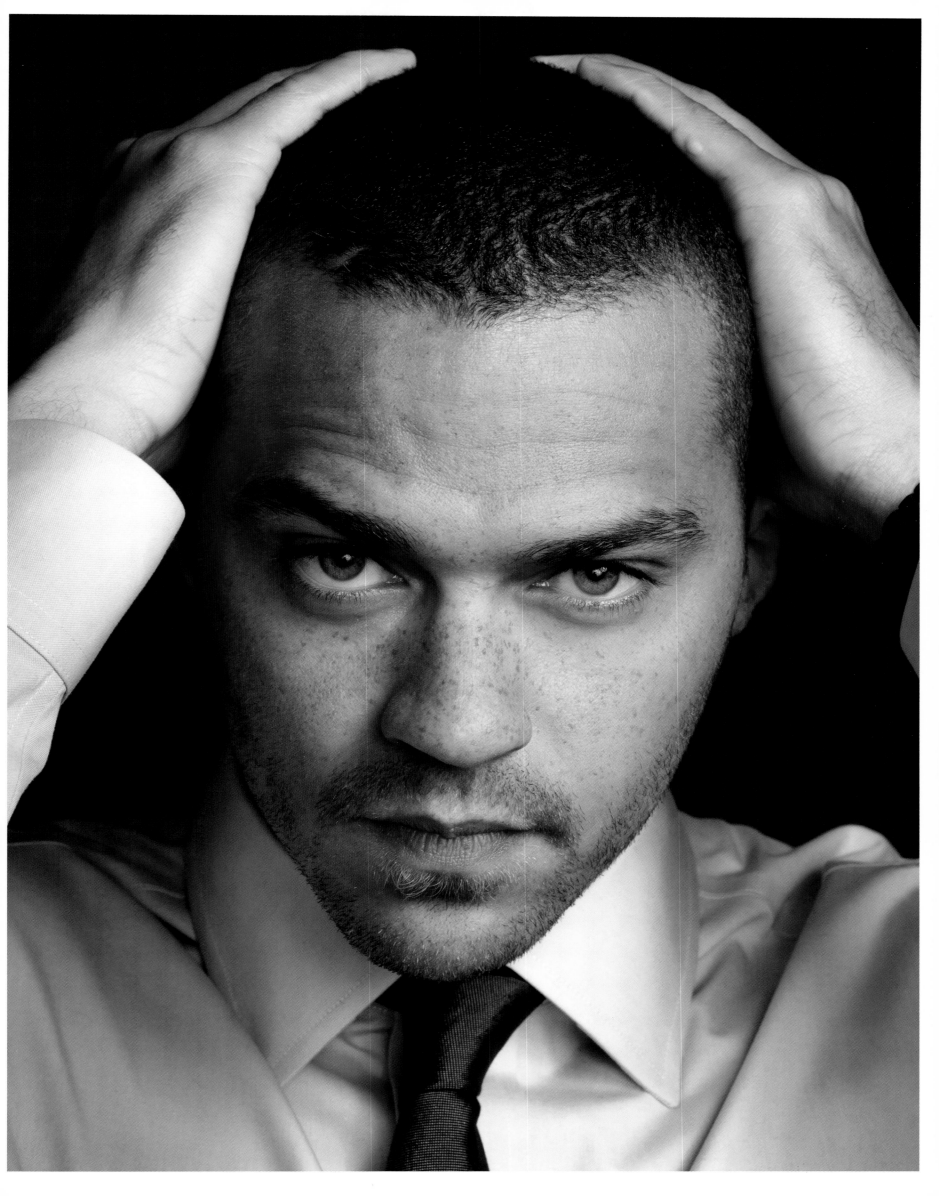

The Arts to me help me express myself. Being BORN in Memphis, Tennessee there was only one performing arts school. Attending that (Overton High School) started my dream.

Elise Neal

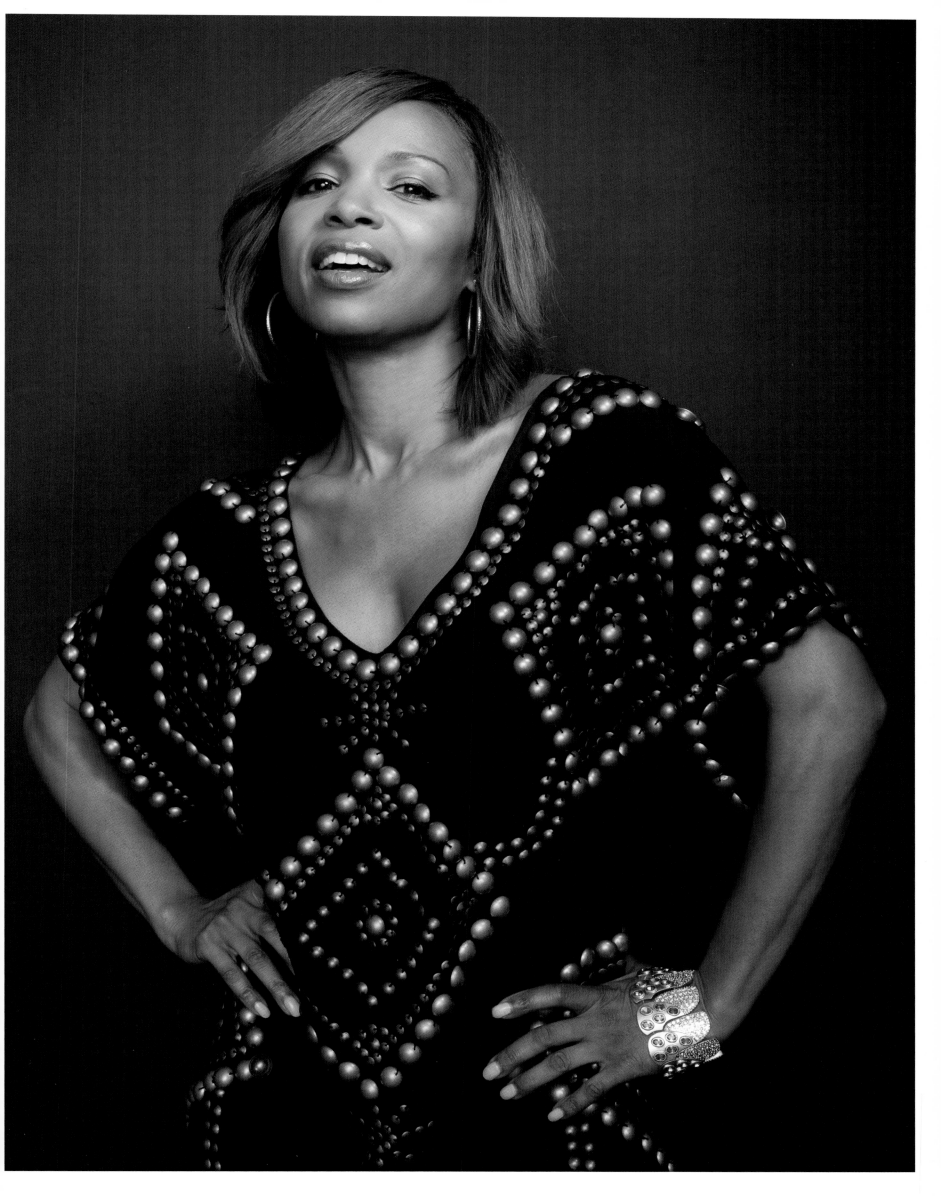

We learn Art As children.
It is a Gift we must share
And Keep Alive

Ciao

[signature]

ANTONIO **SABATO** JR / ACTOR

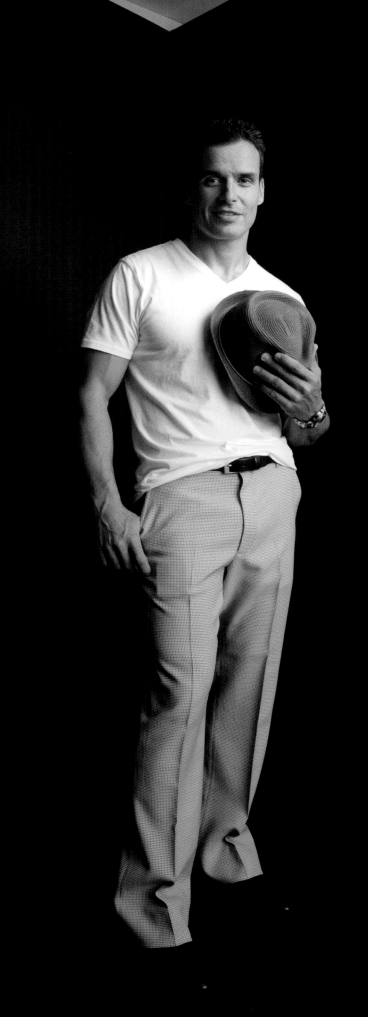

The arts? the arts!! the ARTS?!!? Where do I begin? where would we all be without them I ask you. (I for one would be living in a cardboard box)

OLIVER **PLATT** / ACTOR

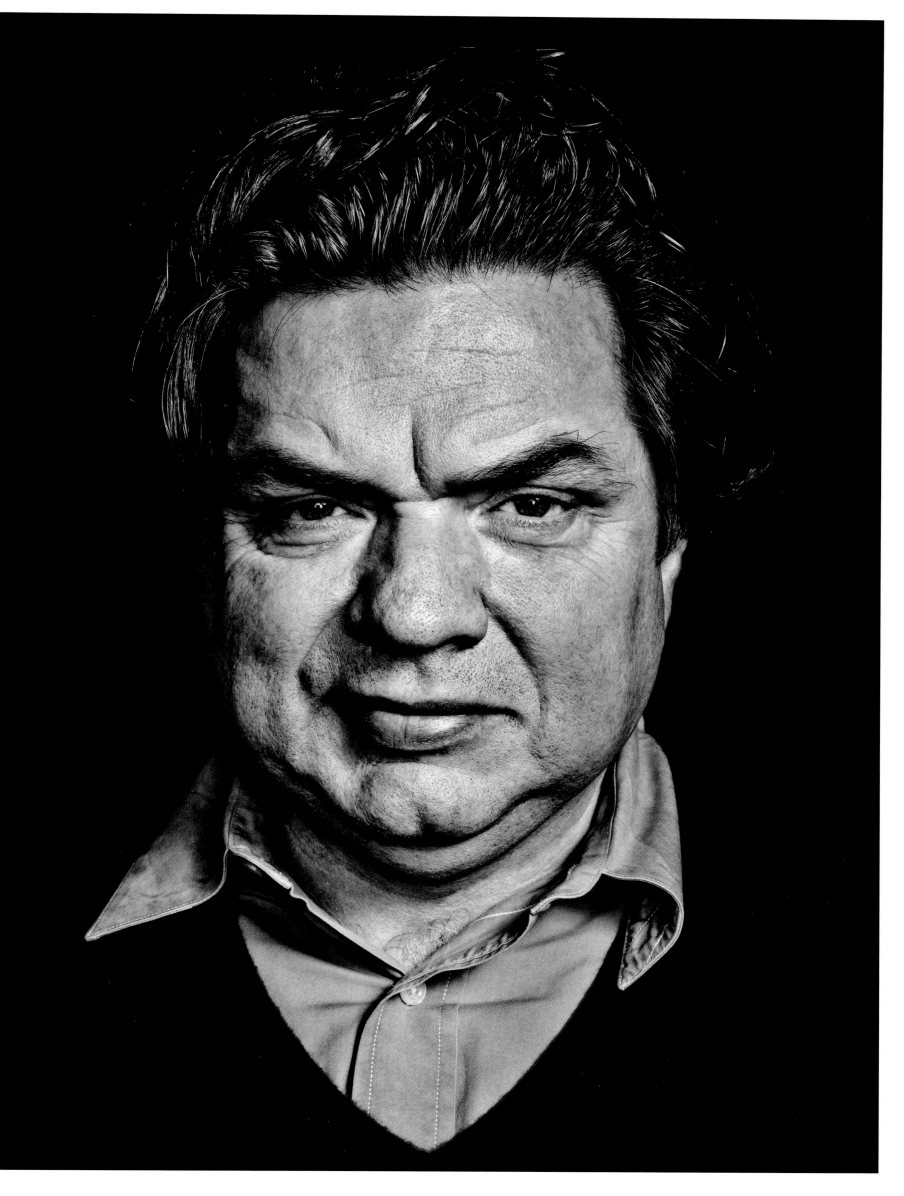

ART is LiFE !!

PAINTINGS + PHOTOS
SHOW US THE WORLD

MUSIC + DANCE SHOW
US THE BEAUTY of OUR
BODIES

THEATRE LETS US in THE
WORLD of THE IMAGINATION

WITHOUT THE ARTS WE HAVE
PLATES WITH no FOOD

GLASSES EMPTY OF WATER

MINDS AND HEARTS EMPTY OF
LOVE AND SYMPATHY

Alfred Molina

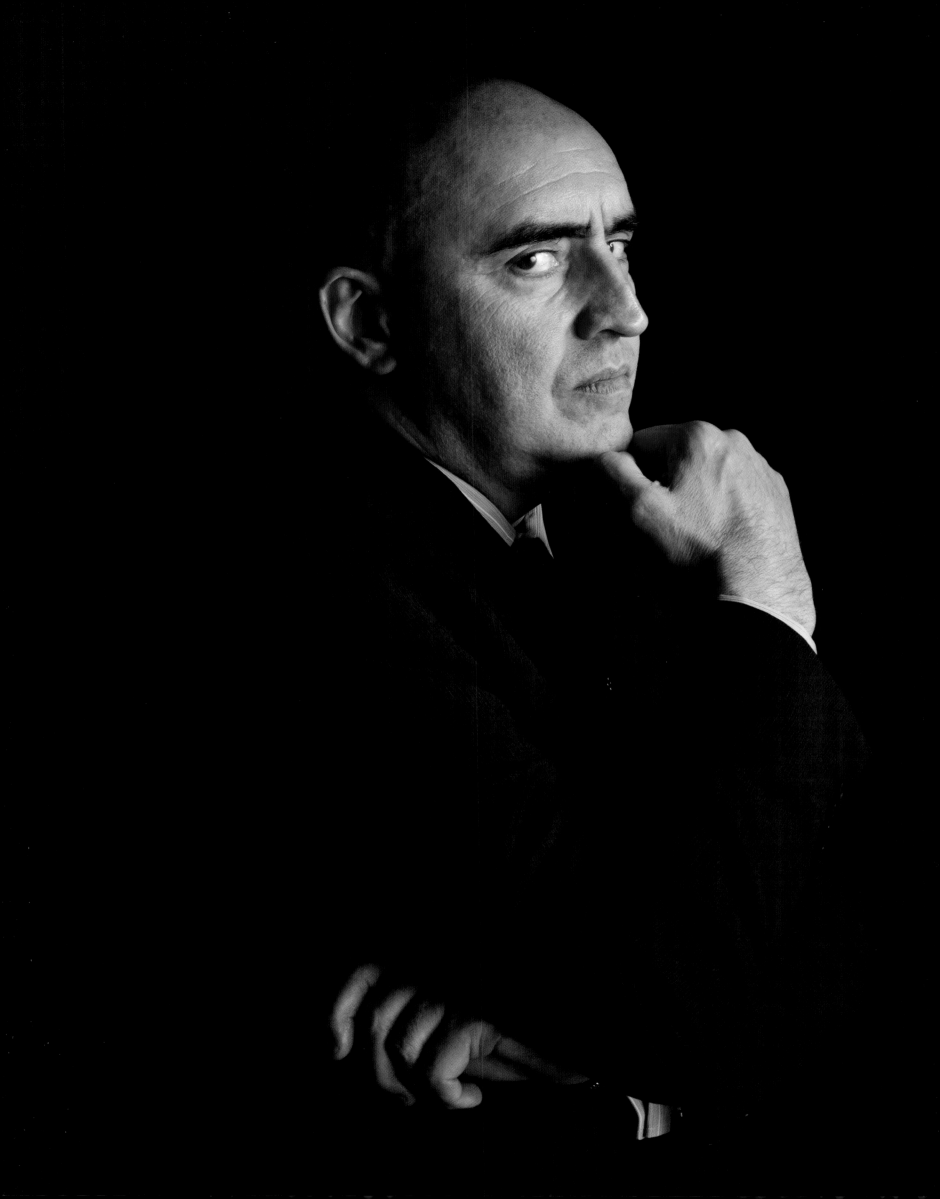

My French teacher in H.S. taught me that "Coevr" means HEART... And I've always felt that ART means Courage...

ART is all about Courage which to me means following our Hearts...→ our "Coevr"!

Goals & Dreams are 1 in the same Just say you BELIEVE & Both you will Attain!!! With Love & Act & Heart

Hill Harper
'10

HILL **HARPER** / ACTOR / AUTHOR

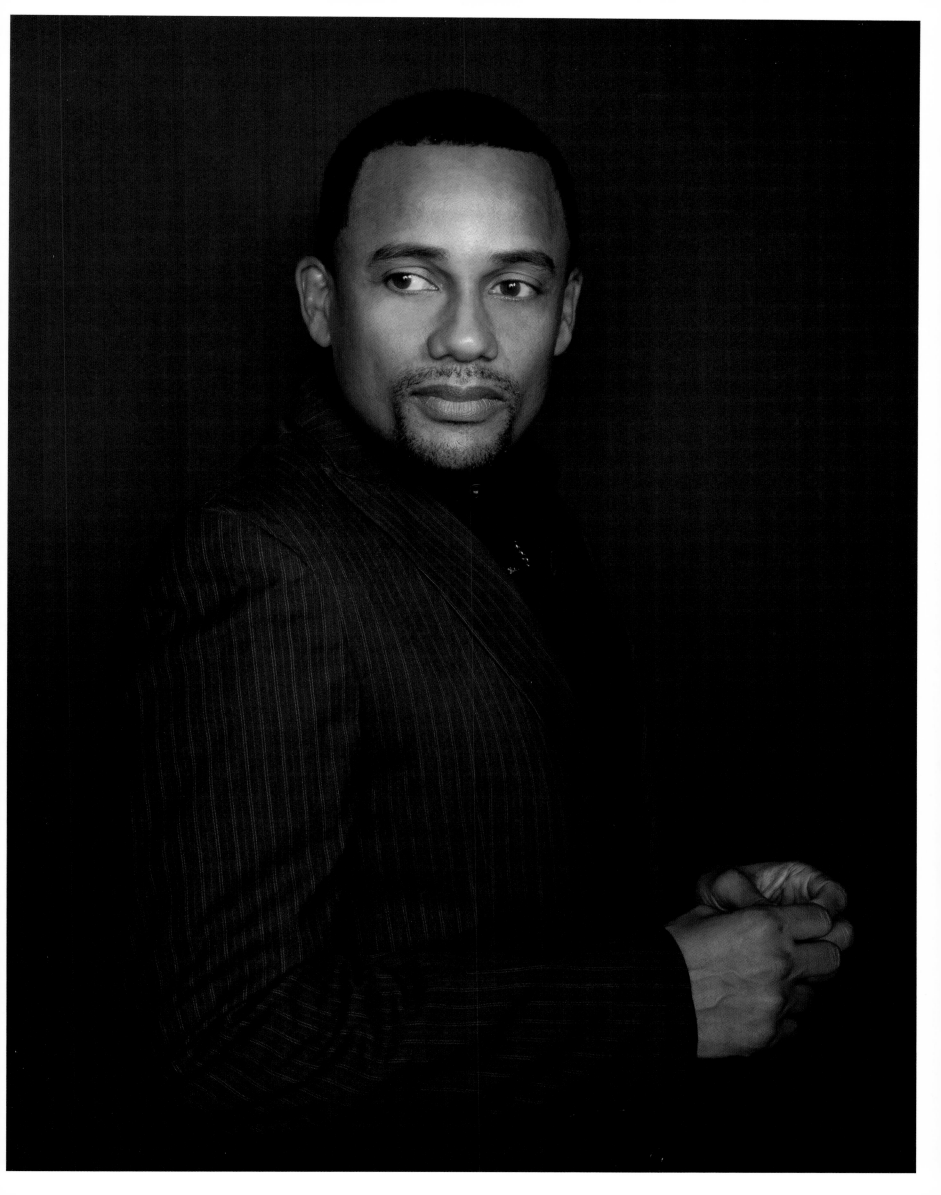

"In this Biginong God
Created..."
I Am Blessed to Be in
the family of Creative Artist
To express that which is
 our Birthright, we are to
be Creative in all and through
all Life. for we are the
Creative Expressions of
God Art works
"How Cool is That"

(signature)

BEN **VEREEN** / ACTOR / DANCER

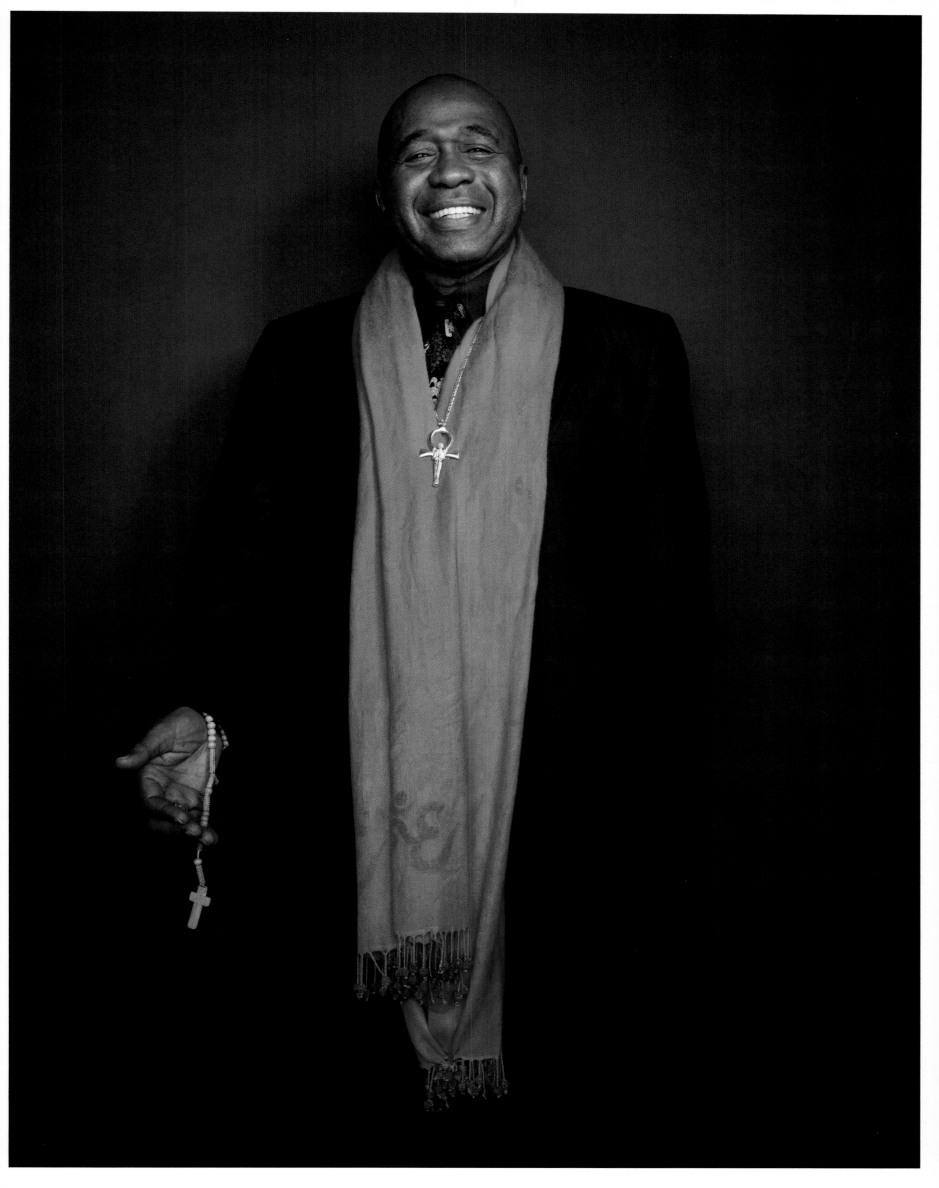

EVERY IDLE, DISENFRANCHISED,
OVER ACHIEVER, BORED, LONELY,
IGNORED, CHILD I KNOW
HAS BEEN SAVED BY THE
ARTS
A HARNESSED IMAGINATION
IN THE MOLD OF ARTISTIC
EXPRESSION = A WHOLE
HUMAN BEING!!
CCH POUNDER

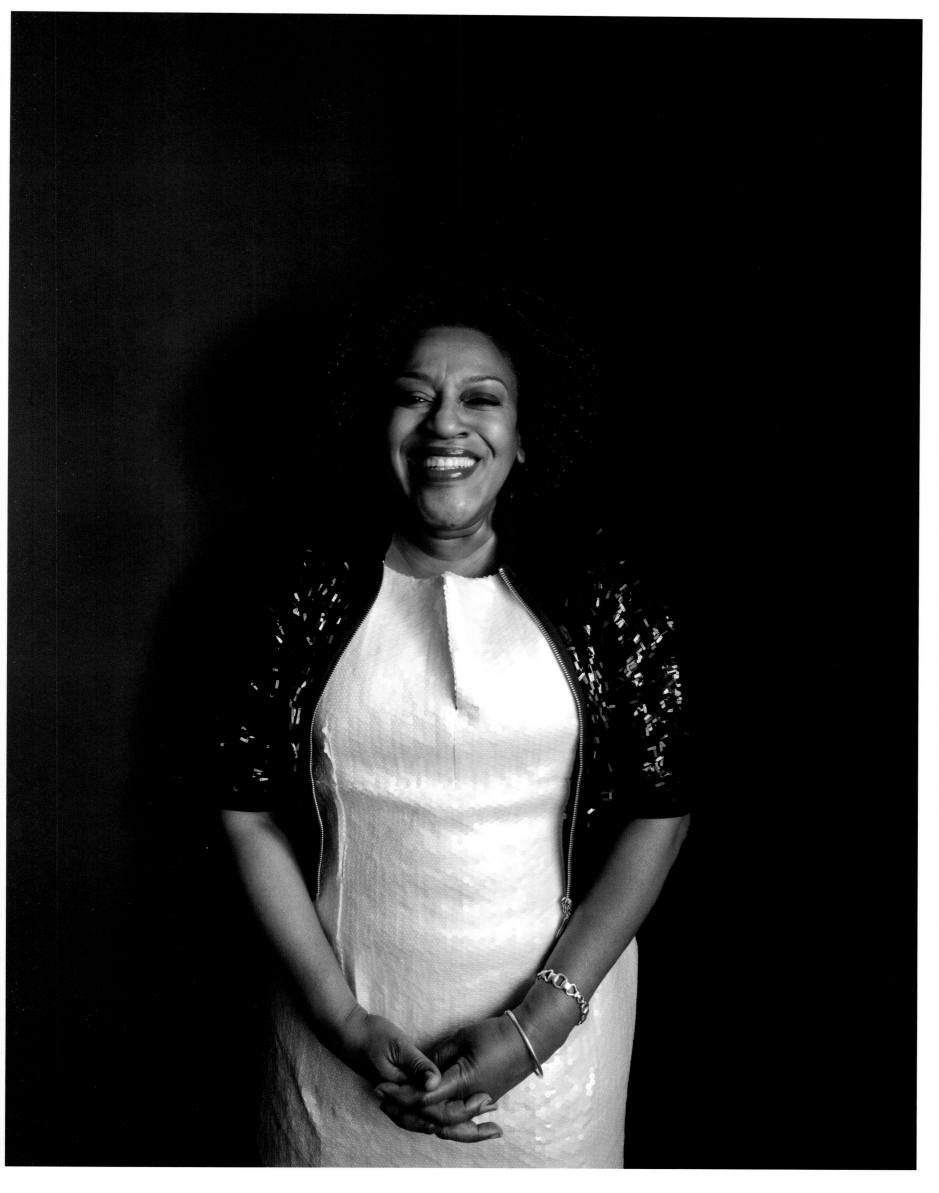

The Studio Arena Theatre in Buffalo, New York, where I was nurtured as a young writer, closed this year. How many writers/actors/directors will never be?

Tom Fontana

TOM **FONTANA** / WRITER / DIRECTOR / PRODUCER

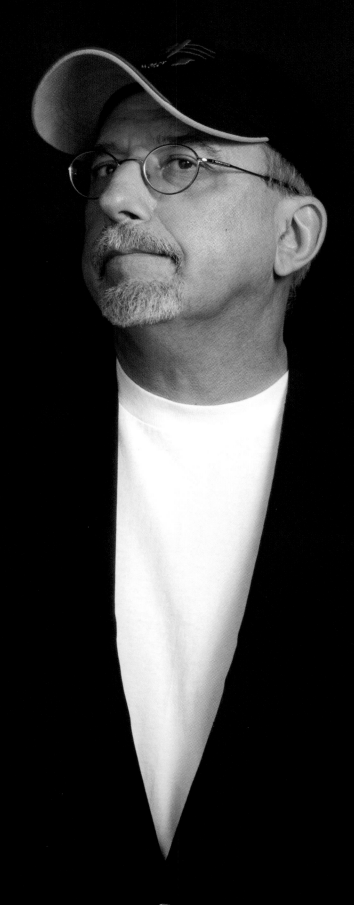

The Arts
Saved my Life.
It's my responsibility
to save the Arts!
Much Love & Many
Blessings Tichina
 Arnold

TICHINA **ARNOLD** / ACTRESS / SINGER

IT'S TRUE
"ART is THE SOUL"...
BUT ALSO SOOTHING TO THE
EYE...

LOVE: OXOX "Miss J"

J. Alexander (signature)

♡

"ART is everything"
Dance has touched my
life in so many amazing
ways.
Dance is fun, it is my
Passion, it is' my life

Mary Murphy

MARY **MURPHY** / DANCER

Art museums would be totally boring without art. It's true. Every once in a while it's important for some people to BREAK THE RULES a little bit.

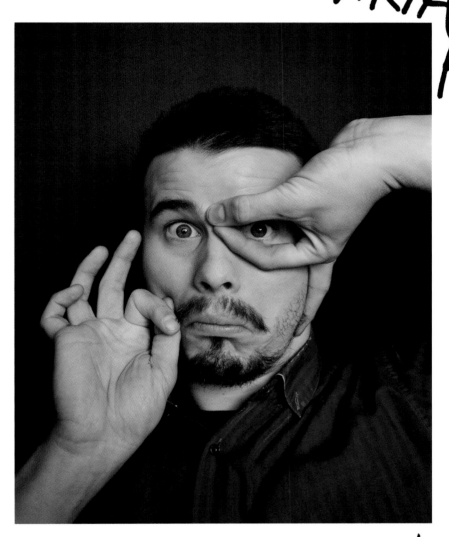

just to keep it interesting.

—Jason Ritter

"Now I Don't Proclaim to know the Key to Happiness, But I know the key to Unhappiness is trying To Please Everyone!!"

- MEKHI 2010

MEKHI **PHIFER** / ACTOR

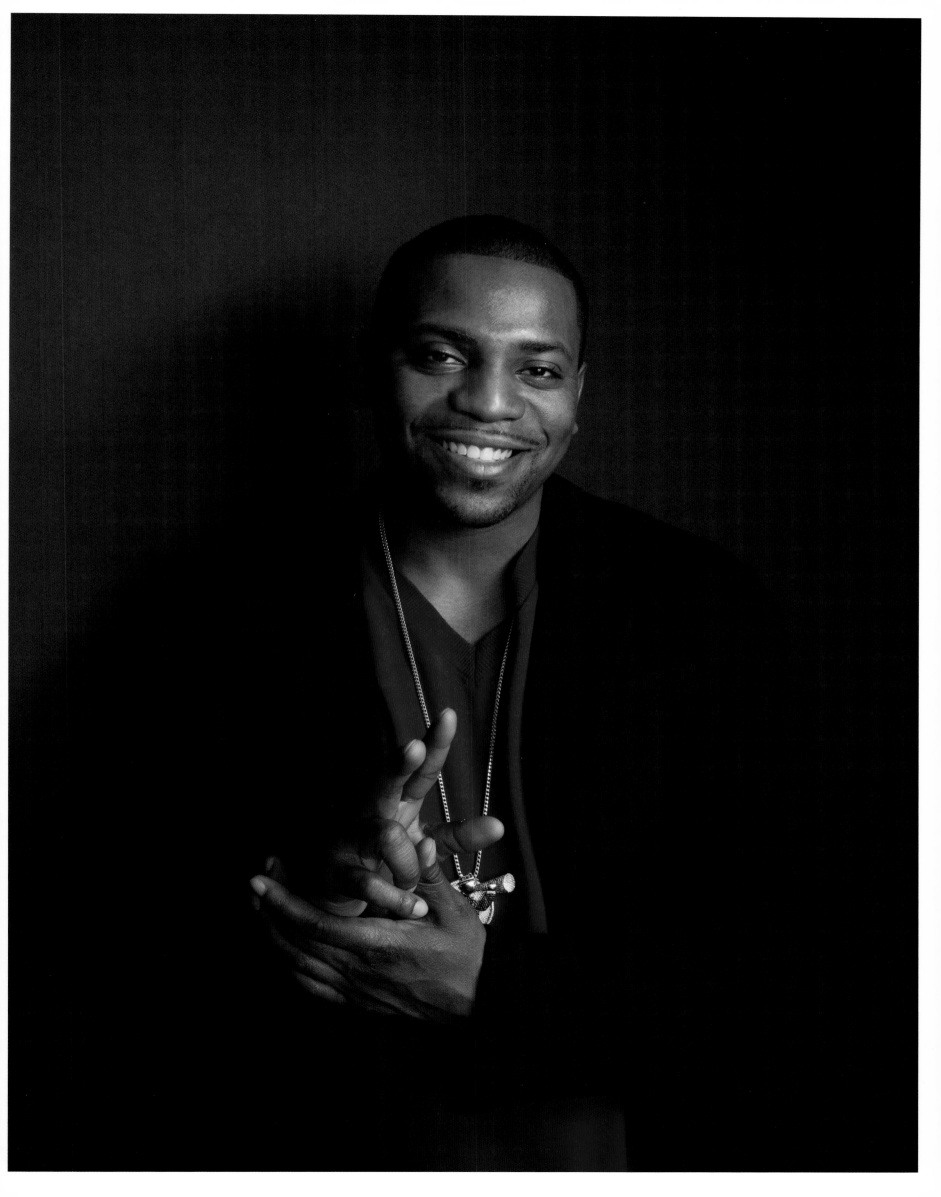

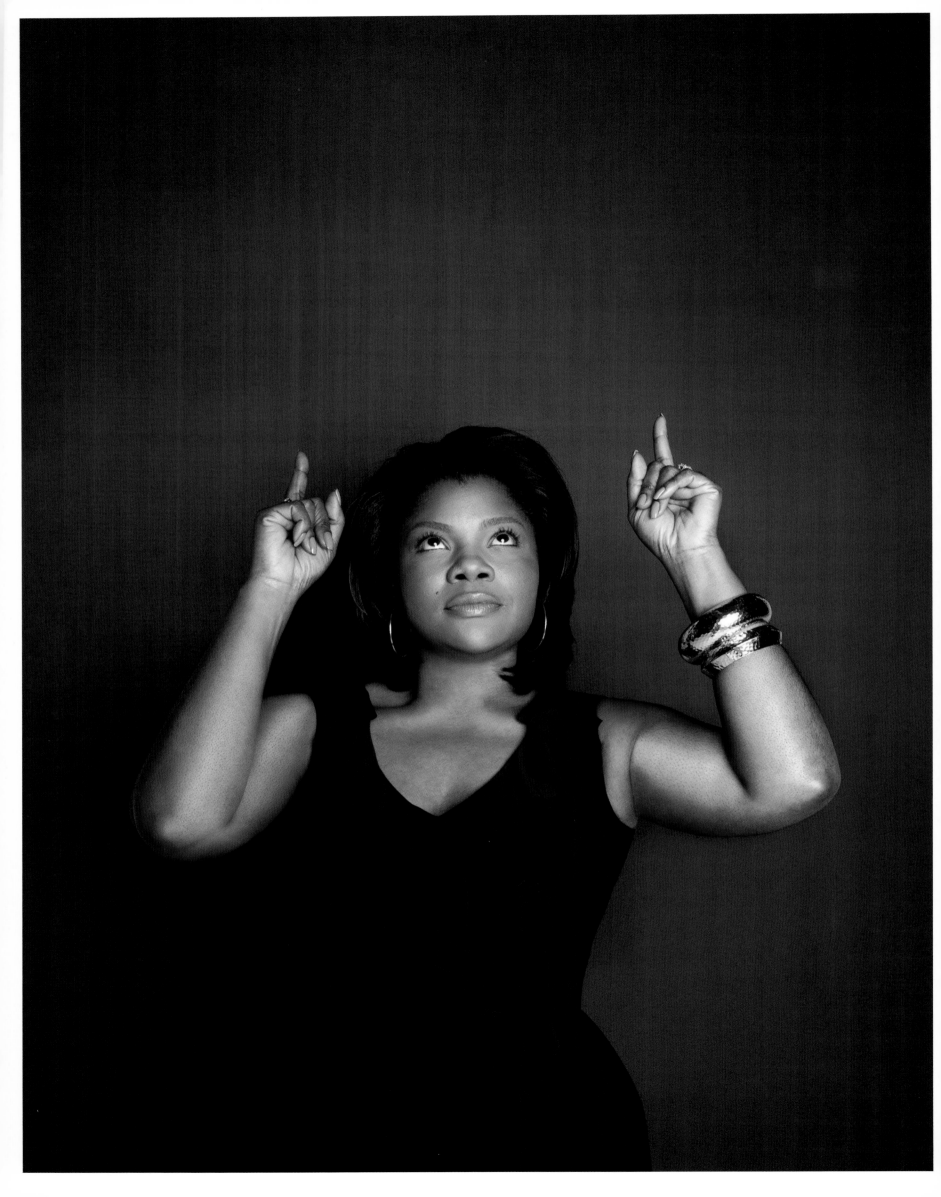

Art is a Beautiful Gift from the Universe take care of your present!

Mo'Nique

MO'NIQUE / ACTRESS

The Human
Race has
no chance
without love
& Art !!!

Joel
Schumacher

JOEL **SCHUMACHER** / DIRECTOR

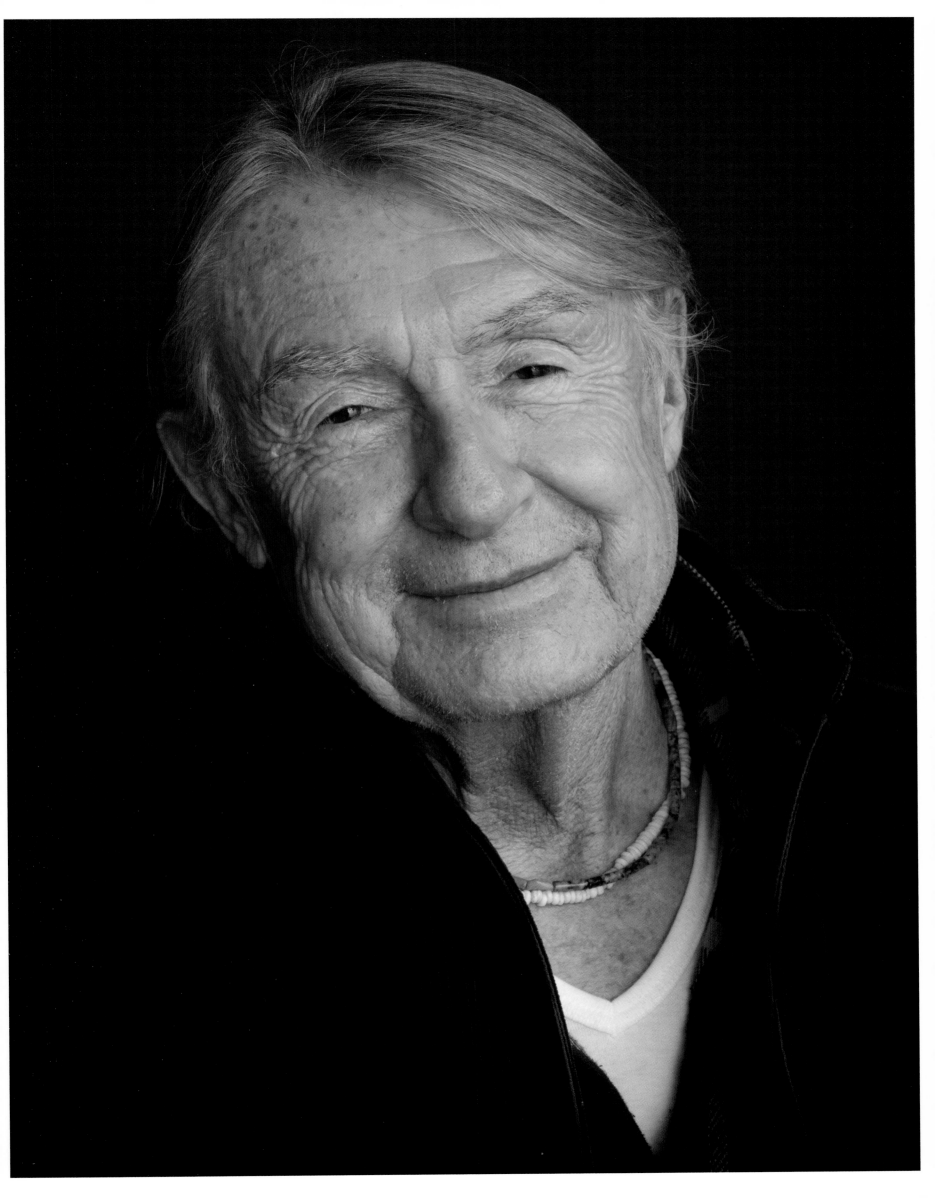

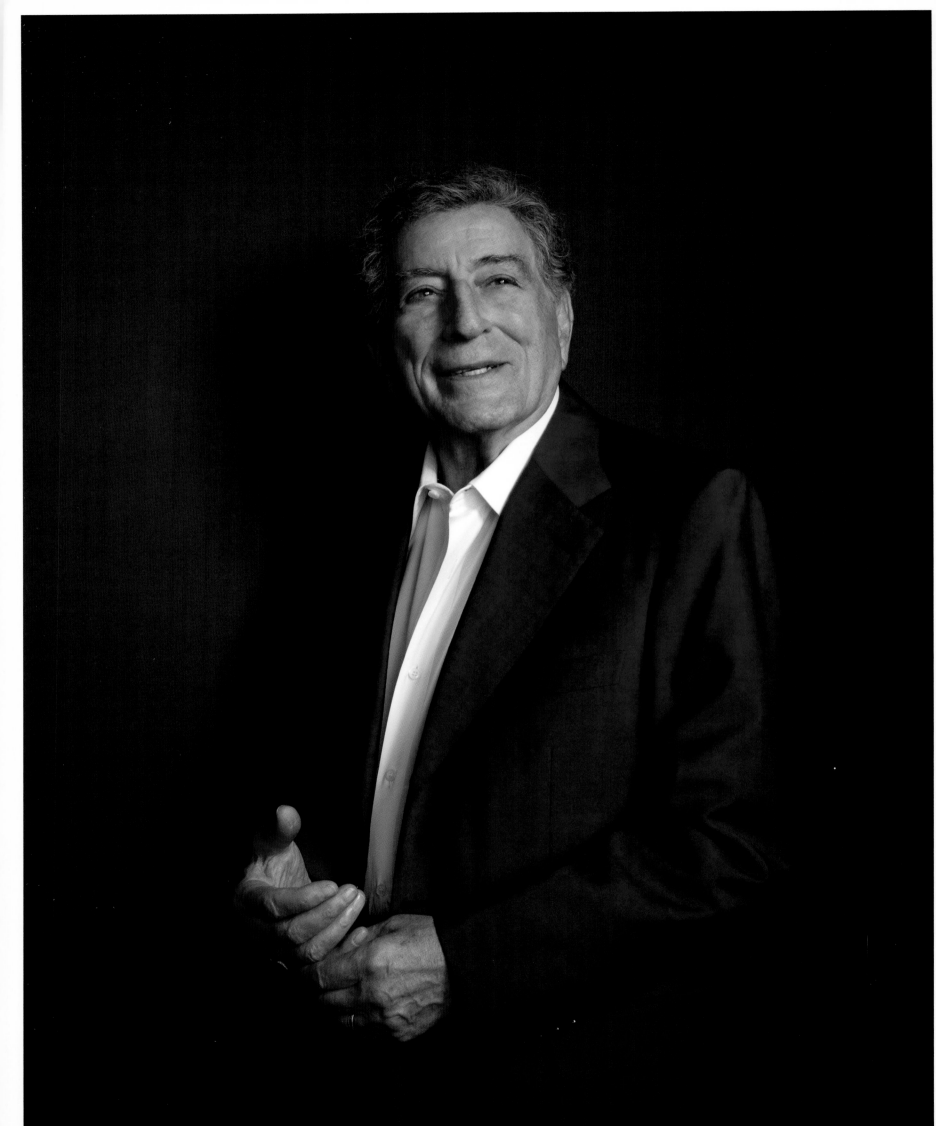

I grew up during the great depression and unfortunatly my father died when I was 10. My mother had to work and raise three children my sister my brother and myself. My wonderful relatives would come over on the weekends and help my mother feel good. As children we entertained our relatives and in turn they encouraged us. They were impressed with my singing loved my painting. That was enough inspiration to last a lifetime for me, so much so that I didn't want to do it — I had to do it — to this day.

" Tony Bennett

I am inspired by 100% commitment to ones artistic vision. We are never fully satisfied as artists. but nothing is more inspiring then an artist going full force and stop at nothing to fulfill their vision

FISHER **STEVENS** / ACTOR / DIRECTOR / PRODUCER

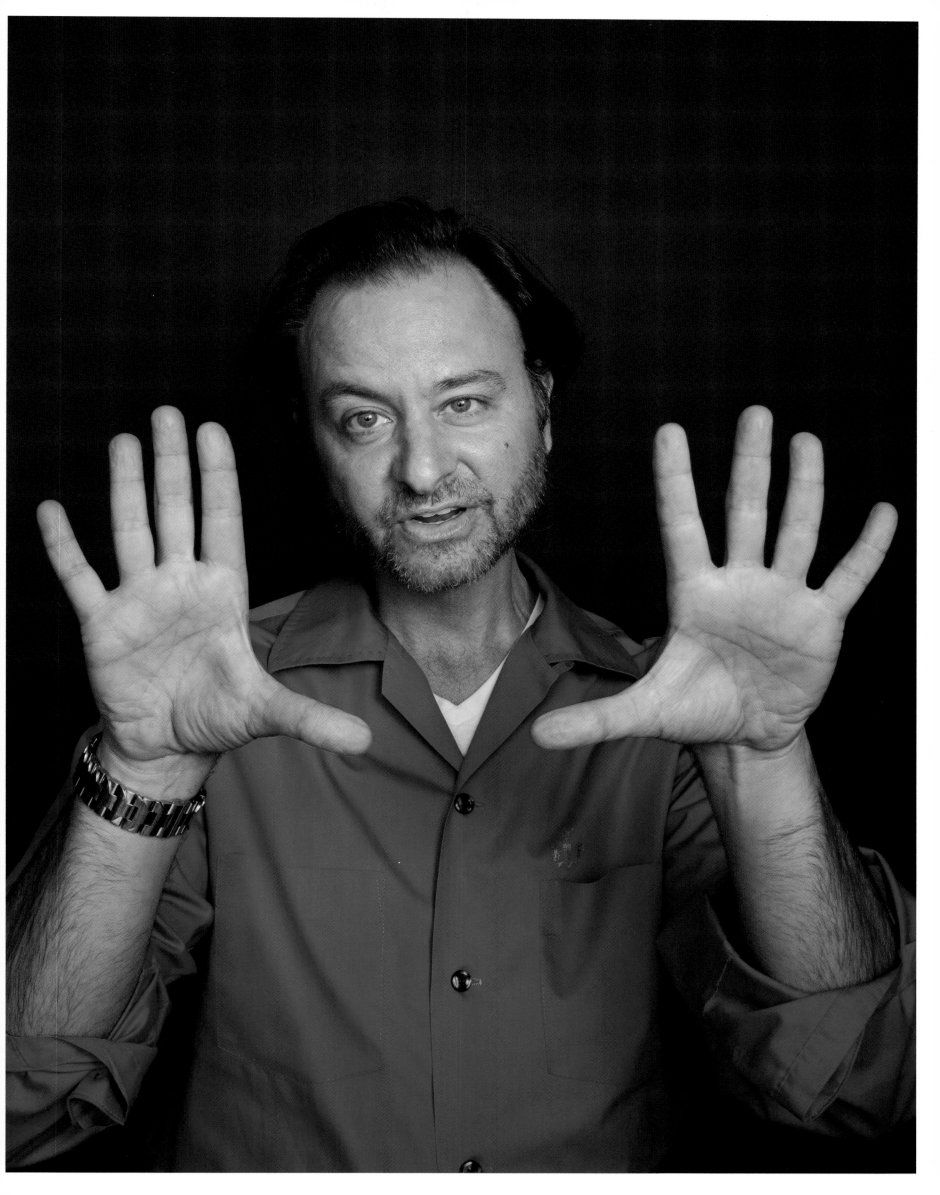

The arts are the creative, connecting force that unites us all as one human family. It is through the arts that we find a way to express our experiences and be of service to each other.

Particularly, the dramatic arts, educate, illuminate, inspire, entertain and take us to places we might otherwise never know. We get to experience complexities and depths and hidden sides of human stories and human beings that we live with and who, in fact, are us. The arts expand our world and give us the rare opportunity to touch each others' lives, hearts and souls and better understand our humanity.

What has always meant so much to me is 'giving' a performance. From the audience, I feel given to and I have always wanted my work to make a contribution to those seeing it. Art is the gift of giving.

Judith Light

JUDITH **LIGHT** / ACTRESS

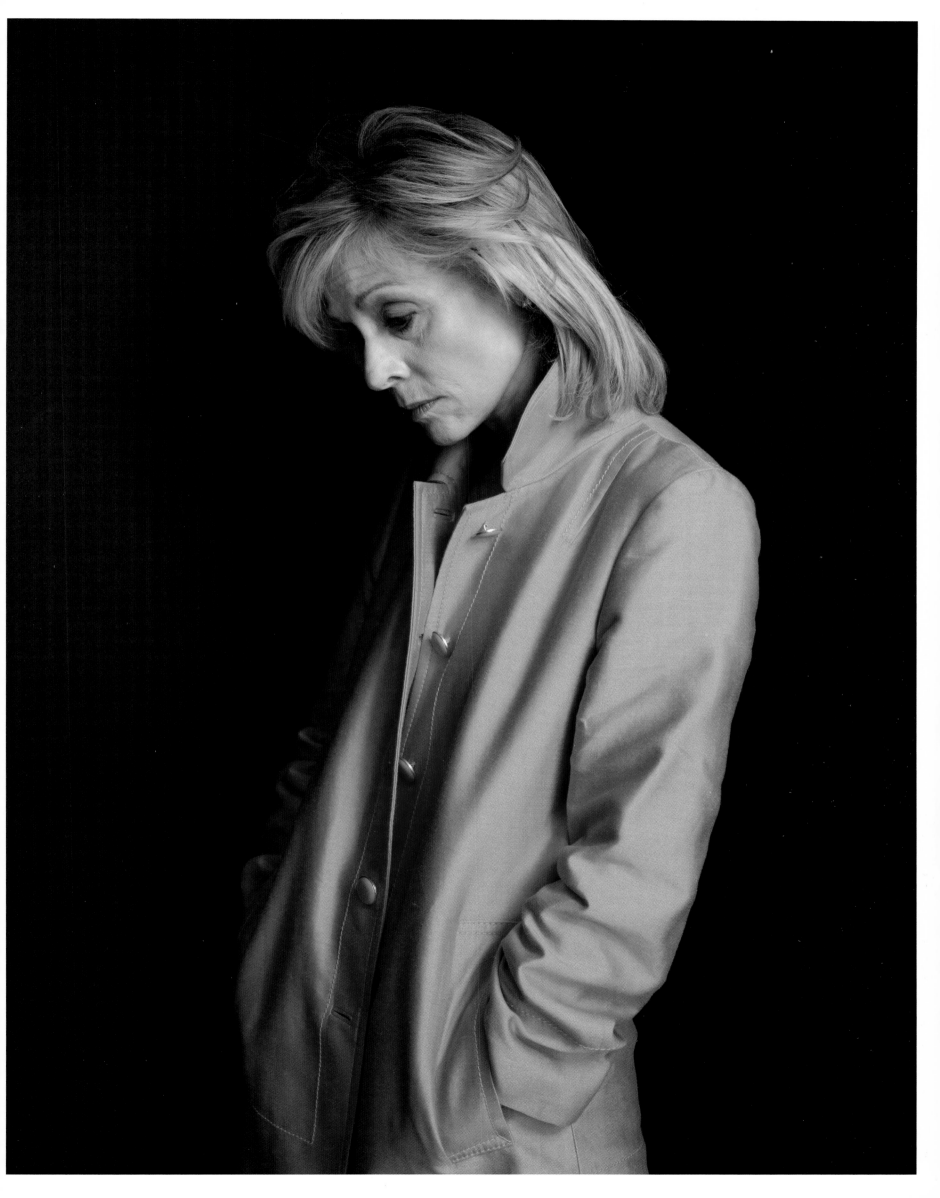

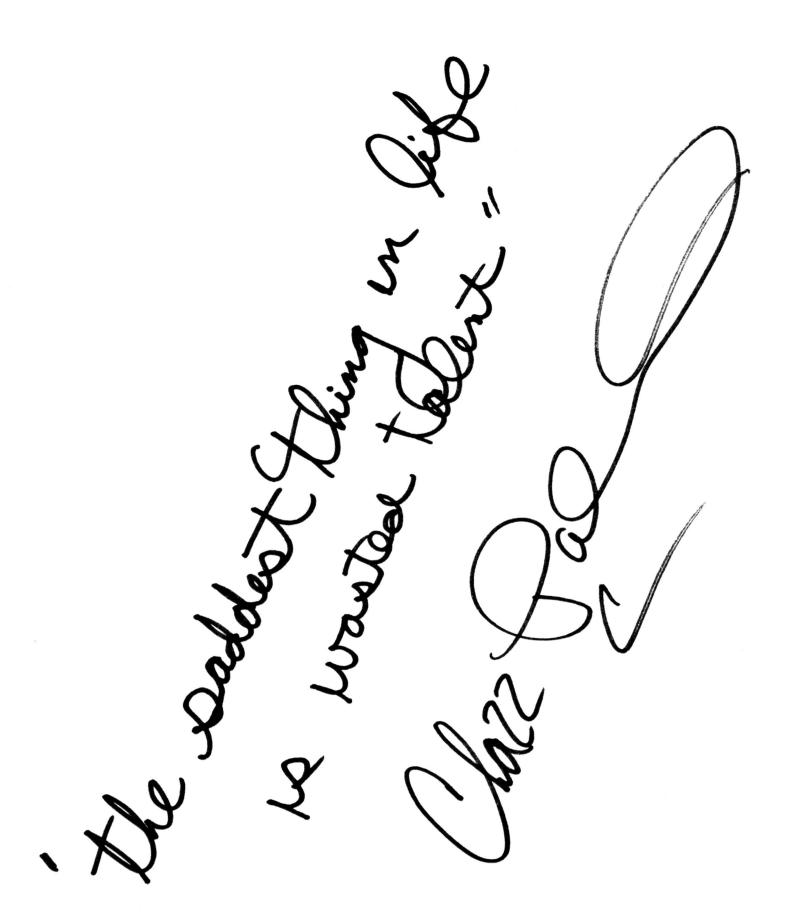

"the saddest thing in life
is wasted talent"

Chazz Palminteri

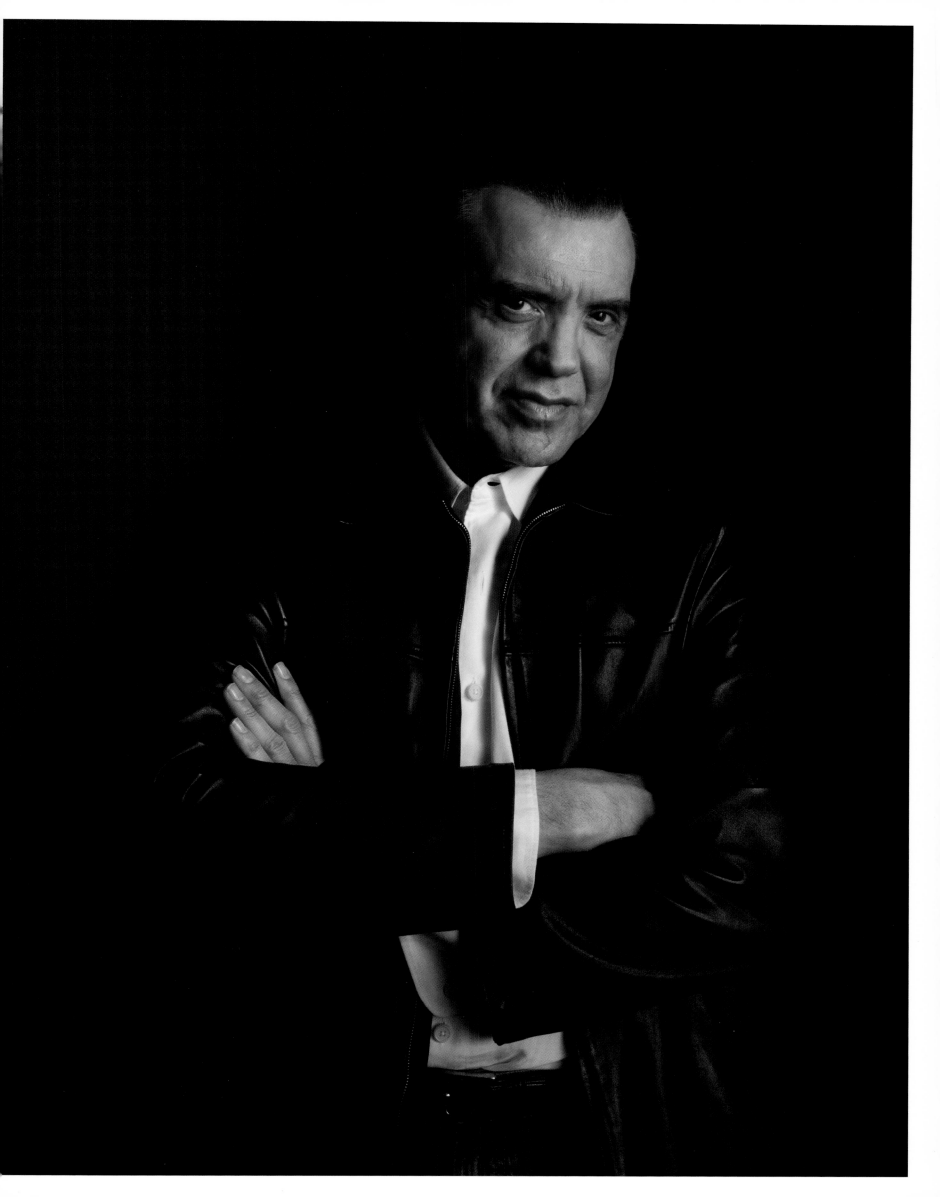

Rembrandt, Coltrane,
Shakespeare or Danny Kaye —
Sometimes in Creativity
the divine intervenes
and my molecules alter
their path...

Richard Schiff

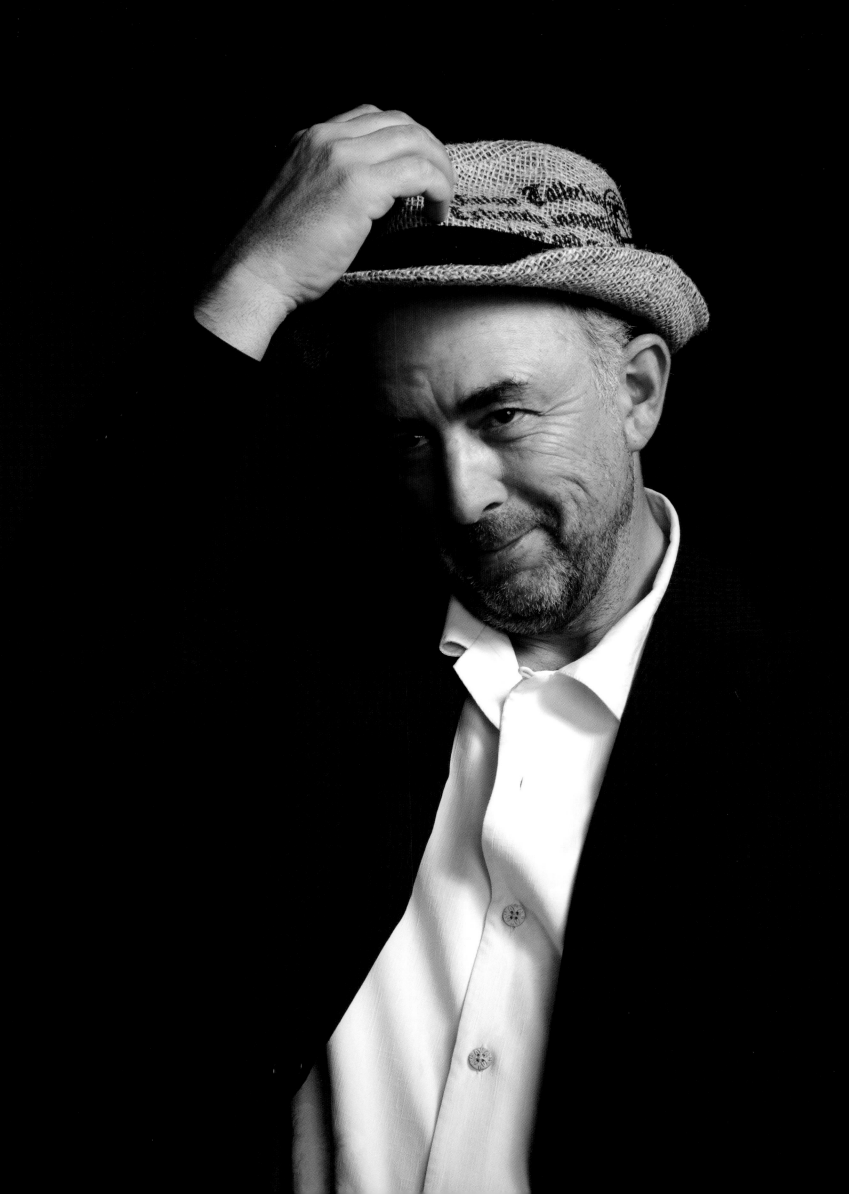

We all experience things
in front of others.

Artists just have a
process.

That process is life·death·truth
and nothing more.

[signature]

ADAM **BUSCH** / ACTOR / DIRECTOR

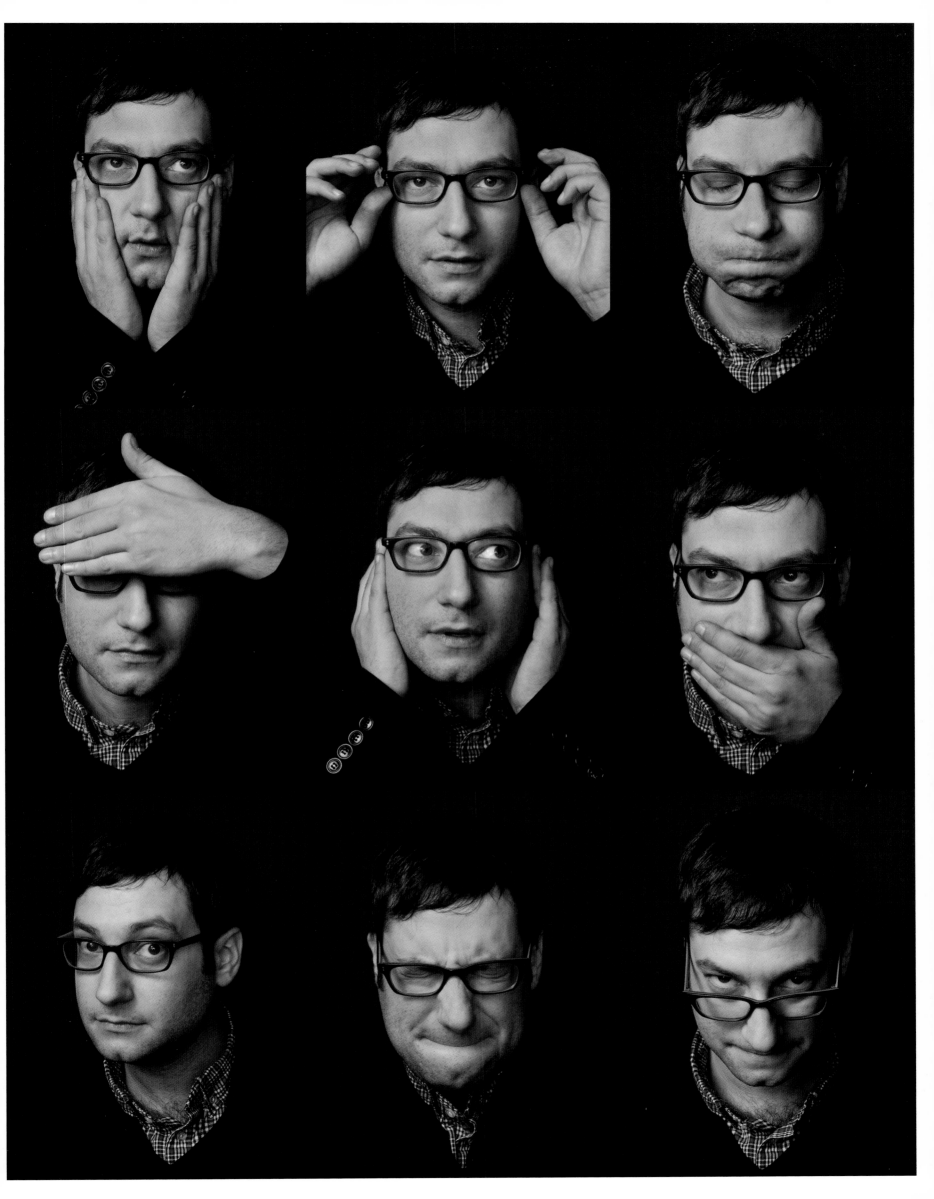

Daniel Stern

I had no interest in "academics" in high school, I was just into theatre + sculpture. In fact, I dropped out in my senior year. Since then I have lived my life as an actor, director, writer and sculptor. But through the pursuits of these artistic endeavors I have grown to become a businessman, an avid reader, a teacher, a mad scientist, president of a non-profit organization, a linguist, and father of three college grads. Art doesn't enhance an education. ART IS AN EDUCATION

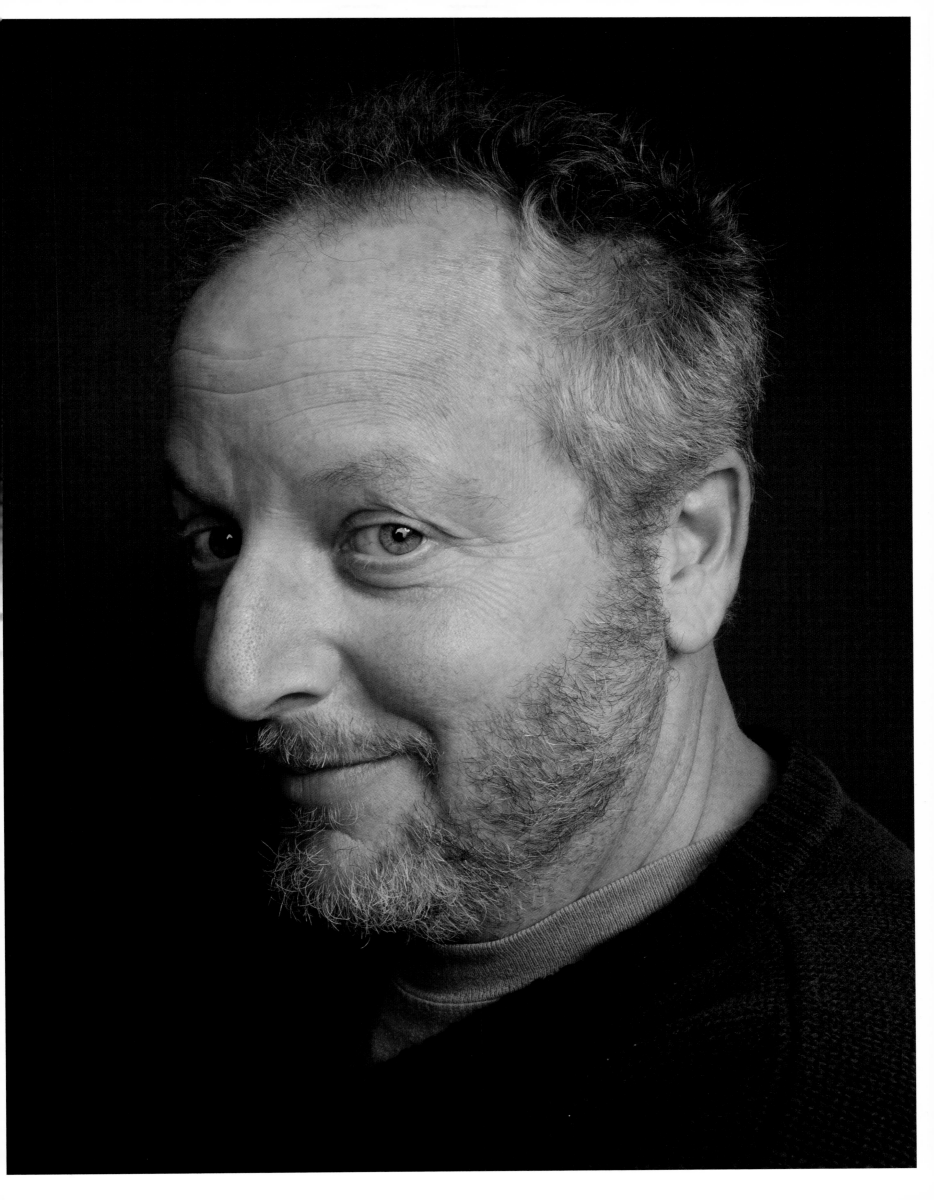

Drama class was my favorite subject! And, they never made me climb a rope.

In theater nerd solidarity,

Nia Vardalos.

NIA **VARDALOS** / ACTRESS

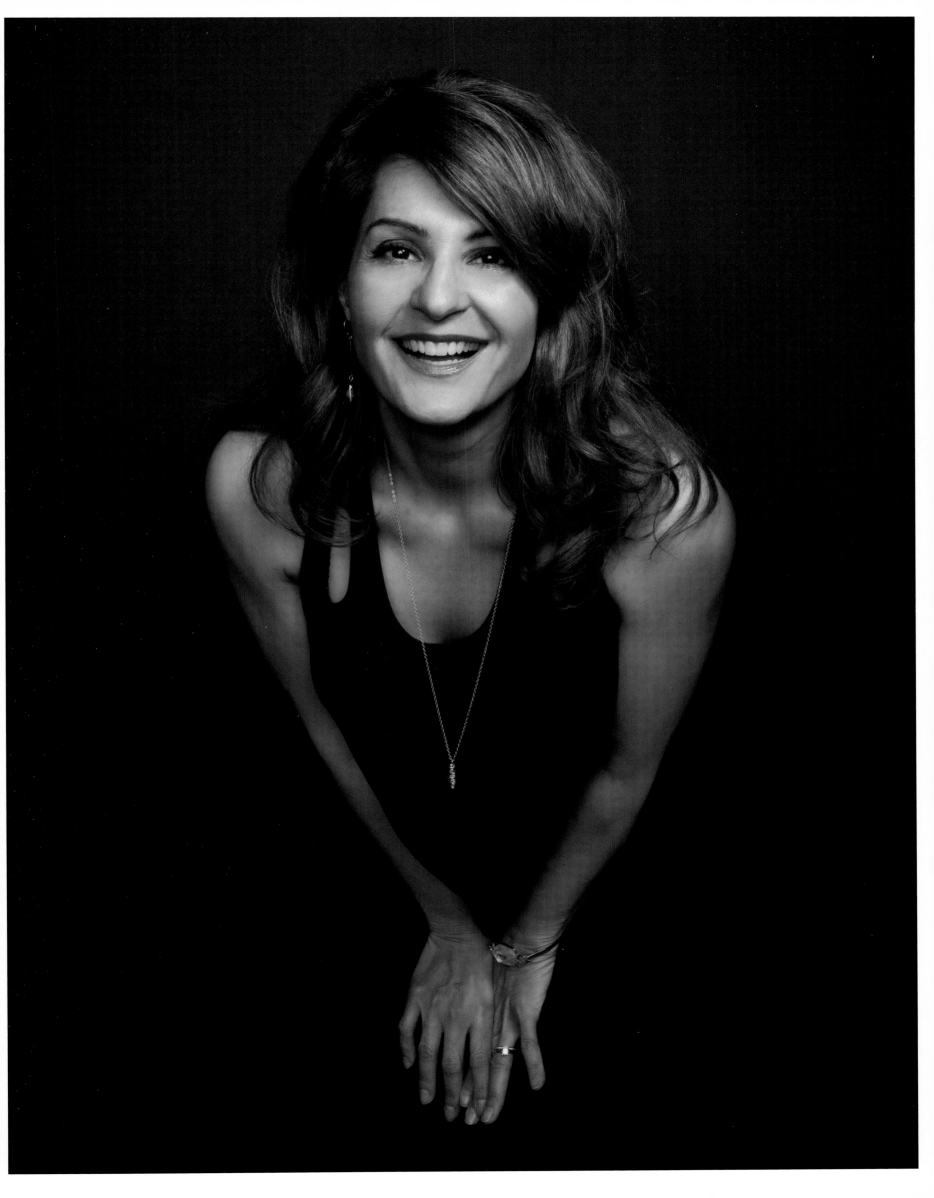

A curvy, curly AWKWARD lAss
FouNd "Home Sweet Home"
 iN DramA Class

While dolls + jocks romped oN THE BeacHes
This odd Duck was makiNg speeches!
OklahomA! Godspell! HAiR!
THEATRiCAls BeyoNd CompARE!
She lived AND LEARNED upoN the stAGE
Cause high school ARTS - it was the rAGE!
THE uNlikely kid had show-biz smArTs
AND ThaNk HEaveN above, sHE HAD
 THE ARTS!

How Blessed to
fiNd my passion
& VOiCE at my modest
public school iN
saN Diego!

Kathy Najimy

ARTS for
ALL KiDs!

KATHY **NAJIMY** / ACTRESS

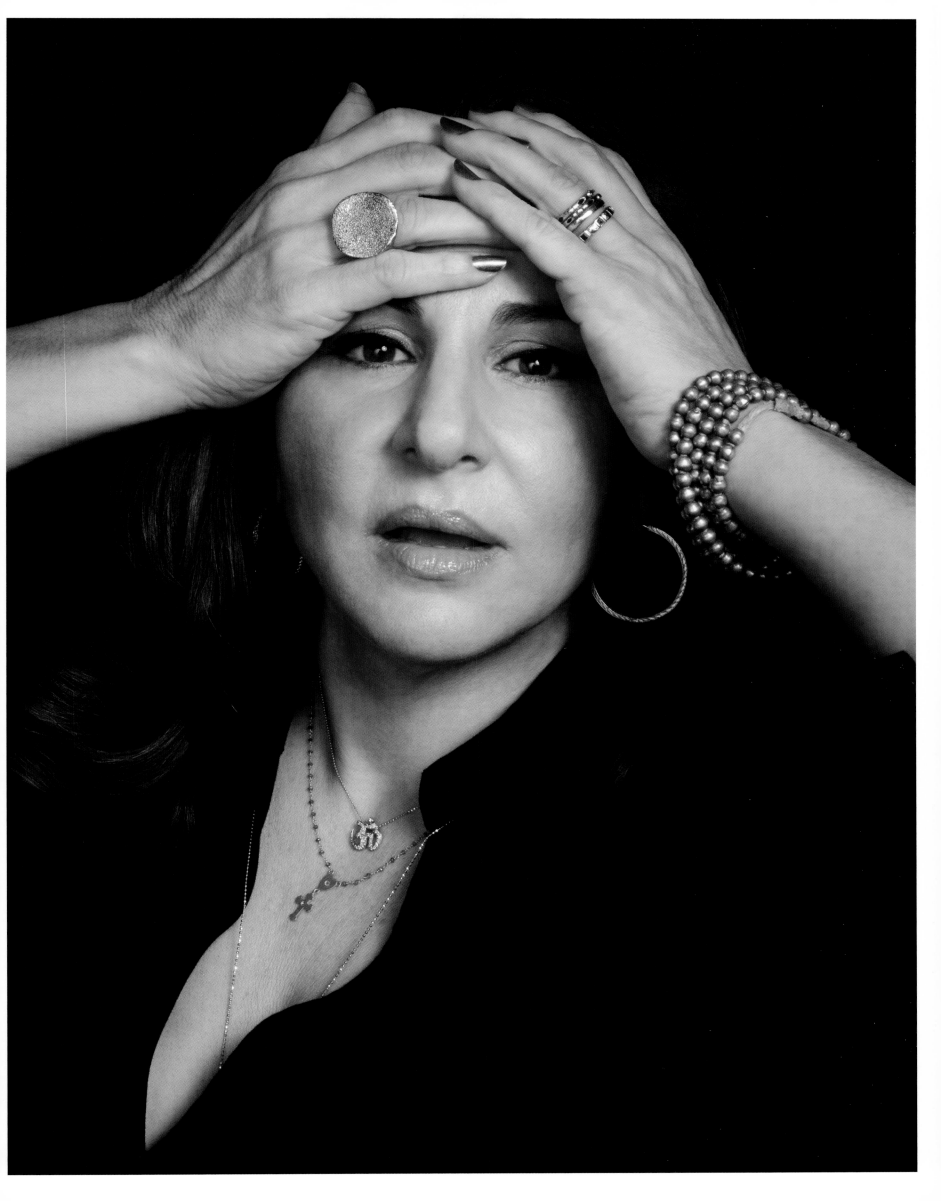

Every child CREATES
INSTINCTIVELY THROUGH
PLAY ACTING, DRAWING
AND DANCE! We ARE
ALL ARTISTS until
told otherwise!
Support the ARTS
AND NURTURE THEM
FOR ALL HUMANITY IS
EMBODIED WITHIN
THEM!

RICHARD **BELZER** / ACTOR

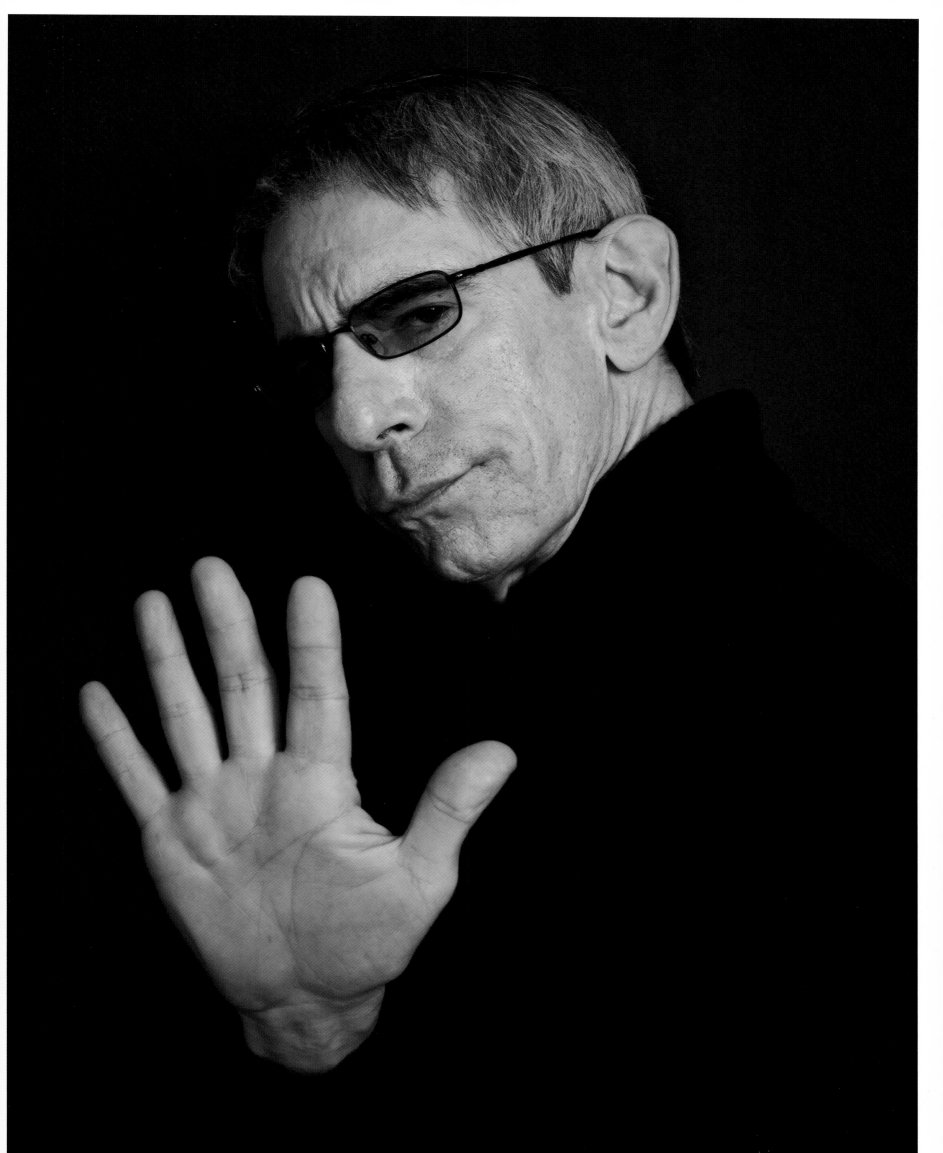

2·19·09

Art -- is like a
looking glass -- mirroring
all that we are -- from
our depths, to our
superficial beauty -- -

We can see our weaknesses,
our nobility, and our
futures -- -- our flaws or
fate -- -- --

Technique frees us to express
our -- -- -- excellence --

Lynn Whitfield

LYNN **WHITFIELD** / ACTRESS

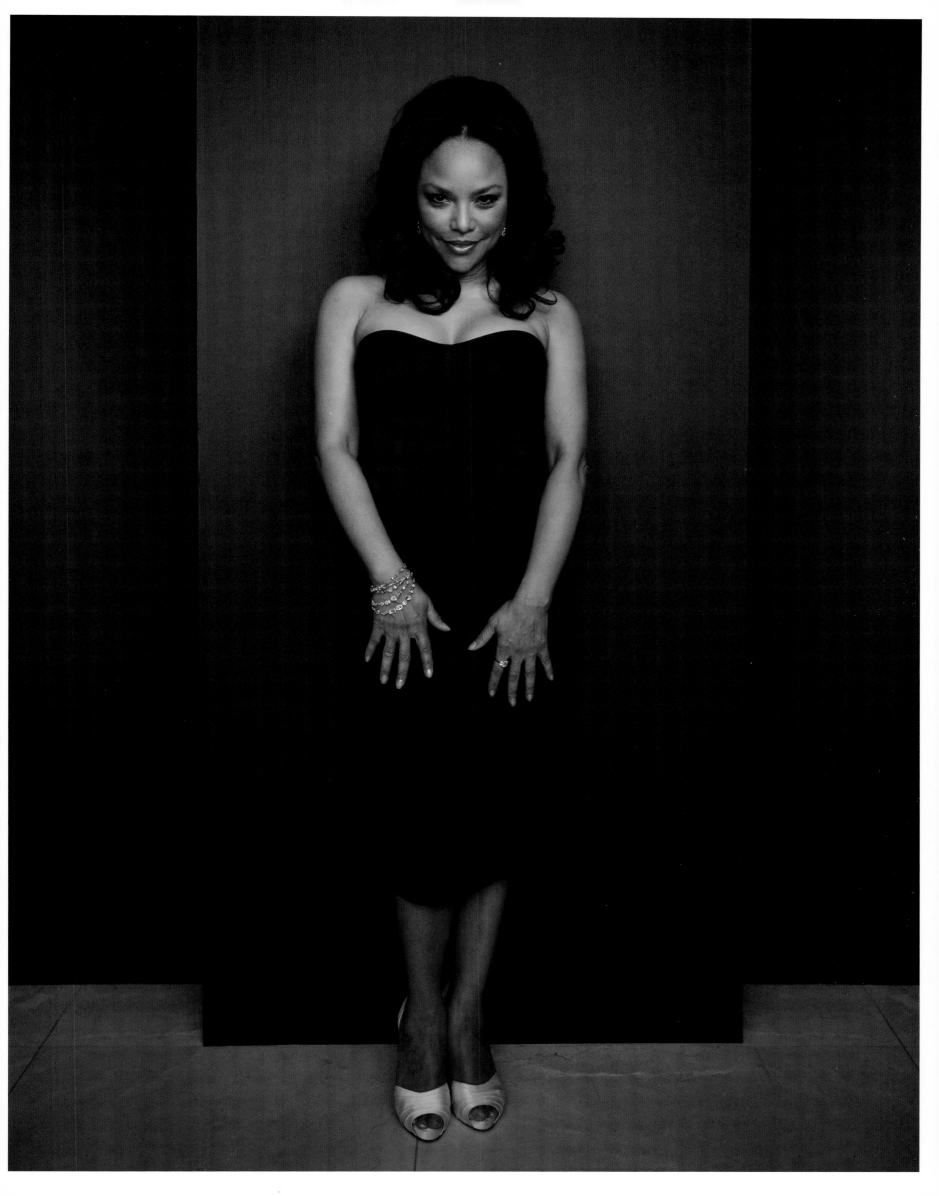

Successful writers, actors, and painters pay <u>taxes</u>. Arts funding pays itself back in spades. A tiny grant to help Alfred Uhry write "Driving Miss Daisy" helped create a play that sold out in theaters all over the U.S. Filled theaters mean filled restaurants and hotels — which mean TAX REVENUE. The movie of "Driving Miss Daisy" grossed 500 million dollars. How's <u>that</u> for balance of payments ??

Stephen Collins

STEPHEN **COLLINS** / ACTOR

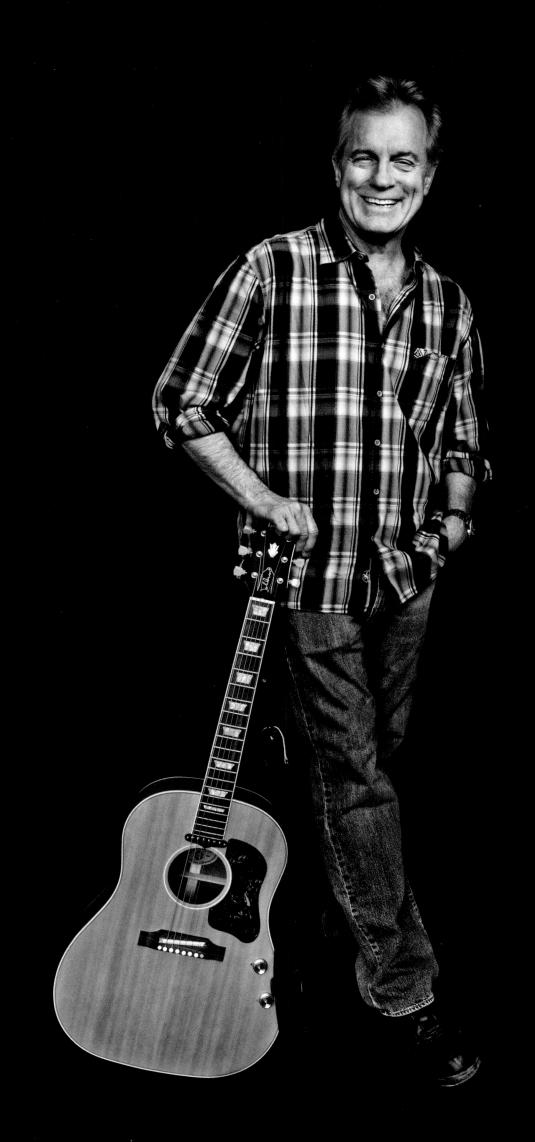

Art continues to teach me about others and the sense of what it is to be a human being. Without art I wouldn't feel free.

Kate Mara

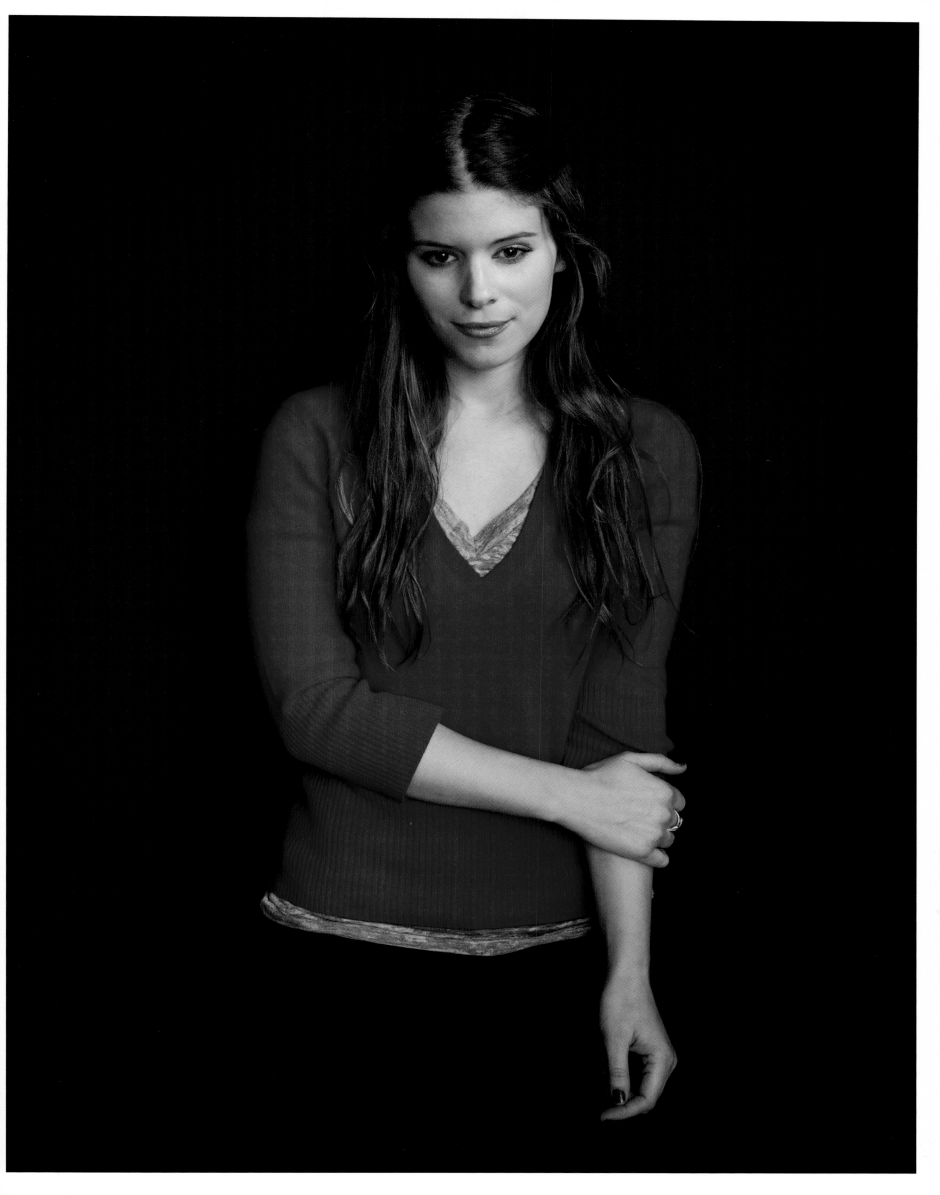

There's an old saying:
"Art is long; life is short."
I've been involved in some
very short-lived art.
But I keep going because
you never know!

Amanda
PEET

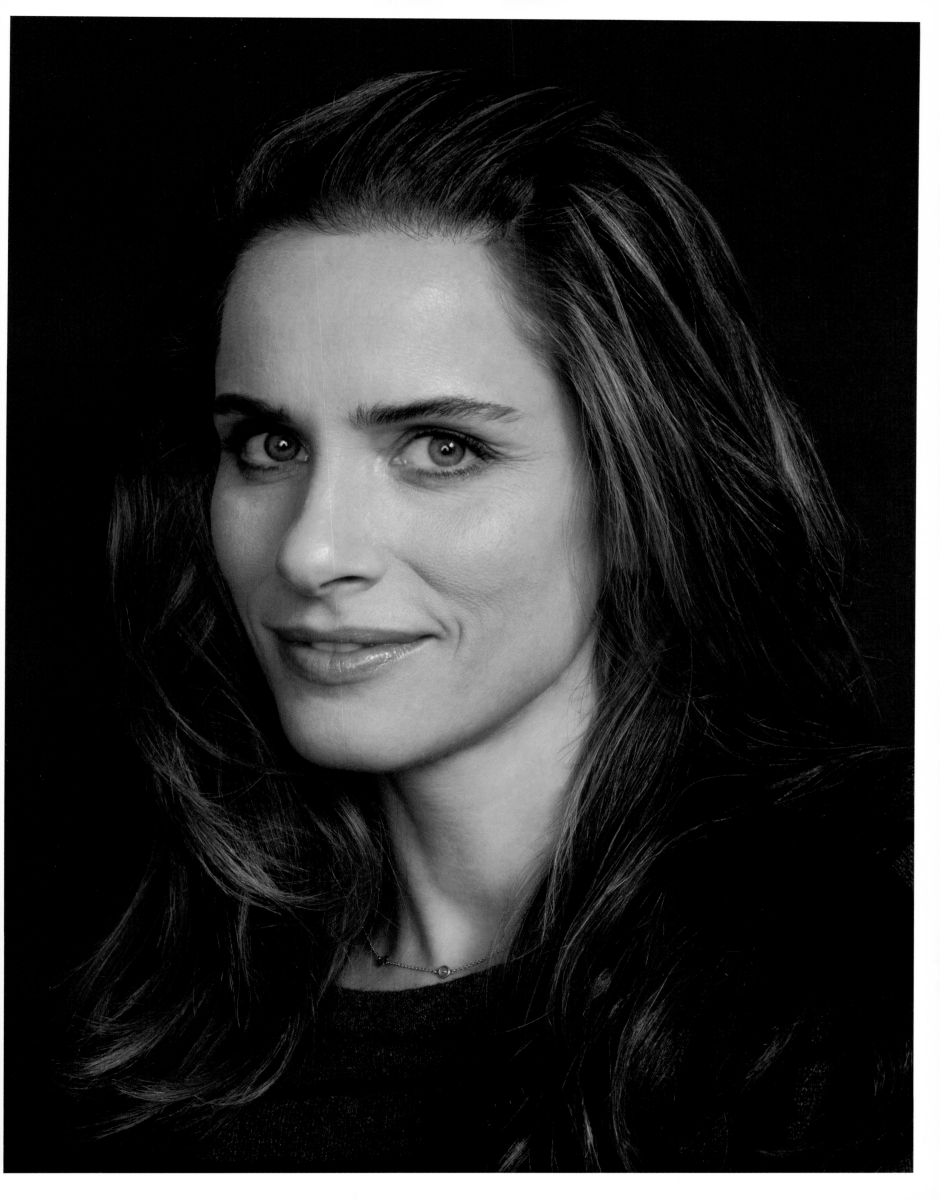

ART
IS
THE
ESSENTIAL
FUEL
OF...
THE HUMAN EXPERIENCE!

♡

OMAR EPPS / ACTOR

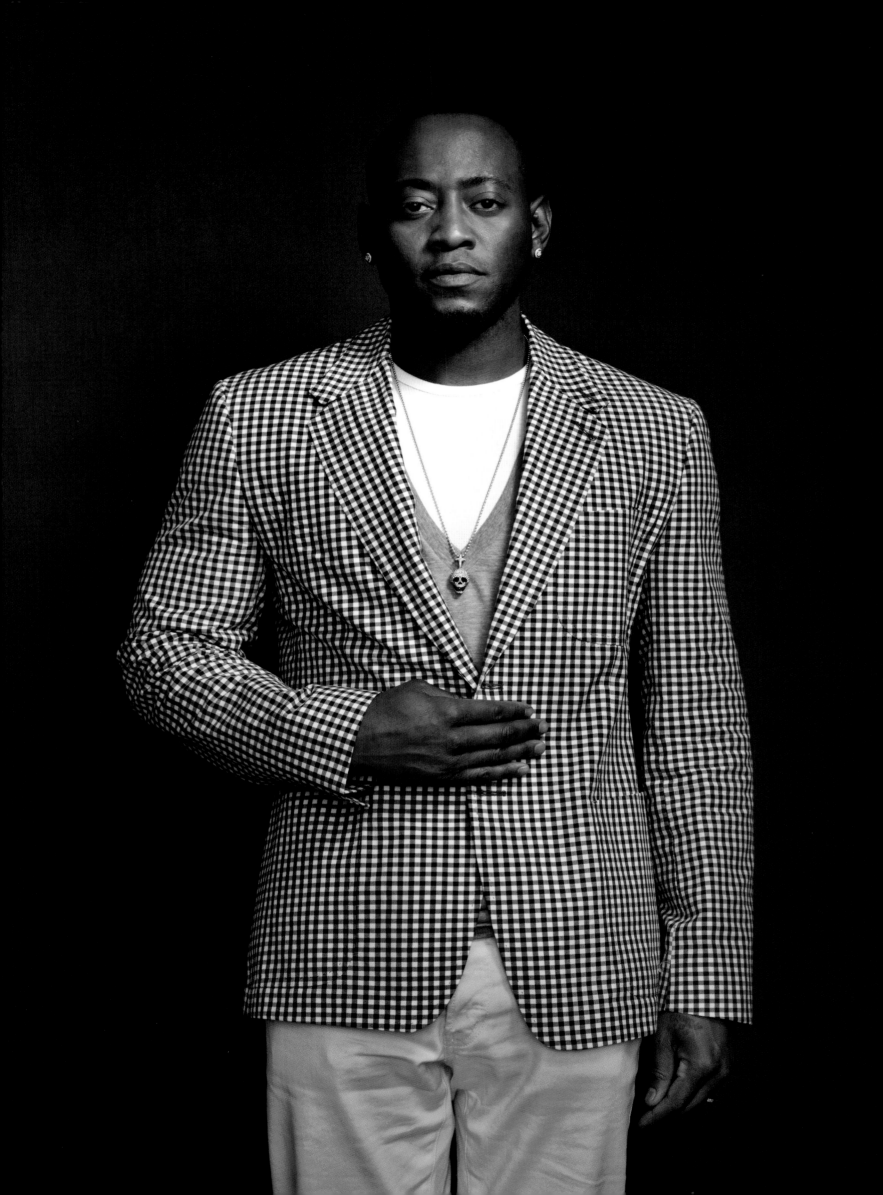

I CREATE FOR

THE POTENTIAL
THE HOPE

THAT IN ONE MOMENT

WE CAN BE UNIFIED

AND FEEL TOGETHER
UNDERSTAND TOGETHER
LEARN TOGETHER

- IN THAT MOMENT BECOME GREATER TOGETHER

THERE'S NOTHING MORE BEAUTIFUL!

Anita Briem

I think people get confused when there's talk of arts funding: it's not about funding artistes or tomorrow only; it's more about giving everyone the opportunity to be creative, challenged, provoked and therefore a happier, kinder, more fulfilled person.

Arts truly is the most successful industry — because it reaches and affects us all.

ALAN **CUMMING** / ACTOR

Every single day, someone's art expands my humanity and my perspective. We would all be lost without the arts — whether it's graffiti on a wall or an exhibit at MOMA.

Please continue to support Arts Education!

Love,

Kathryn Erbe

KATHRYN **ERBE** / ACTRESS

The Arts
Have gifted
me with a
JOYOUS
and
CREATIVE
LIFE!

Melissa Leo

MELISSA **LEO** / ACTRESS

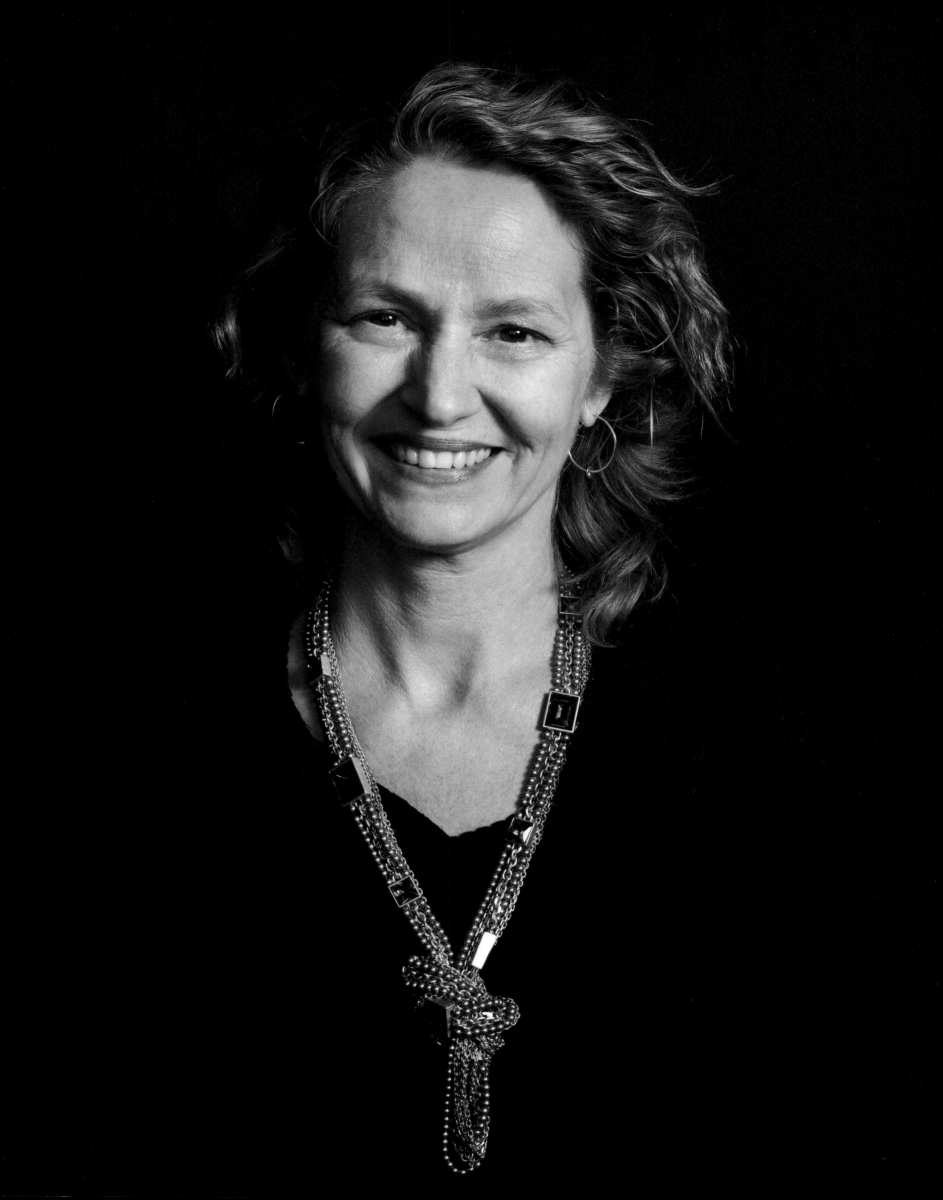

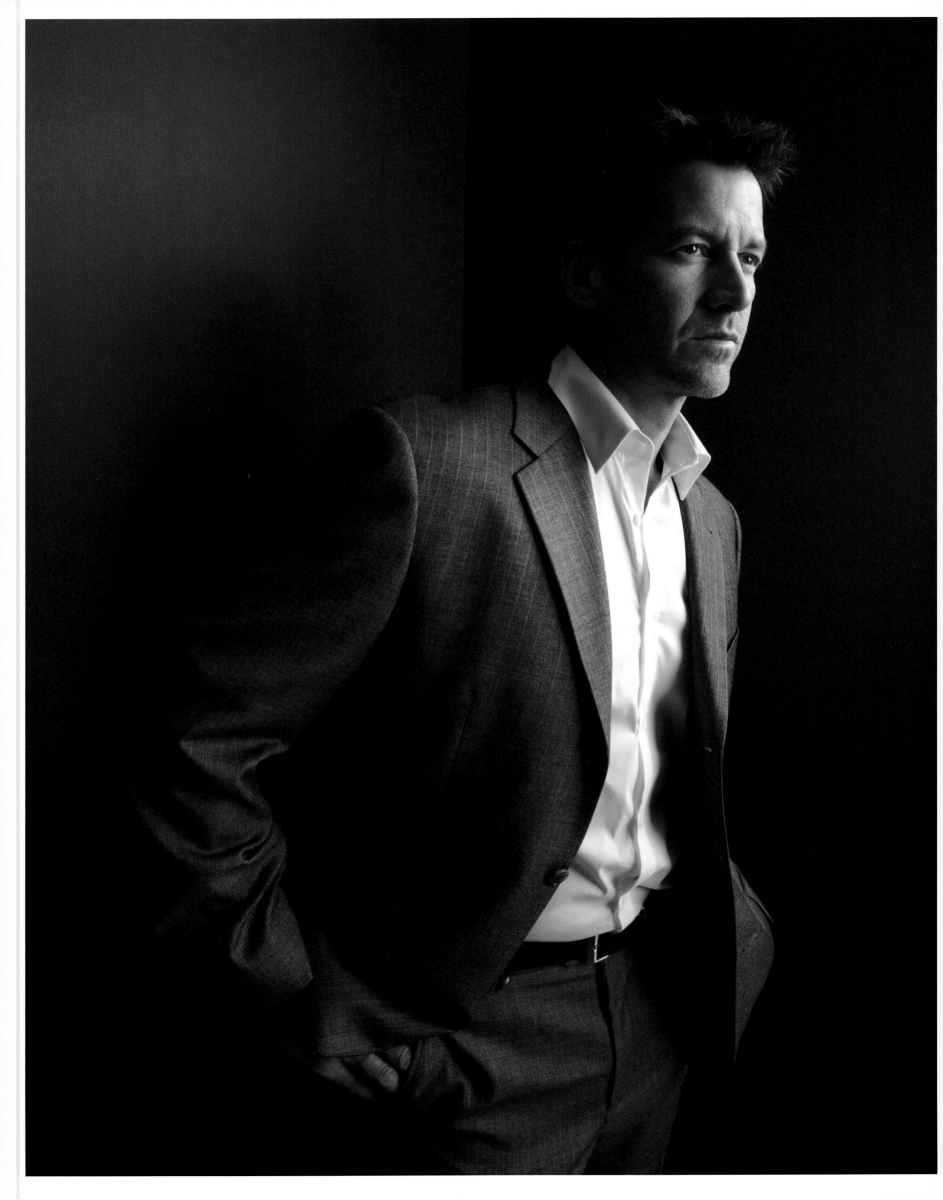

THROUGHOUT MY LIFE, I'VE
FOUND THAT EVERYTHING THAT
I KNOW ABOUT HUMAN NATURE
THAT IS MEANINGFUL, I EITHER
LEARNED FROM, OR WAS CONFIRMED
BY, THEATRE.

James Denton

I discovered my passion for creating at a very early age in life, around four years old. I've always loved using my imagination and escaping into another world. Without it, I would not be me. Most people lose it or feel the need to compromise "playing" as they get older. My work is my play, and for that I consider myself incredibly lucky!

-Andrea Bowen

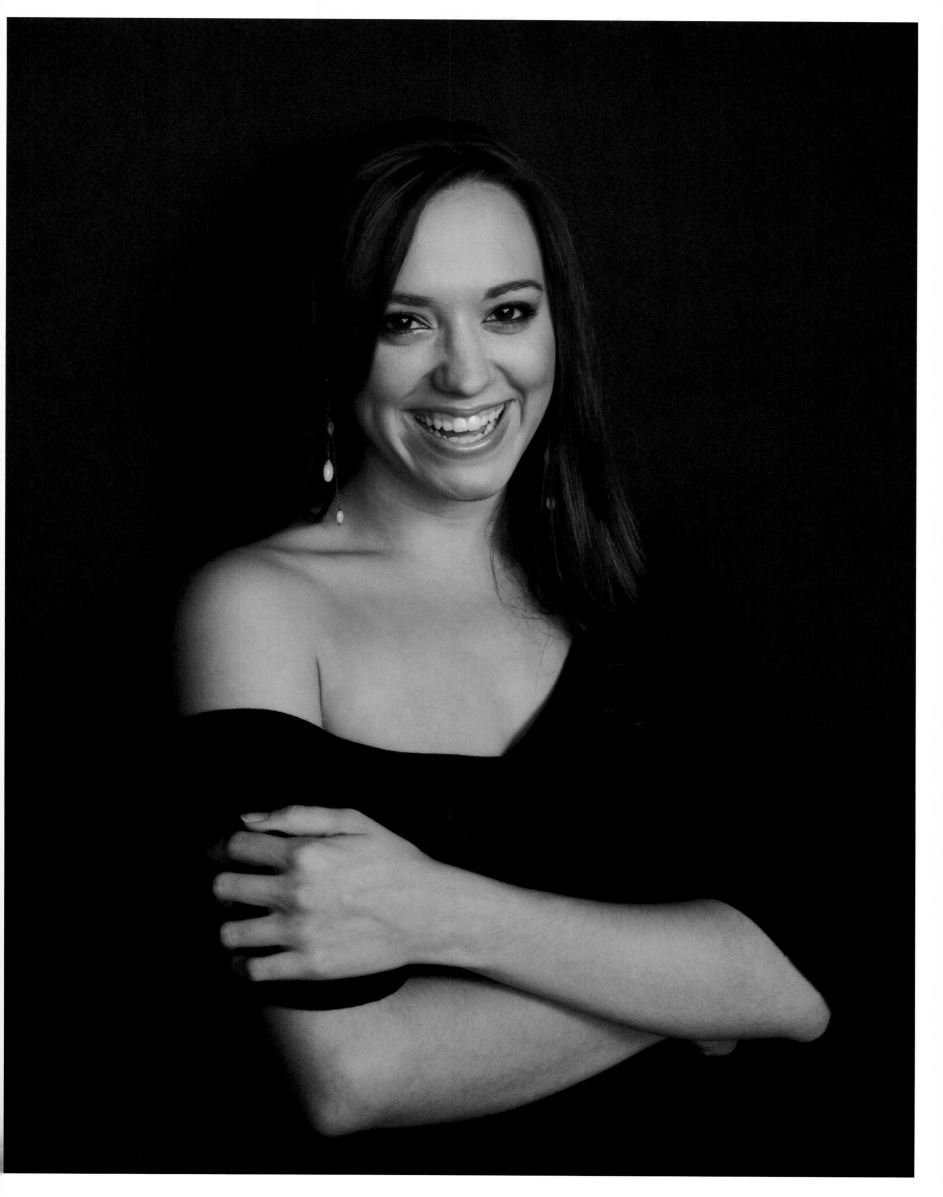

Music

Dance

Theater

Art...

Frees the soul.
Saves Lives.

Gloria Reuben

GLORIA **REUBEN** / ACTRESS

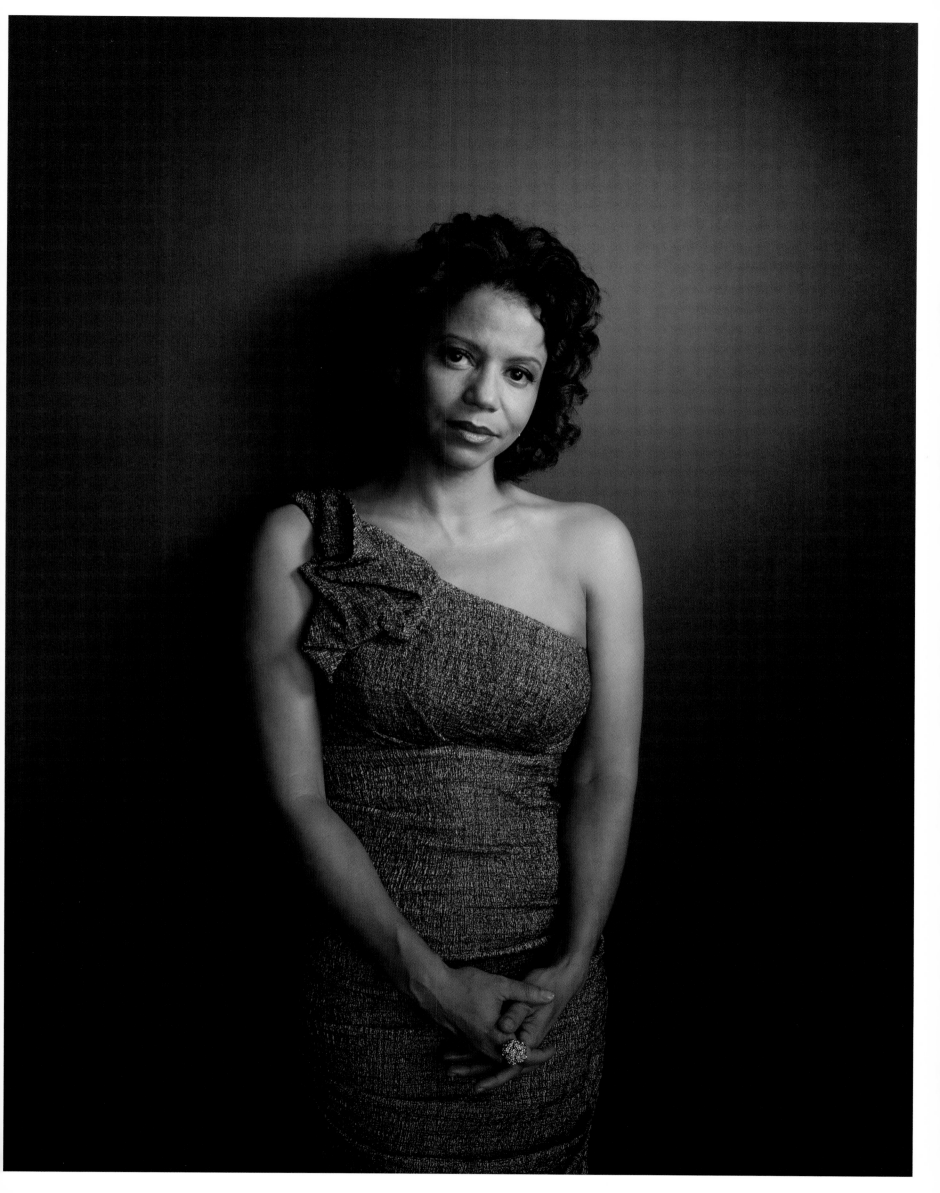

Art builds bridges.

Between our inner selves
 and outer communication.

Between individuals, as they practice
 the delicate art of collaboration.

Between cultures as they proclaim themselves
 for all time.

I may not understand someone's politics,
but if I can tap my toe to the rhythm
of their song, then I'm one step closer
 to empathy.

~~~~~~~~~~~~~~~~~~~~~~~~~~~~~~~~~~~~~~~~~~~~~~~~~~~~~~~~~~~~

I honor my first teachers, Chris Gullotta
and Bill Rauch, midwives of the artist in me.

Since I was 11, art has saved my life.
I have no doubt it will save the world.

*Amy Brenneman*

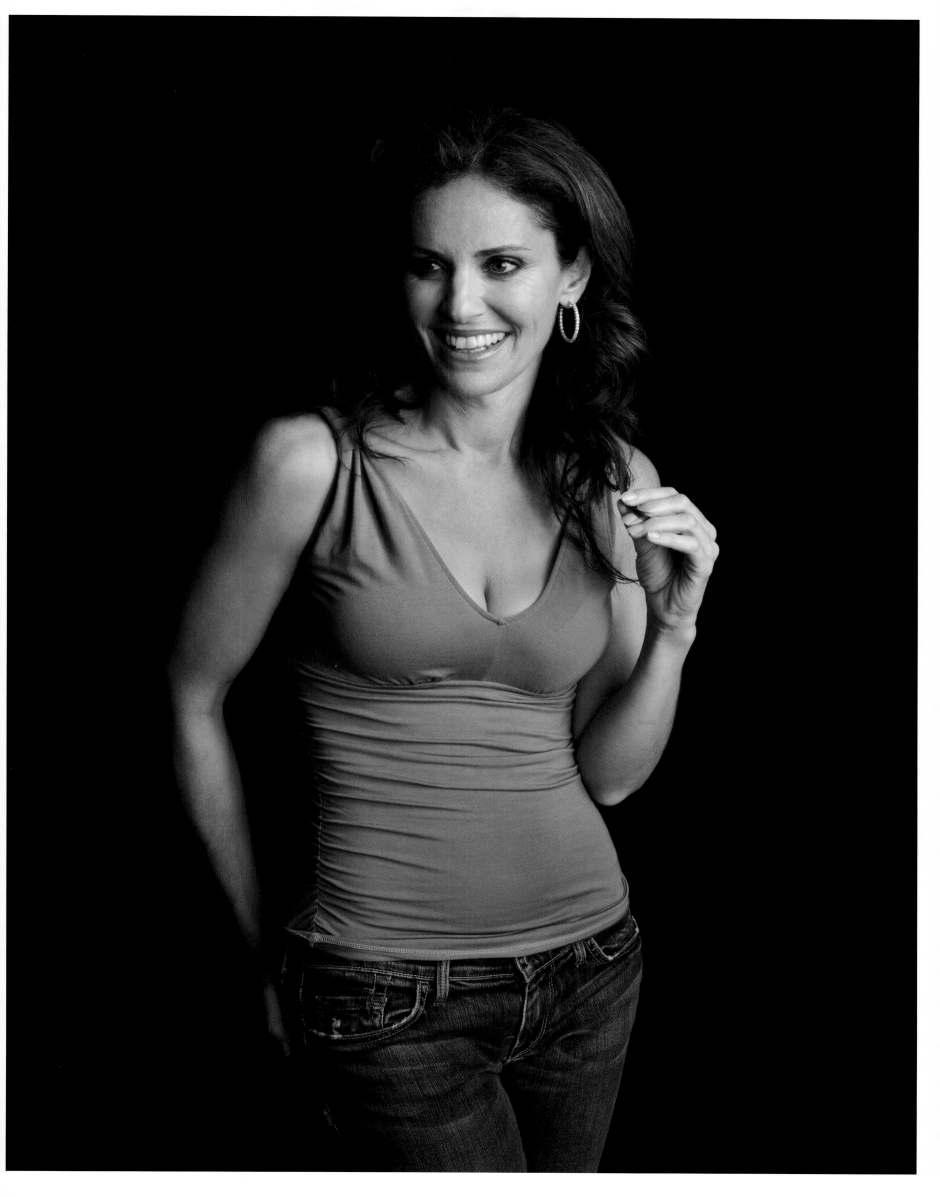

WHILE COMMERCE & POLITICS OFTEN TRY TO DIVIDE US FOR PROFIT & POWER, ART CAN REVEAL HOW MUCH WE SHARE WHEN IT WORKS, FOR A MOMENT, NO ONE FEELS ALONE – AND IF IT'S IN THE THEATRE, WE GET TO BE THERE WHEN IT HAPPENS.

THANK YOU, ART. YOU'VE HELPED ME FIND A PLACE IN THE WORLD.

PETER **GALLAGHER** / ACTOR

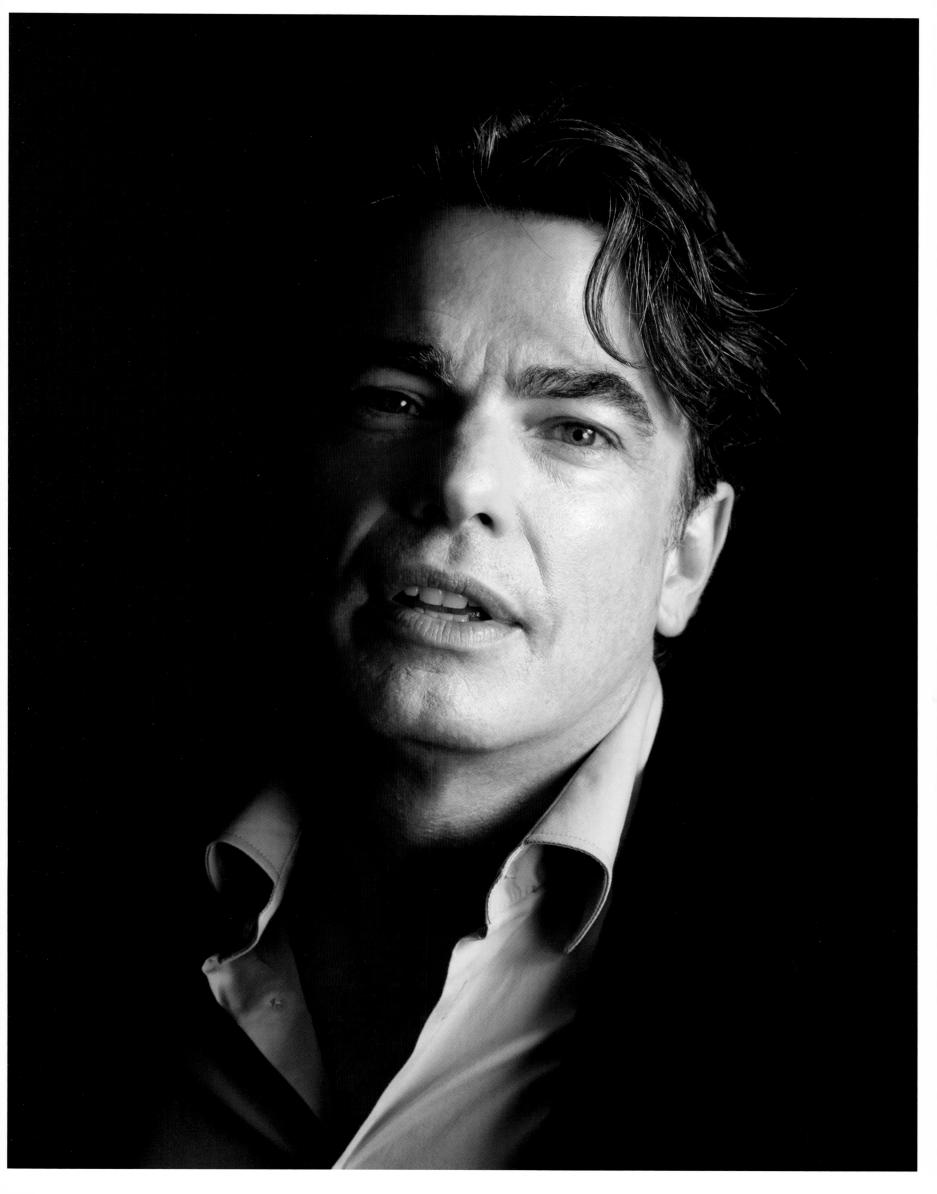

ART . . .
A safe place for children to dream
where dreams may show another way
Through discipline and dedication
Til PASSION leads The way

Expanding The Heart
Informing The Soul
ART . . .

Is a VERY GOOD WAY
To Teach HUMANITY

*[signature]*

*[signature]*

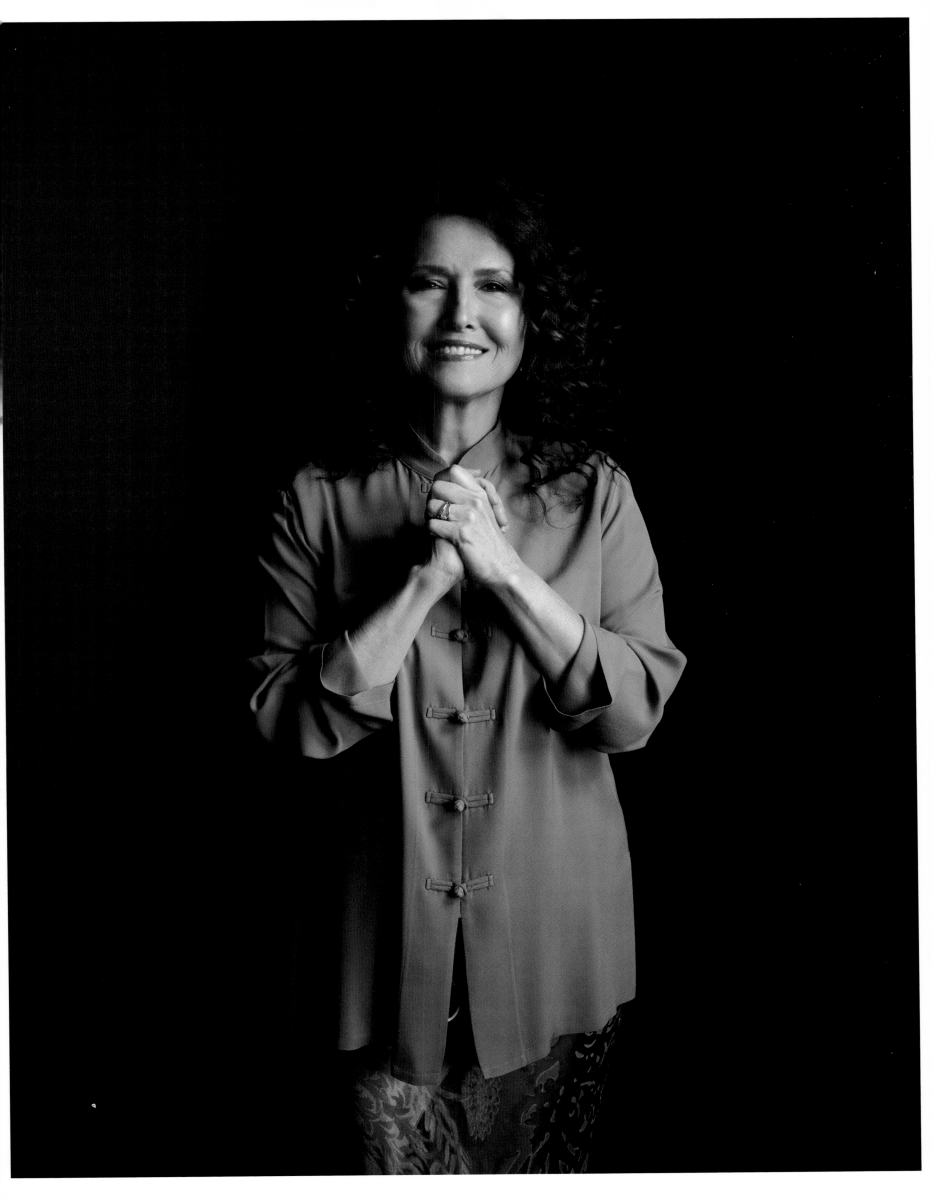

"Choose an unimportant day. Choose the least important day in your life. It will be important enough."

That line is from one of the first plays I ever did – Our Town. I was 15 and played the mom, "Mrs Gibbs." In the final act, Emily has to pick one day out of her entire life to revisit after she has died. She wants to pick the happiest day and I tell her, "No! Choose an unimportant day..."
I've never forgotten those lines. I've never forgotten the experience of working on that play.

It was the first time in my life I felt a true sense of Community. My parents were going thru a terrible divorce. I got to hang out in the school gym all night painting props, hanging lights.
I stayed out of trouble. I learned a new skill; I created a family.

The arts gave me a home. And since then everyday of my life, even the "least important" ones, have been wonderful. I've been so lucky.

CATHERINE **DENT** / ACTRESS

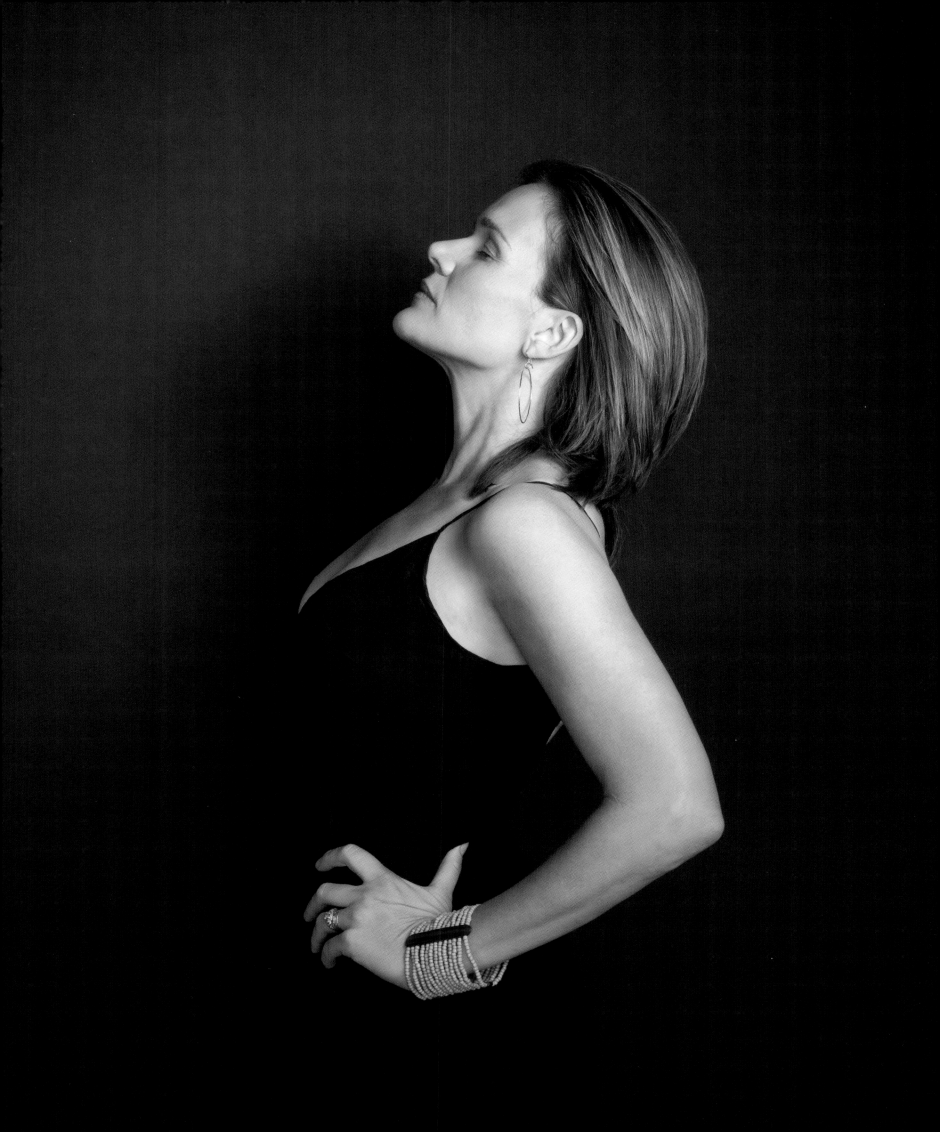

There's an extraordinary feeling of empowerment when one realizes that the mind, body & soul may come together in a single moment & create art (or a very accurate interpretation of it).

We are vessels for creativity + expression + to not make use of such a valuable gift? I can't think of a sadder fate!

— EH

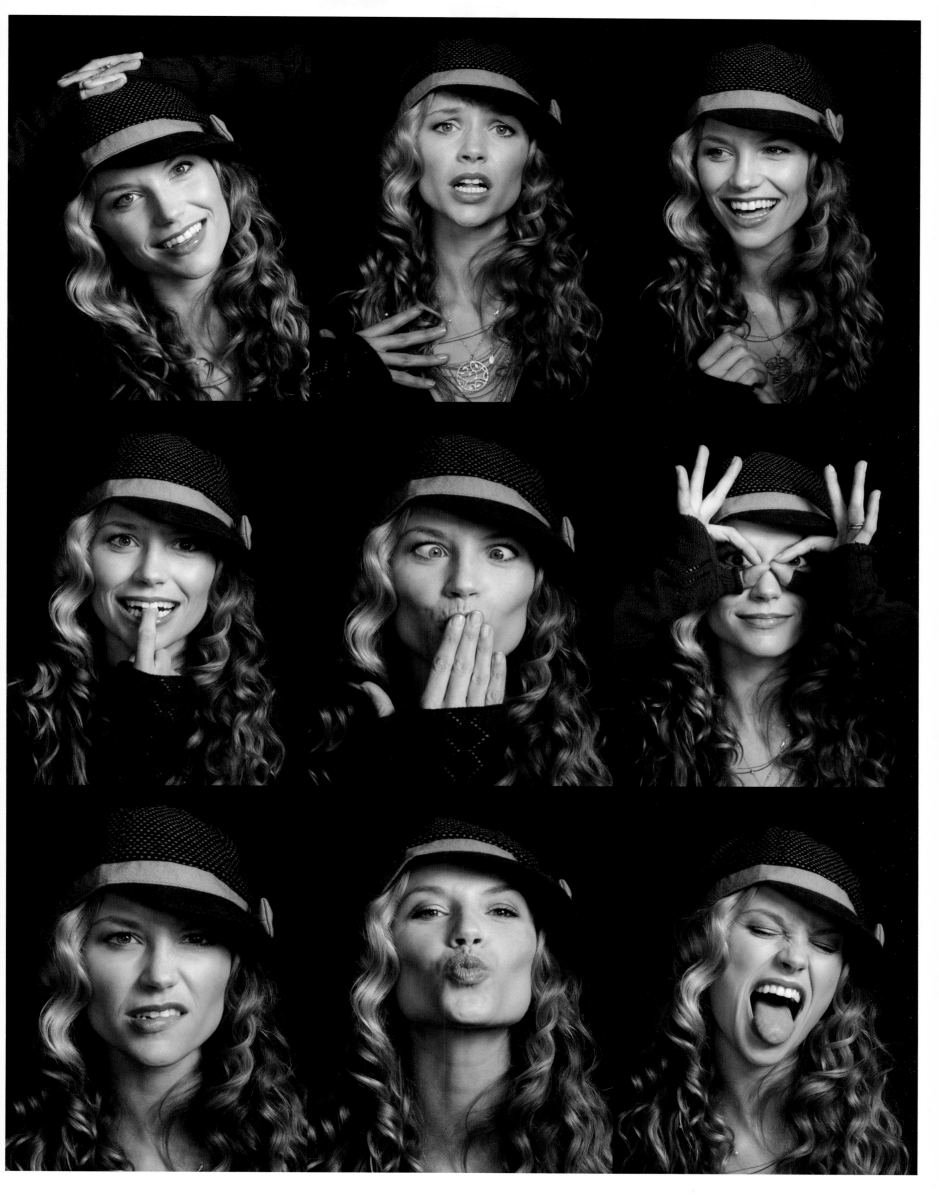

I'm a construction kid, raised all over the world. Art was the one consistency in a tumultuous, ever-changing environment. Crayons, paint and paper kept me grounded.

Art is the Universal language that every human being needs in order to express and communicate. Art is essential to being whole.

*Frances Fisher*

FRANCES **FISHER** / ACTRESS

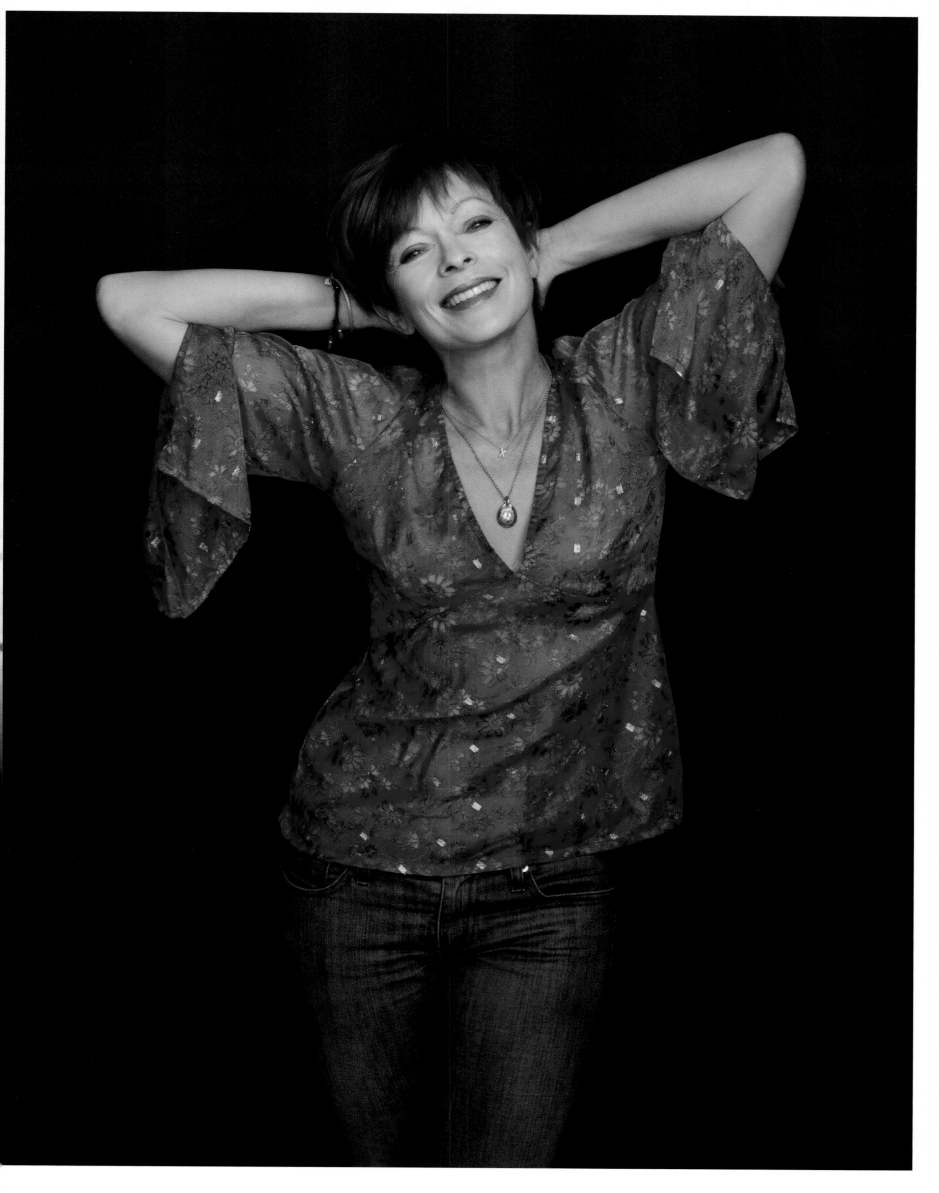

IF you Ain't
CreAtin' you're
Cryin'

*[signature]*

JAMIE **KENNEDY** / ACTOR / COMEDIAN

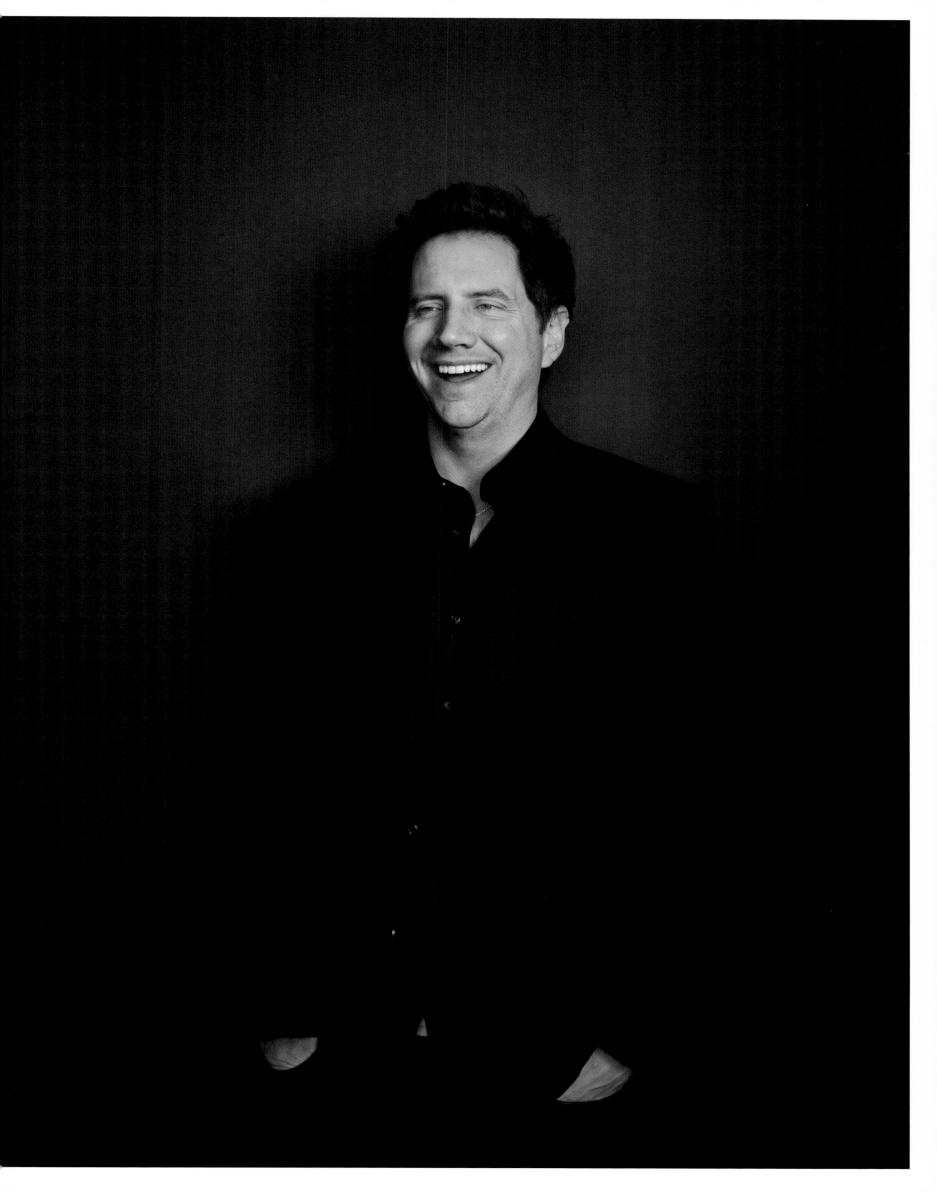

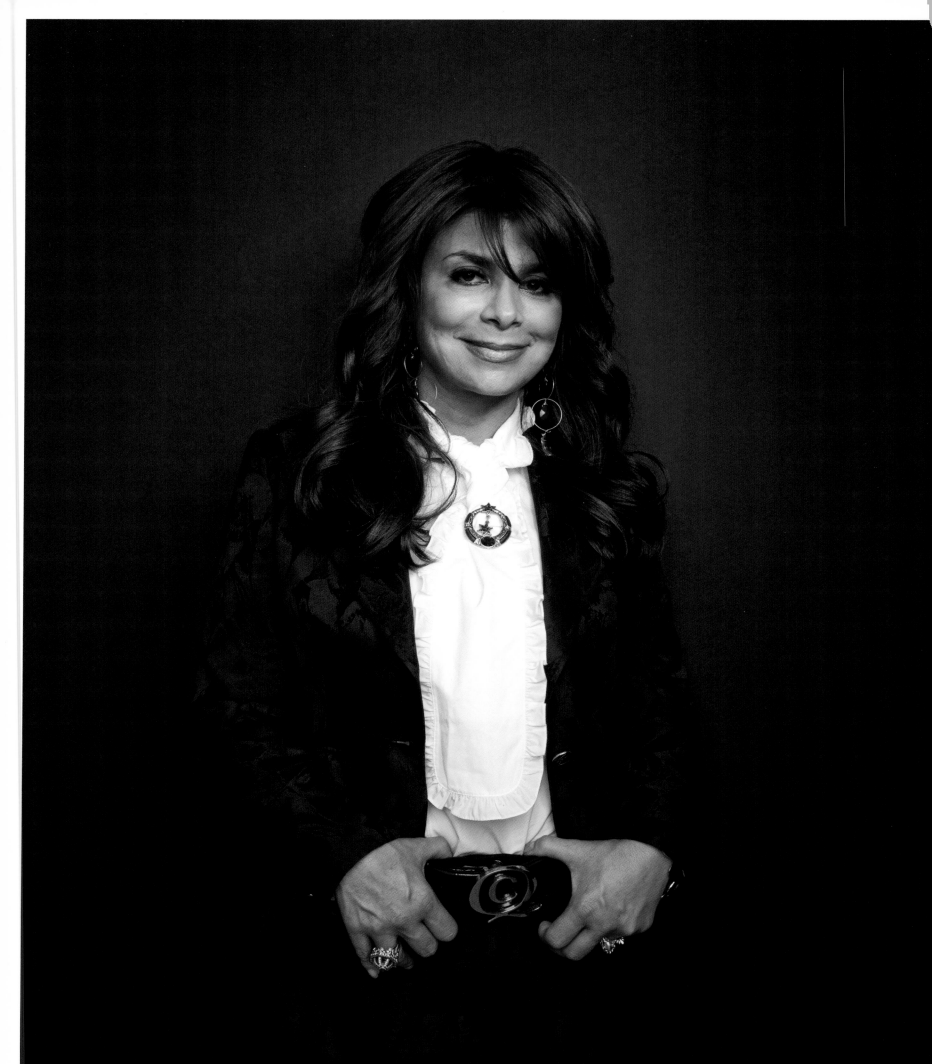

EVERY SINGle one of us
is special + unique in our
own way. The Key to finding
that "Happy" Place in one's
Heart, I Believe, is to
Engage in some form of
"ART"! Whether its painting
Playing an instrument,
Dancing, Singing, etc.
I guarantee you will find
your "Happy Place" in your
Heart! Remember -
Reach for the Stars ...
and you just might
Become one! w/ Love +
Hugs xo

Paula Abdul

PAULA **ABDUL** / SINGER / CHOREOGRAPHER

Art is humanity. It's borderless.
Infinite. Full of possibilities.

The child we were, we are,
and will be.

"To be geek is to be human.
I'd rather be passionate
about something than be
apathetic about everything."

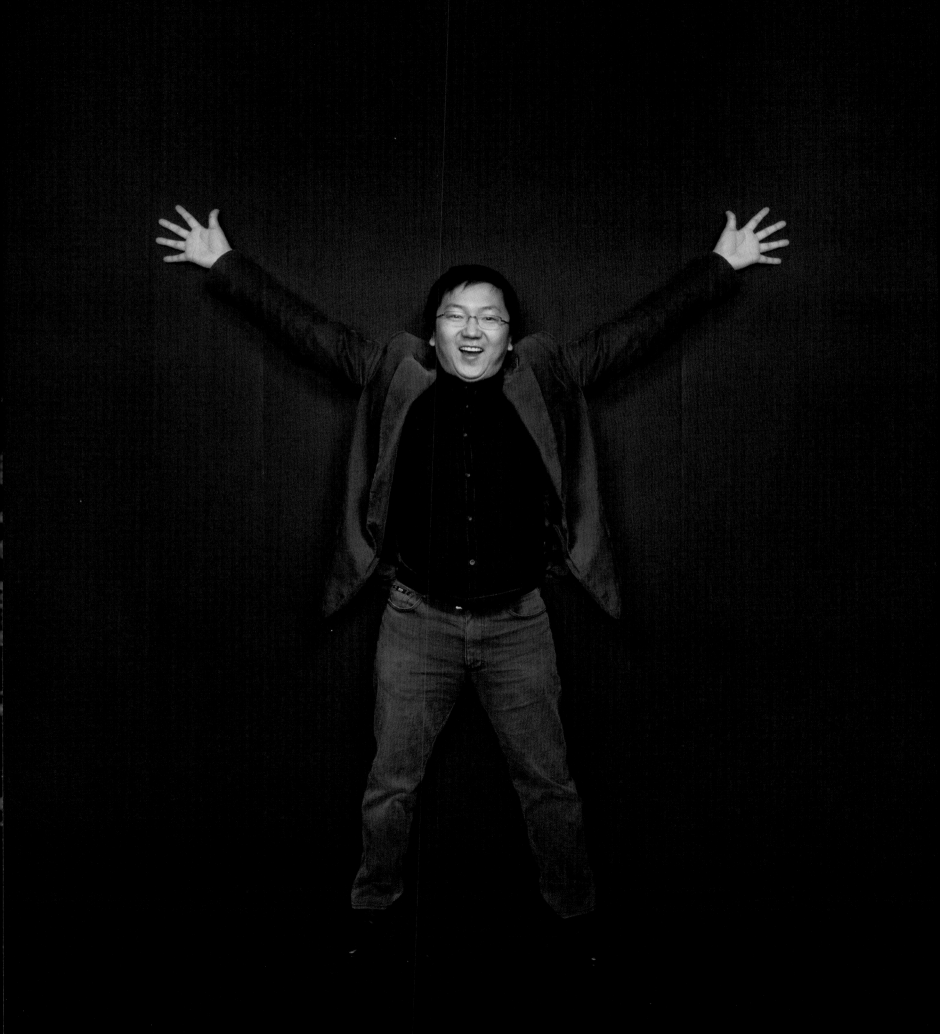

Art gave me on identity and allows me to be who I AM.
It doesn't require the right answer.

— Portia Doubleday

PORTIA **DOUBLEDAY** / ACTRESS

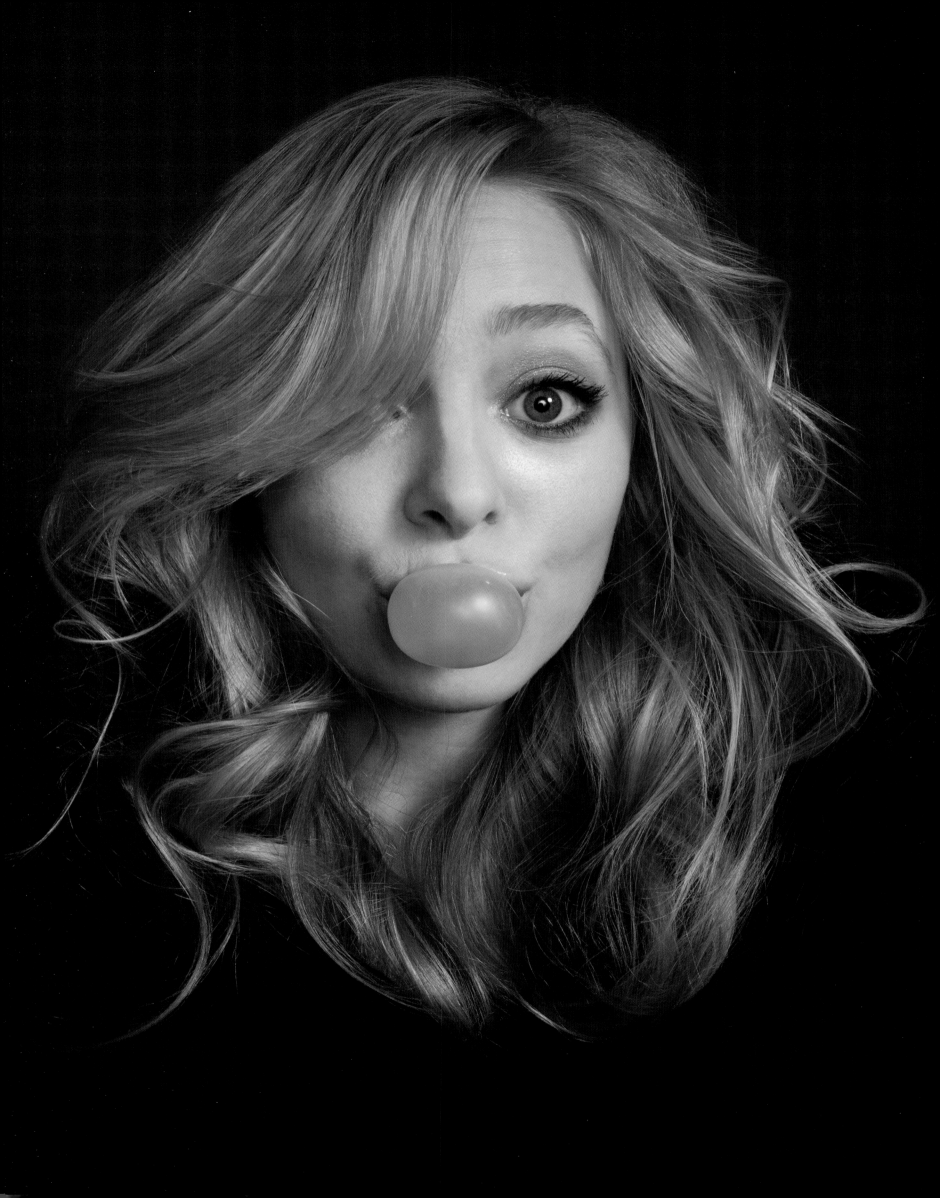

" One of my favorite memories from my childhood is drawing and painting in my art class. I felt like I was creating a new world on the canvas, and it empowered me to create — more..."

— James Kyson Lee

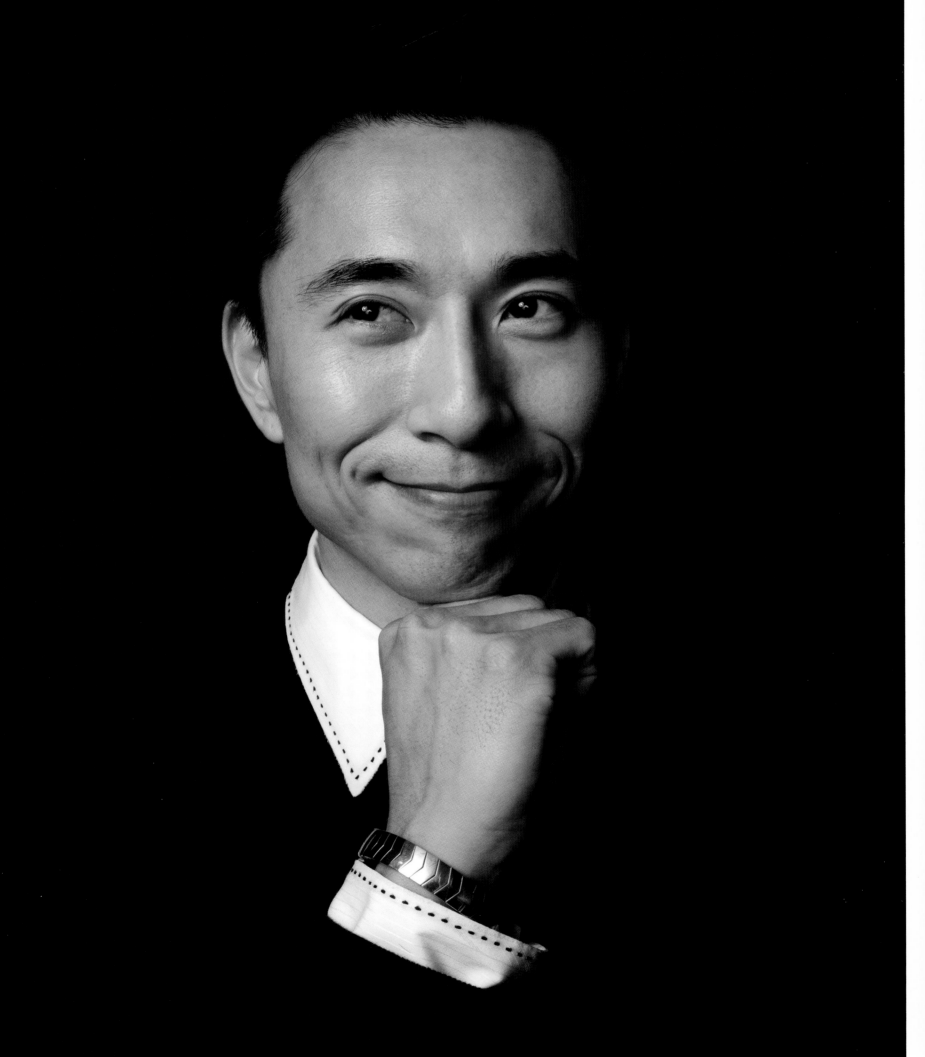

We draw before we write
entertain before we speak
Dance before we stand
    The arts are the essence
of the human spirit
  ...we are all children here

*Rachael Leigh Cook*

RACHAEL LEIGH **COOK** / ACTRESS

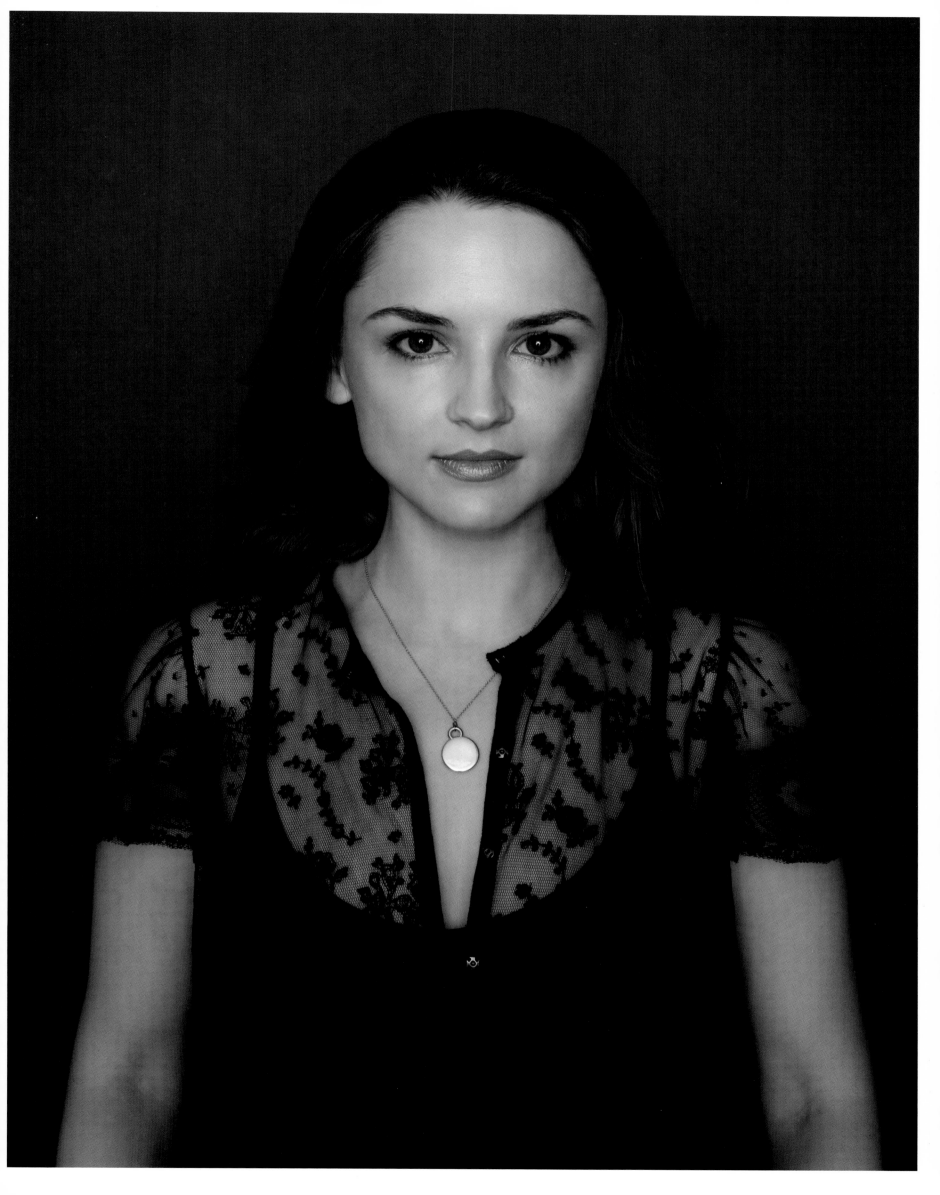

The Arts have allowed us to explore new frontiers, new potentials and new ideas in our search for meaning and purpose.

The Arts have allowed me to glimpse the unending depth of our humanity!

ART = Life = ART = Life

*Linus Roache*

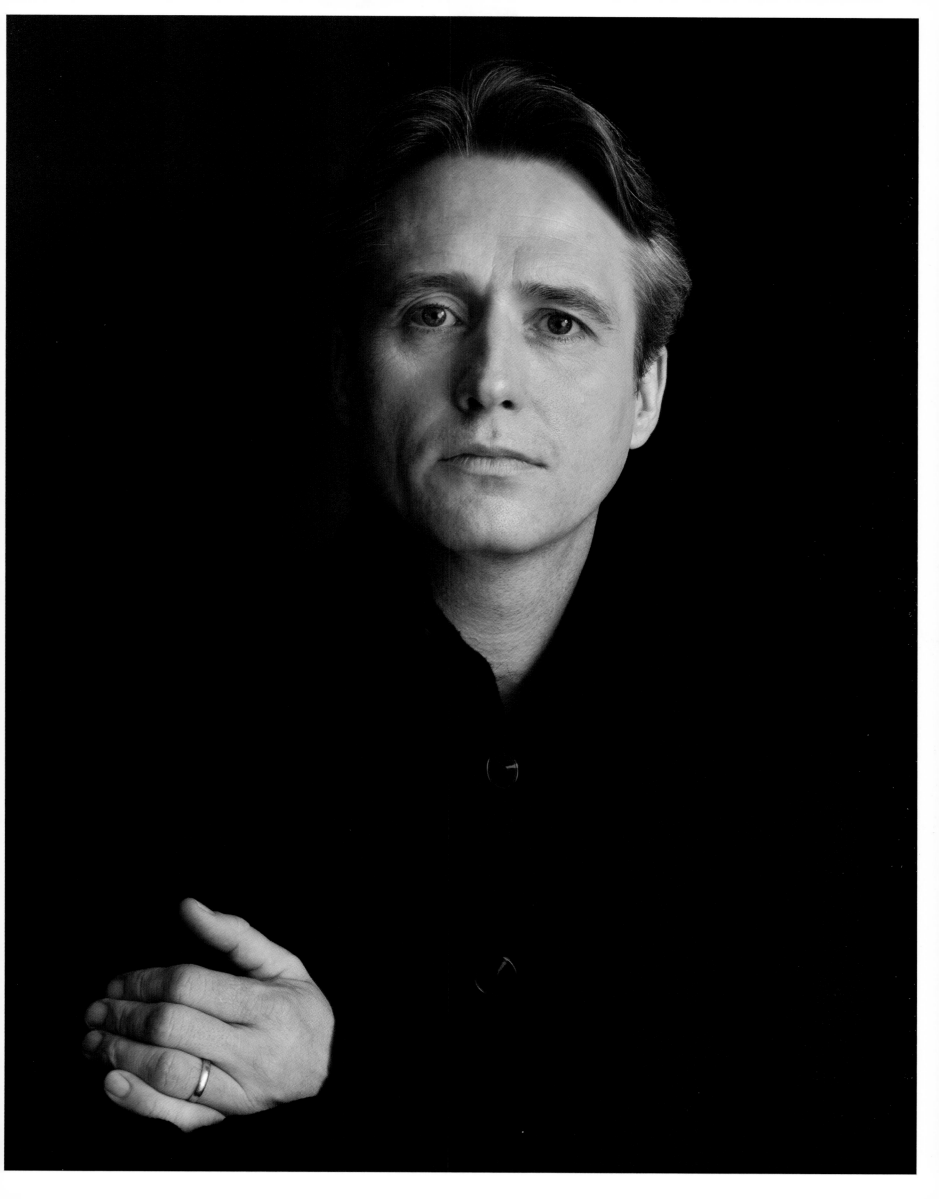

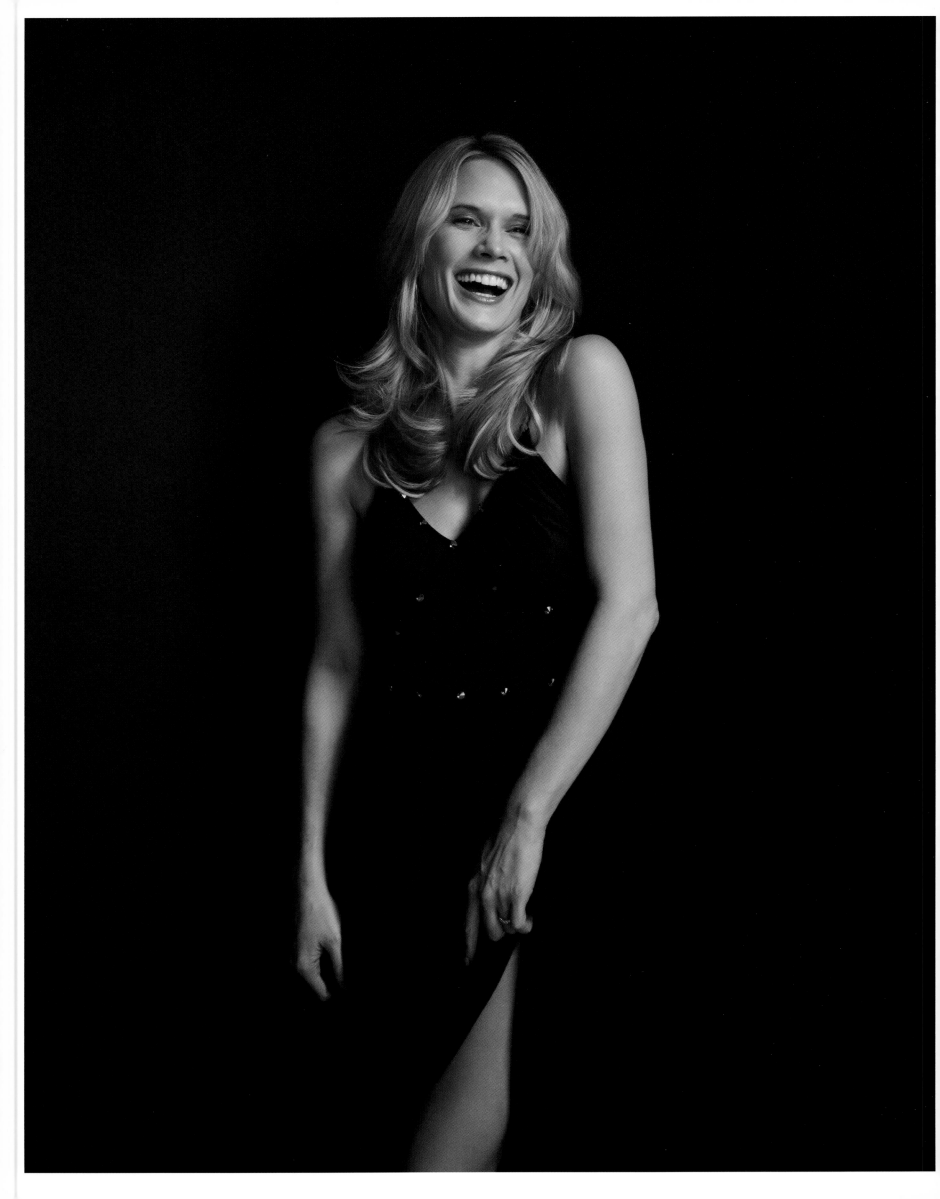

Arts education is like taking a class on the subject of POSSIBILITY.

—SMarch

STEPHANIE **MARCH** / ACTRESS

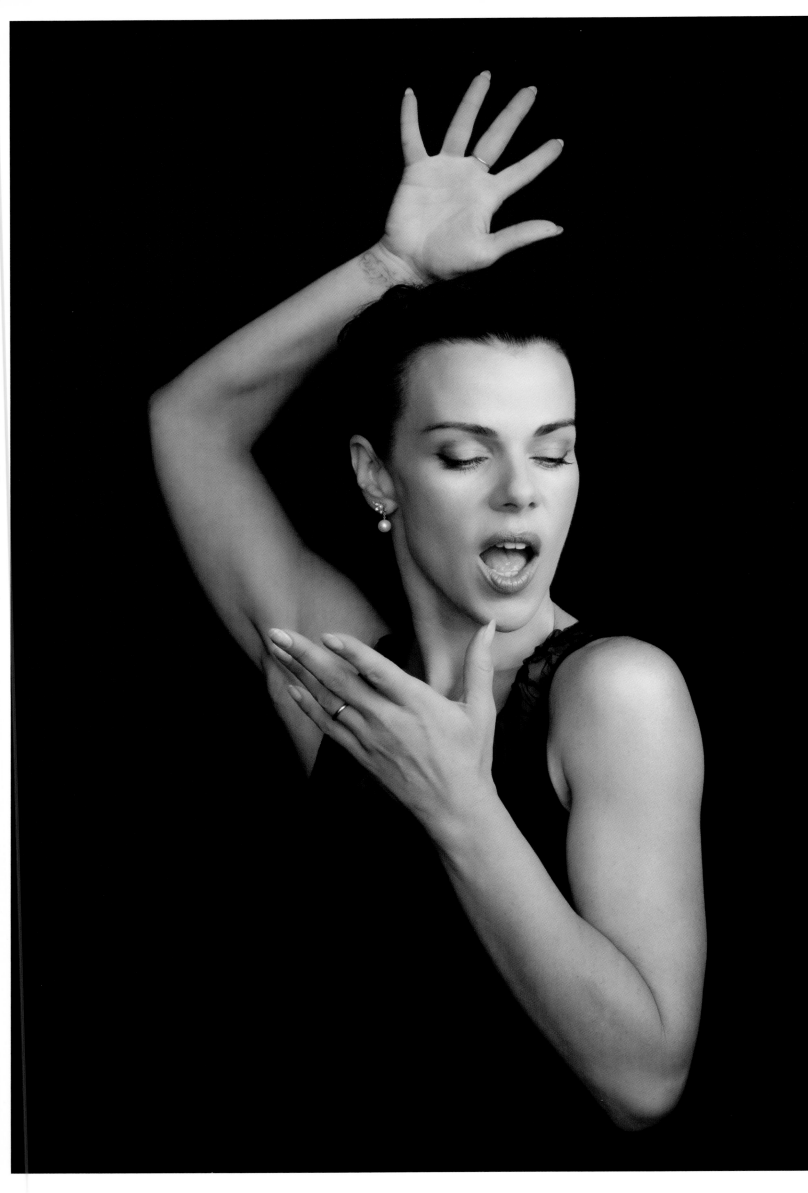

Art saved my life! As a young, N.Y. City gal - with teenage parents and NO money - The Arts kept me out of trouble. Having Art programs in Public School - allowed me to enjoy my academic studies - It gave me a break -

Art see's no color, religion, age - It brings us together - Gives us a chance to dream - to be inspired! I myself was blessed to have SO many wonderful teachers to fill my curious mind - Generations that came before me - Grandparents, strangers, older gay men, that took me to museums, took me to dance halls, fashion shows - kind, generous people - who took the time to feed a young mind . . .
I'll never forget my 1st Theatre moment. My 1st museum visit - beautiful concerts in Central Park - where I'd watch classical World music - My 1st "Nutcracker" viewing . . . It gave me a dream!

I live in Firenze Italy now with my husband and 2 young daughters'. I want to fill my children, with Art & History. Sadly the U.S.A. is taking it out of our Public Schools - and that is Tragic . . . I'll come back when they fix that! ☺
Debi MAZAR

DEBI **MAZAR** / ACTRESS

Being the "Creative Type" in Junior High
wasn't such a novelty as it is now.
I would constantly be bullied for being
different. There were mornings where I
would fake sick because I couldn't
handle the constant verbal and physical
abuse from my piers.

It wasn't until I got my first CD
player that I discovered improvisational
dance and how therapeutic it was.
Even now, with all the pressures of life and
the economy, I put on a song and just
vent. It's my way to escape, to go away,
to feel alive and rediscover the grandeur
and beauty this world has to offer.

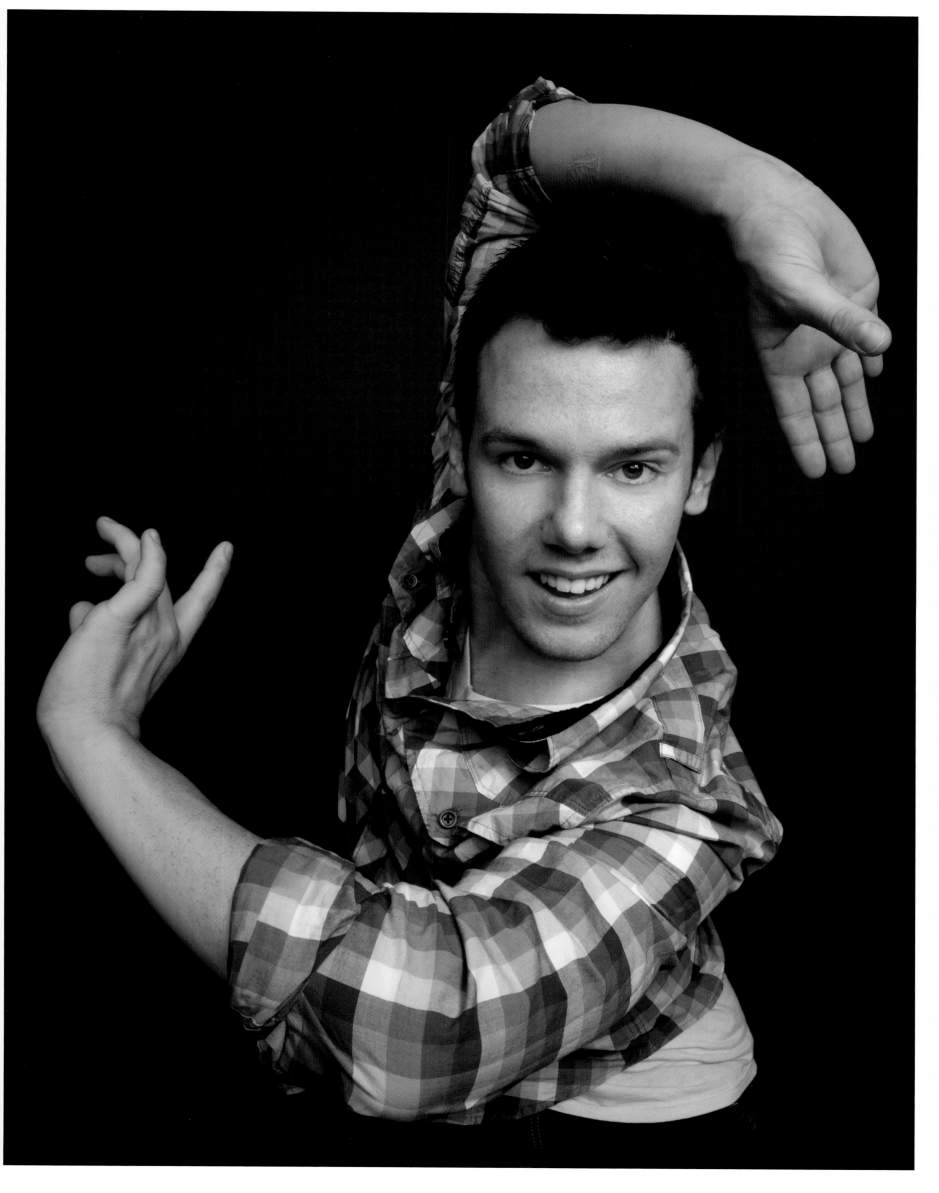

HA!. The ARTS GAVE me A Life! Now my Big mouth makes aRt instead of enemies. ♡

Jeffrey Ross

JEFFREY **ROSS** / COMEDIAN

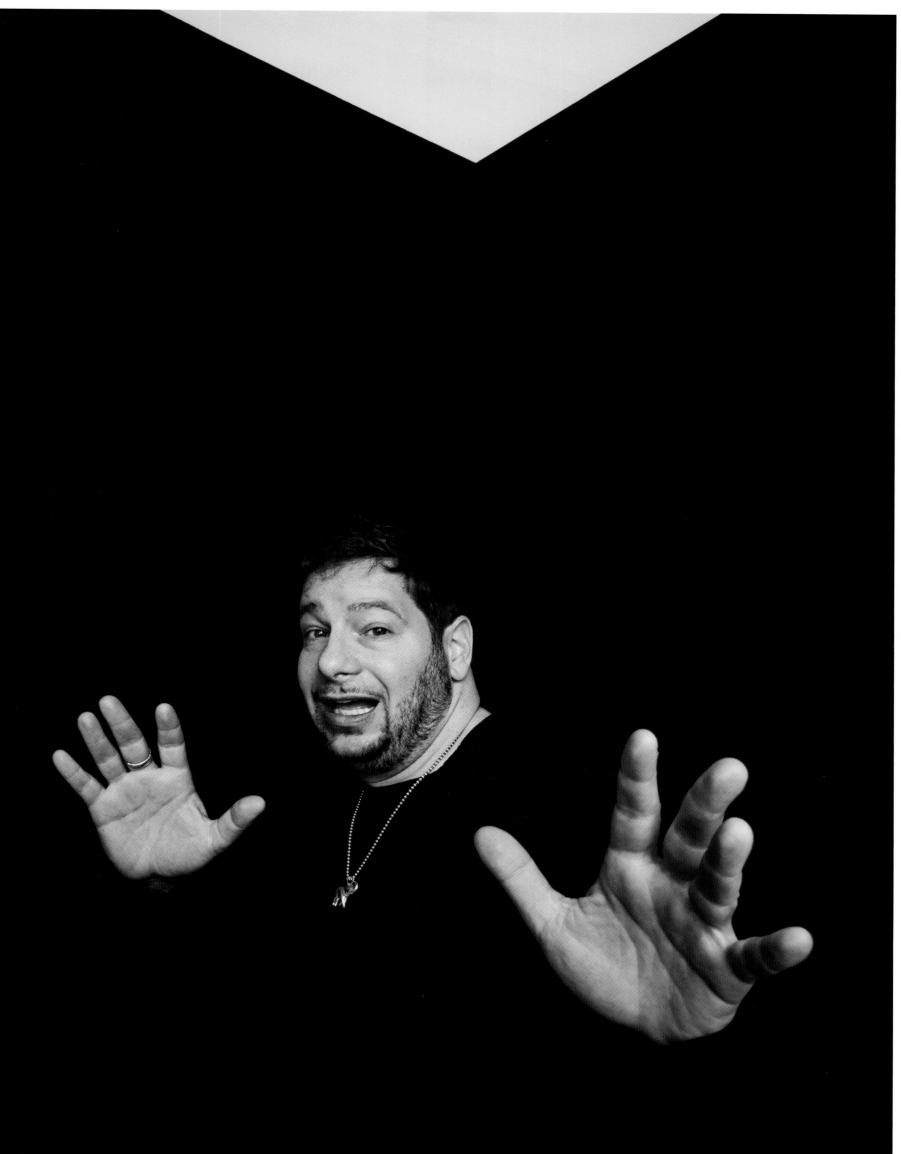

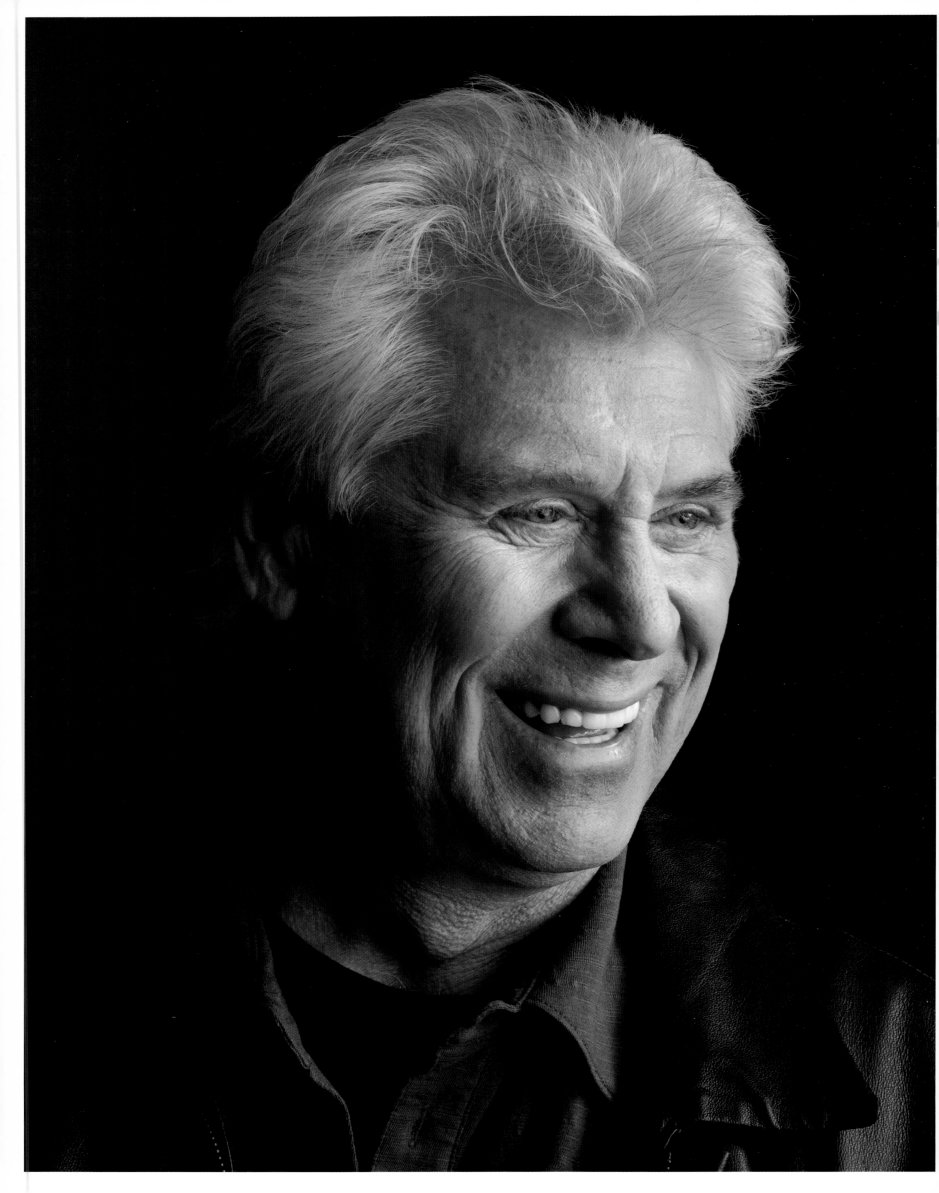

I grew up in the early 60's
life WAS ArT, ArT was
our lives --
we created iT, listeNed To it,
rebelled under it's influence

and changed the world! -

Can't be
SMART
without
ART

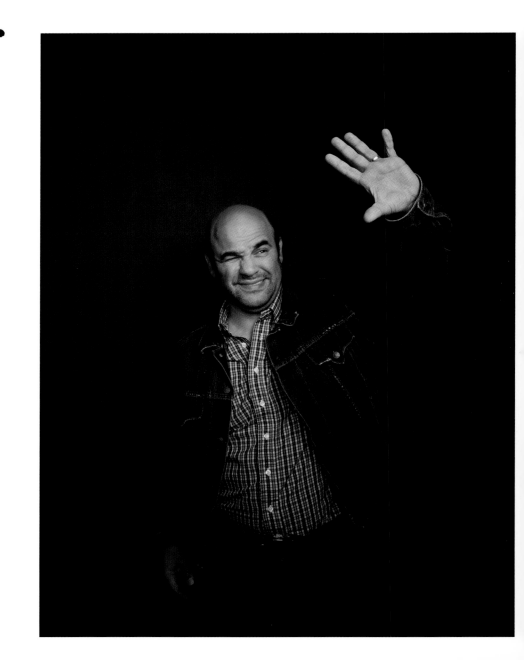

IAN **GOMEZ** / ACTOR

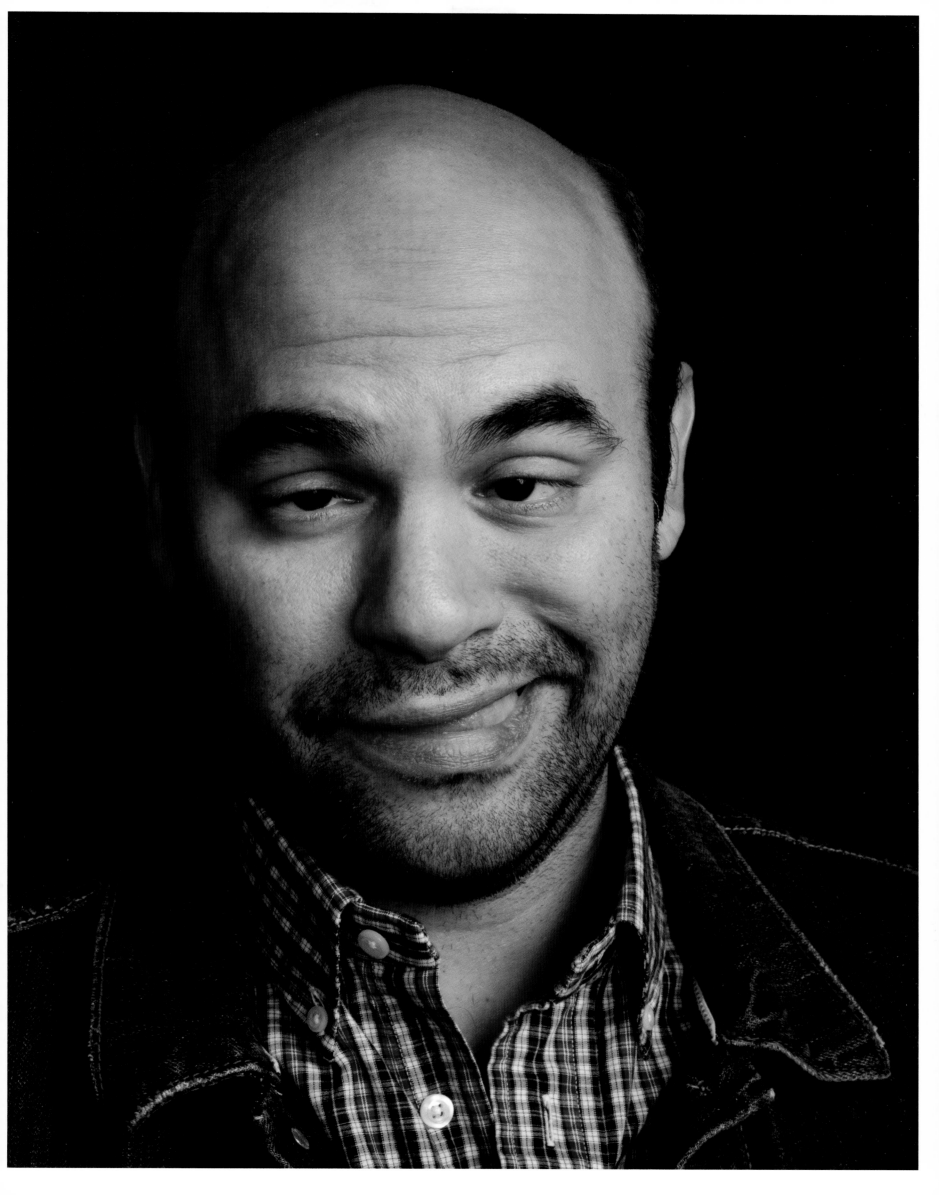

I grew up listening to stories. They fueled my imagination + led me to the theatre, when I got to be part of passing it on. Let's Pay it forward

Wendie Malick

WENDIE **MALICK** / ACTRESS

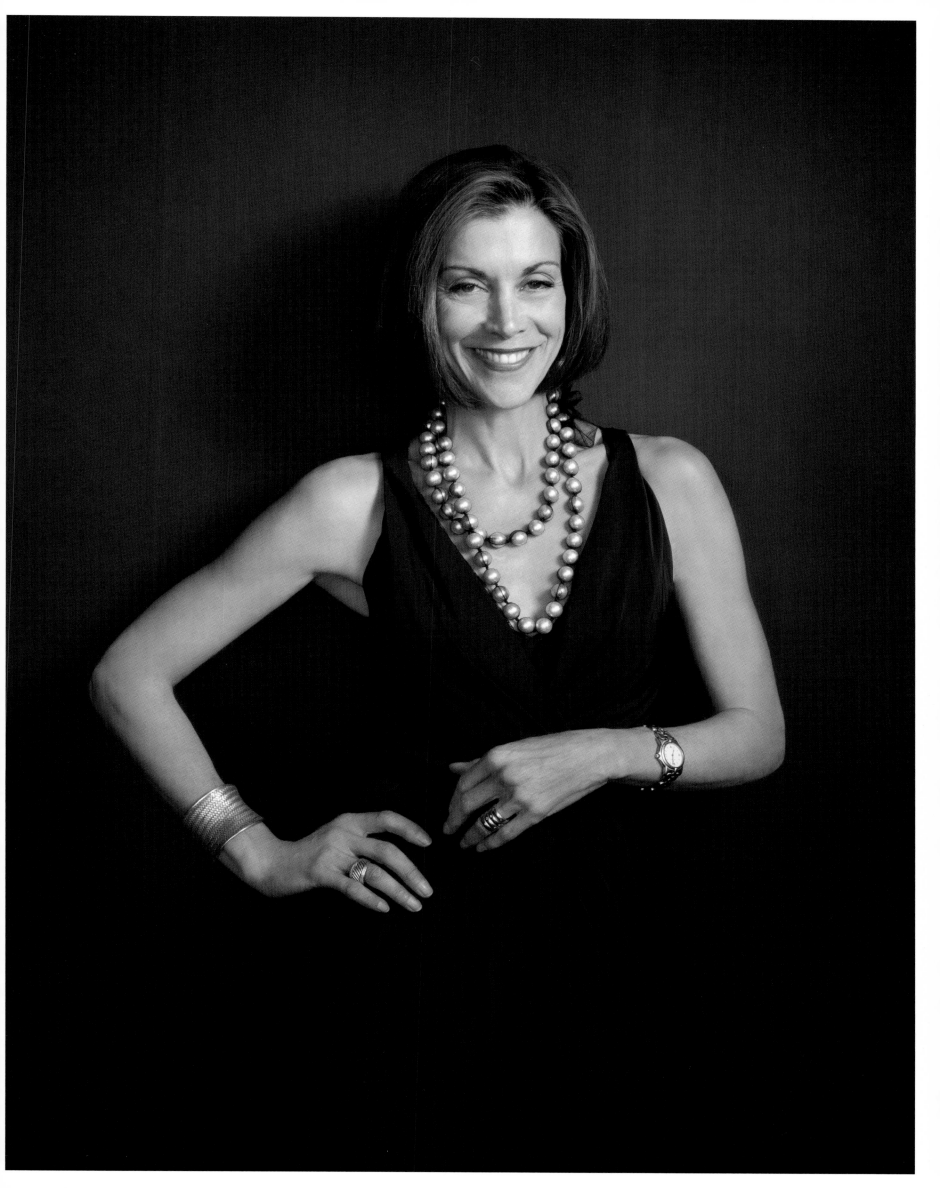

"Aliens in America" was a series about a young Pakistani Muslim foreign exchange student named Raja, who comes to live with a Middle American family.

A poignant comedy, that came at a poignant time, it examined existing stereotypes and relations between the United States and the Muslim world. At times sharply satirical and provocative, at others charming and endearing, it was, at its heart, a story about two young men, from worlds apart, and with seemingly nothing in common, who develop a wonderful friendship.

The show, while seeking primarily to entertain, was also a show I believed that had the potential to leave its viewers asking questions - about themselves and their perceptions about those they deemed as being different. I felt a genuine sense of pride and privilege to be a part of a television program with a voice, a conscience, with something to say.

After wrapping the series, I was invited to speak at a Muslim convention in Long Beach, California. As a non-Muslim, I was both intrigued and anxious to hear the response from the Muslim community. And more than two years on, one memory of a mother coming up to me stands alone, and her words have, to this day, remained with me.

She said, "Thank you for your show. We all enjoy it so much. I want you to know it has really made a difference in my son's life. He is a first-generation American Muslim, and in the aftermath of September 11th, it hasn't been easy for him. He has been ostracized for his beliefs, not accepted because of who he is. And then your show came along. And his peers began realizing that they weren't that different from your character Raja, and that he was not different from Raja, and that after all, perhaps they weren't that different from him. And after that, things started to change, you know?"

The arts can have the most profound and powerful effect on people, resonate with them in a lasting way, truly affect change in society. Their importance cannot be overstated, and so we, in turn, as artists, must embrace the idea that what we do is important. That it matters. For our work, our contribution, our commitment to the development of the arts, is more than a responsibility - it is our duty.

ADHIR **KALYAN** / ACTOR

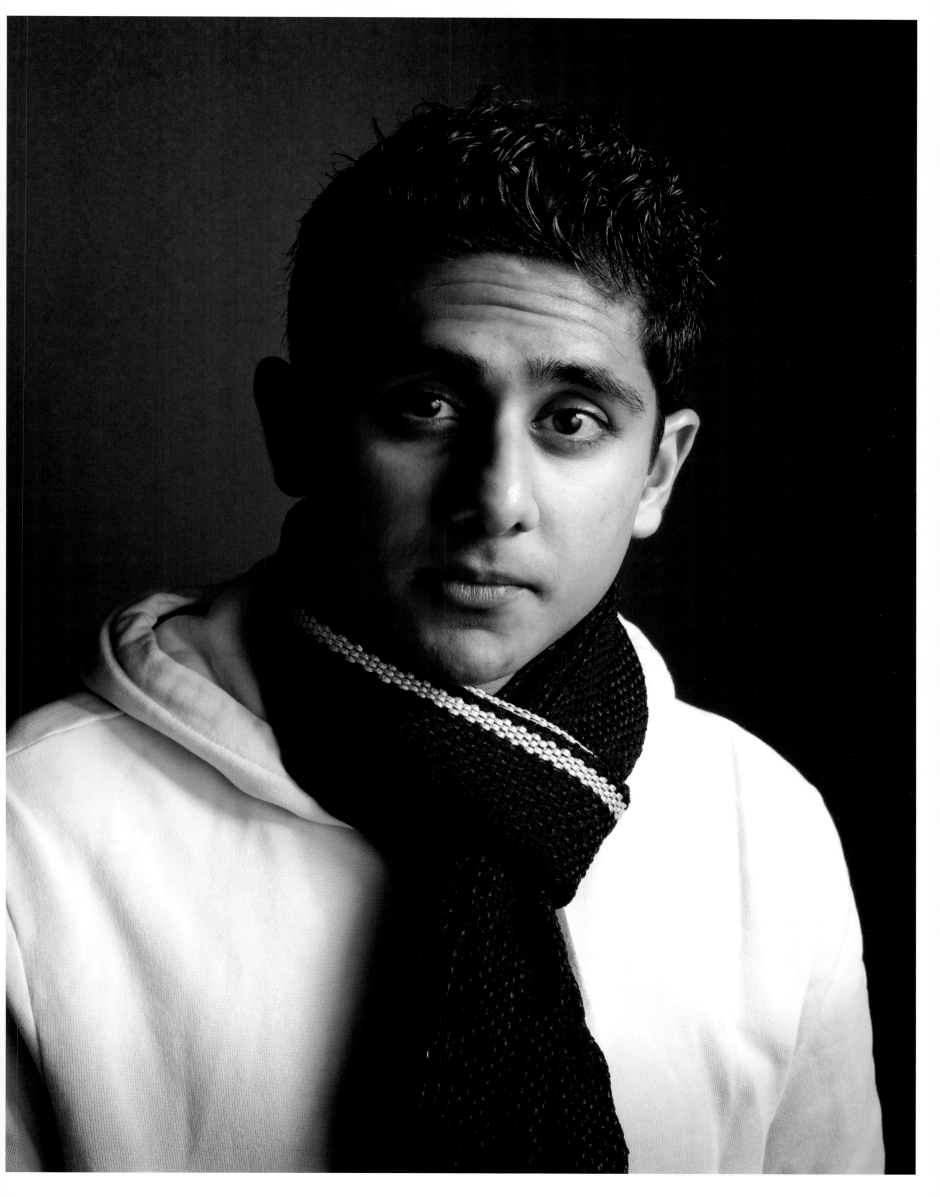

Art !! :)

News to me :

Passion

Dedication

Love

Art gave me a reason to be.
I can't see myself without it.
Gosh What Would be like Without
ART ??

Love Gilles Marini.

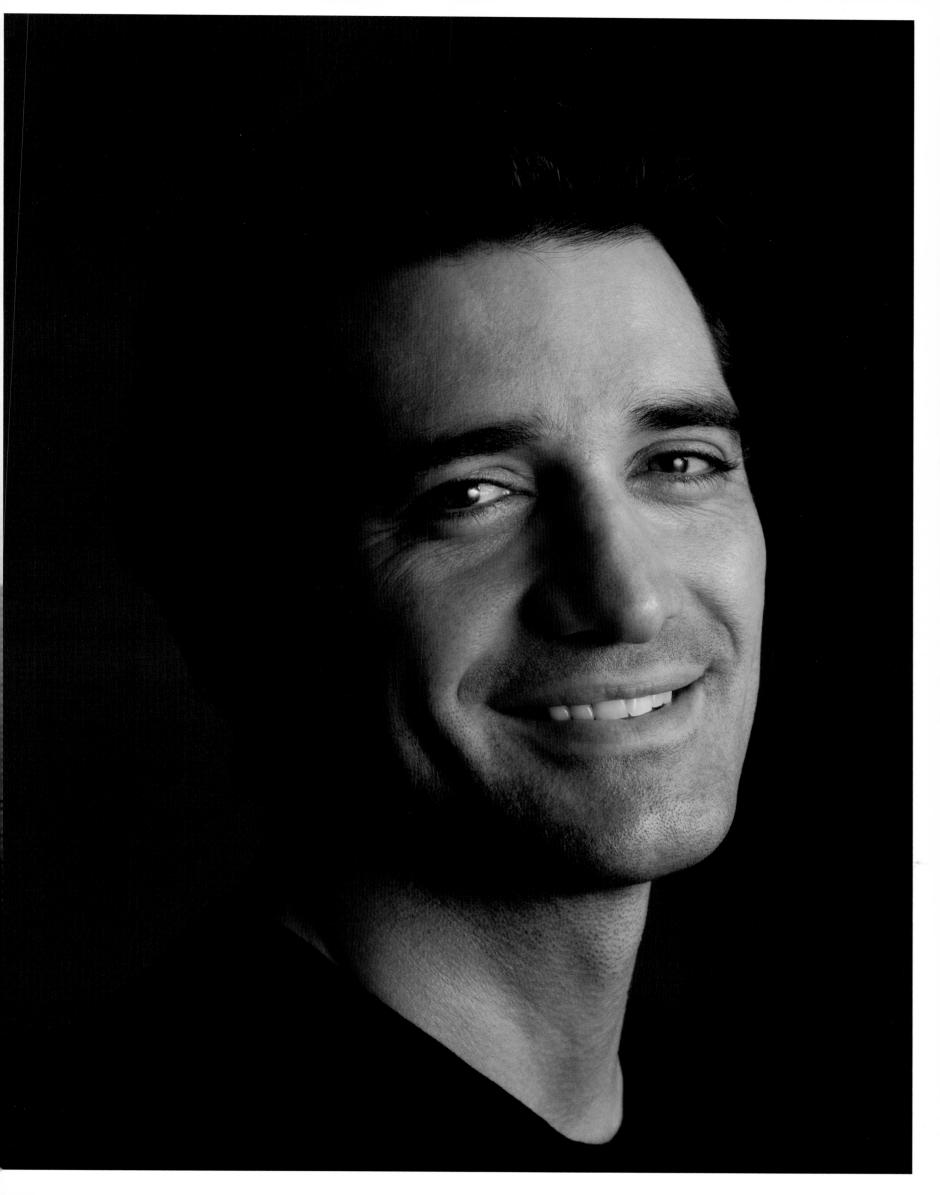

Art is the strongest
gift that the human race
can have. it is music, Painting,
Sculpting, dancing, Acting and
more importantly Art represents
the true essence of an
individuals Heart. Art is
Love
TAMALA JONES

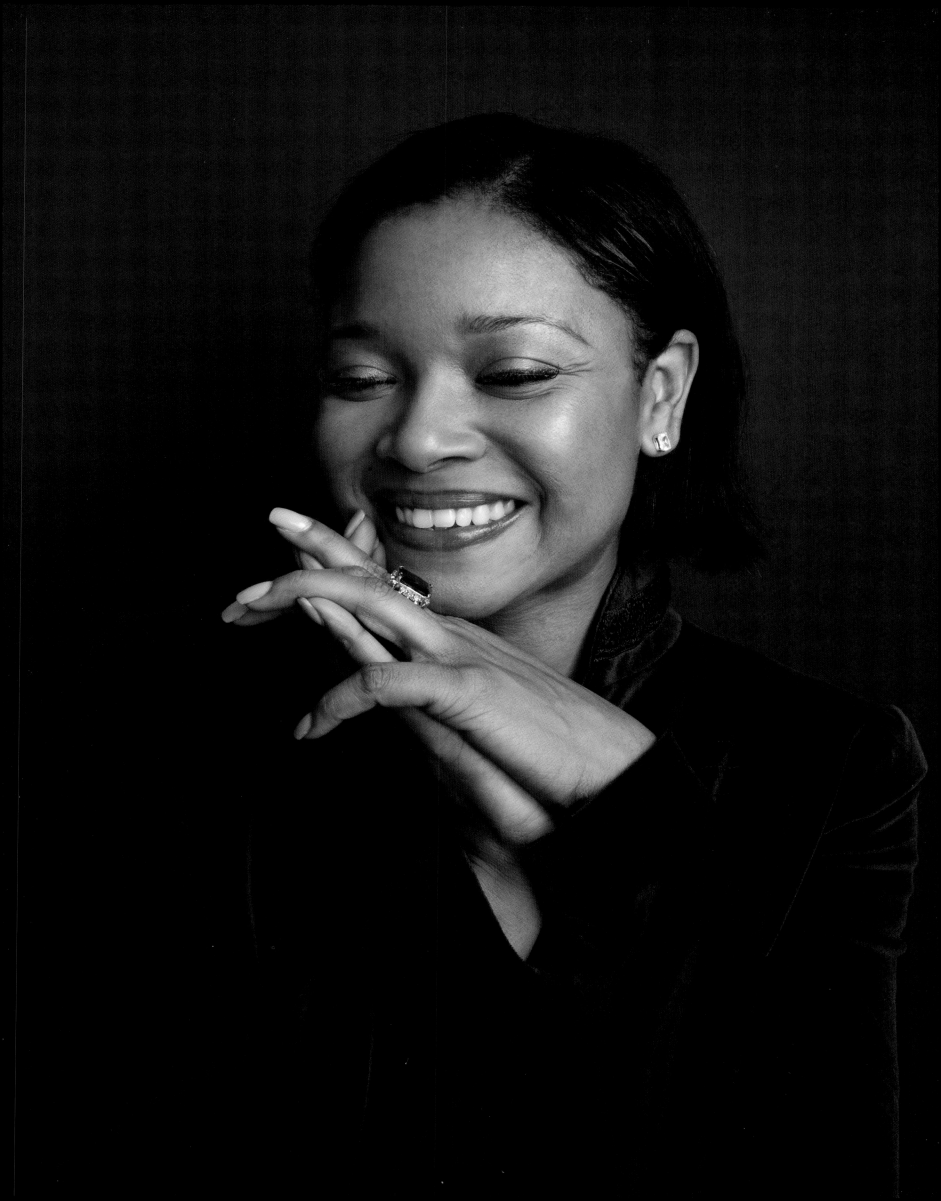

We are here to Create!
It cannot be denied that
Art is everything and everything
is Art!!

Harry Hamlin

HARRY **HAMLIN** / ACTOR

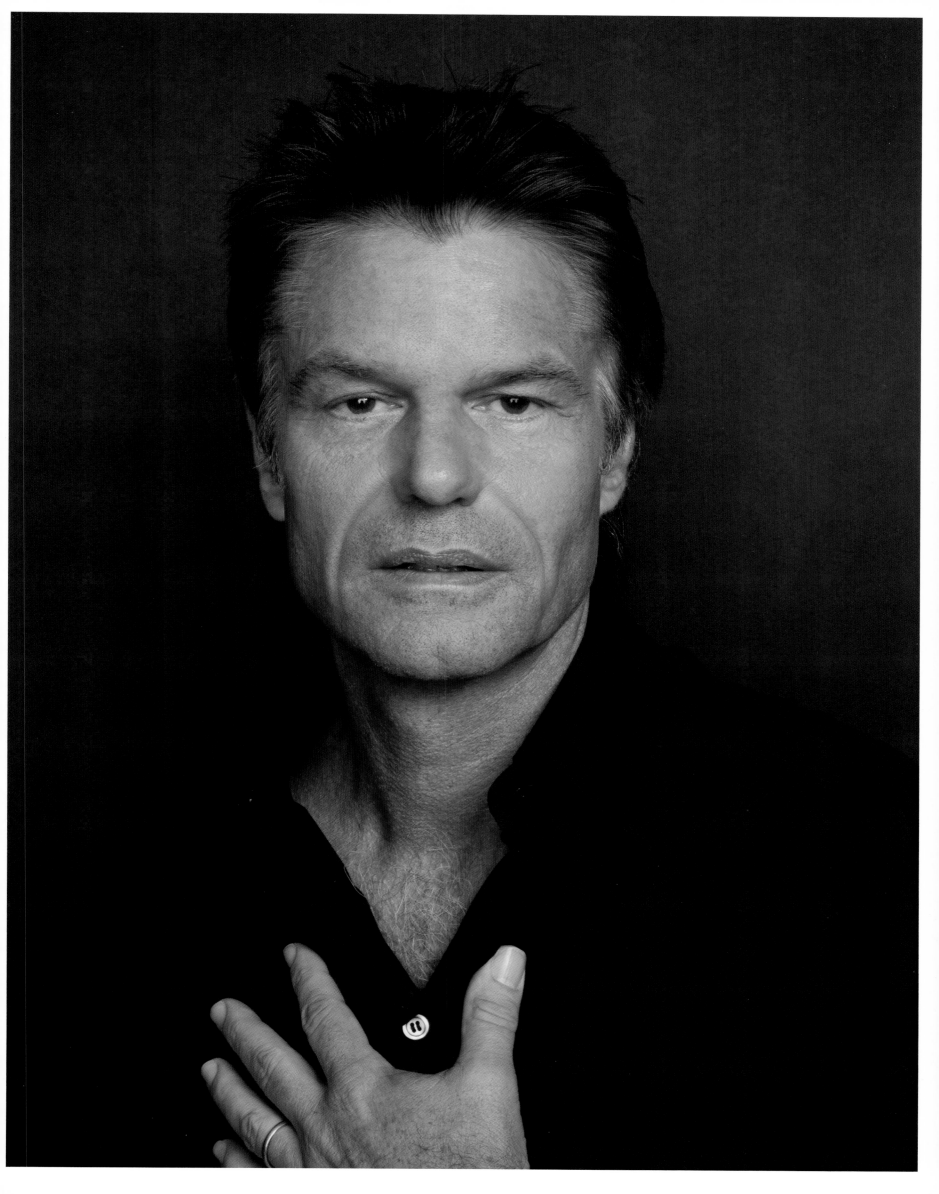

Art is the realization that
we all have similar life
expressions/experiences.
I use my art to connect with
other people.
I make myself vulnerable through
my artistic expression.

♡ ♡ ♡ ♡ ♡ ♡ ♡ ♡ ♡ ♡ ♡ ♡ ♡ ♡

Noureen   DeWulf

sometimes im funny
sometimes im not
both are OK

ART is Necessary.
"The TAQWACORES" 2010 SUNDANCE

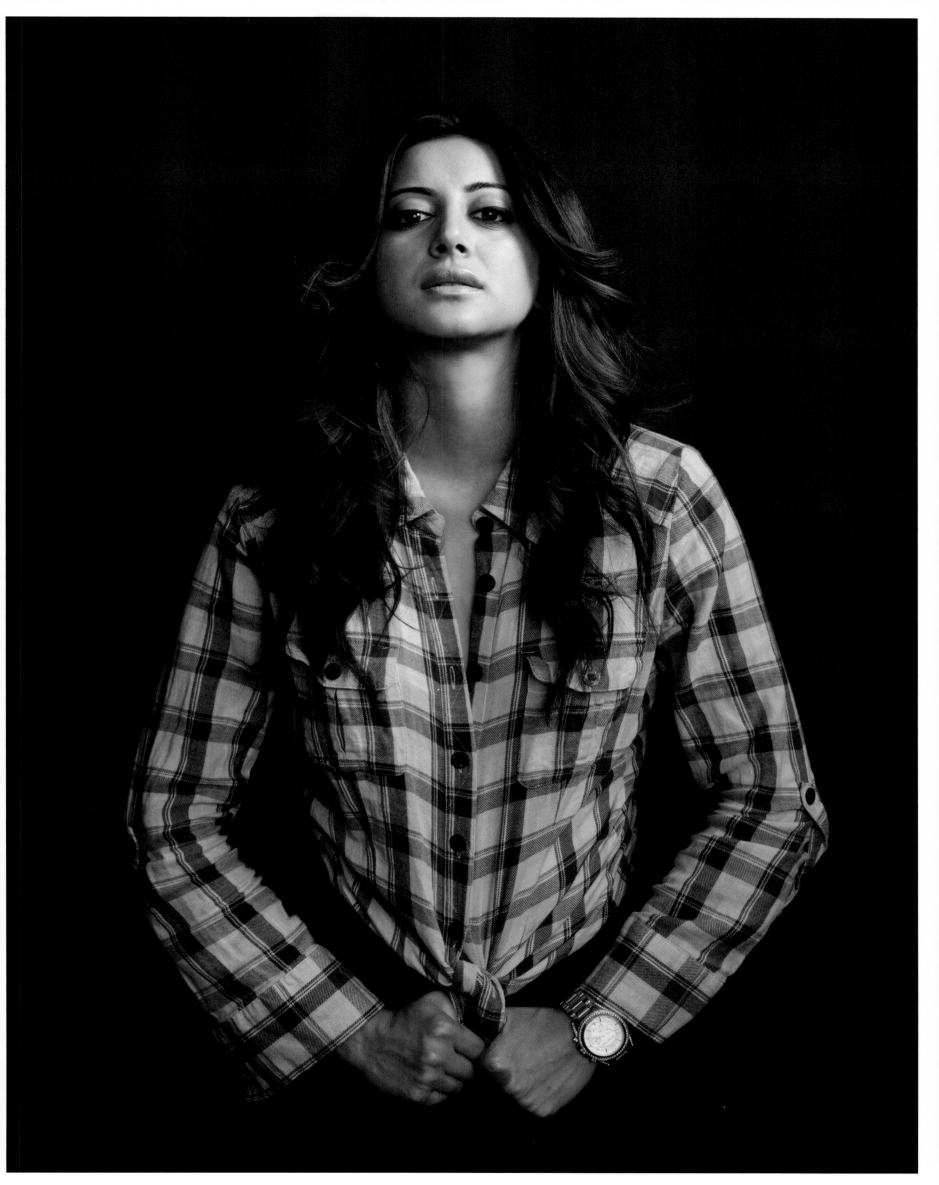

Never give up
on your dreams -
unless they're
really stupid.

♡

*Laura Silverman*

LAURA **SILVERMAN** / ACTRESS

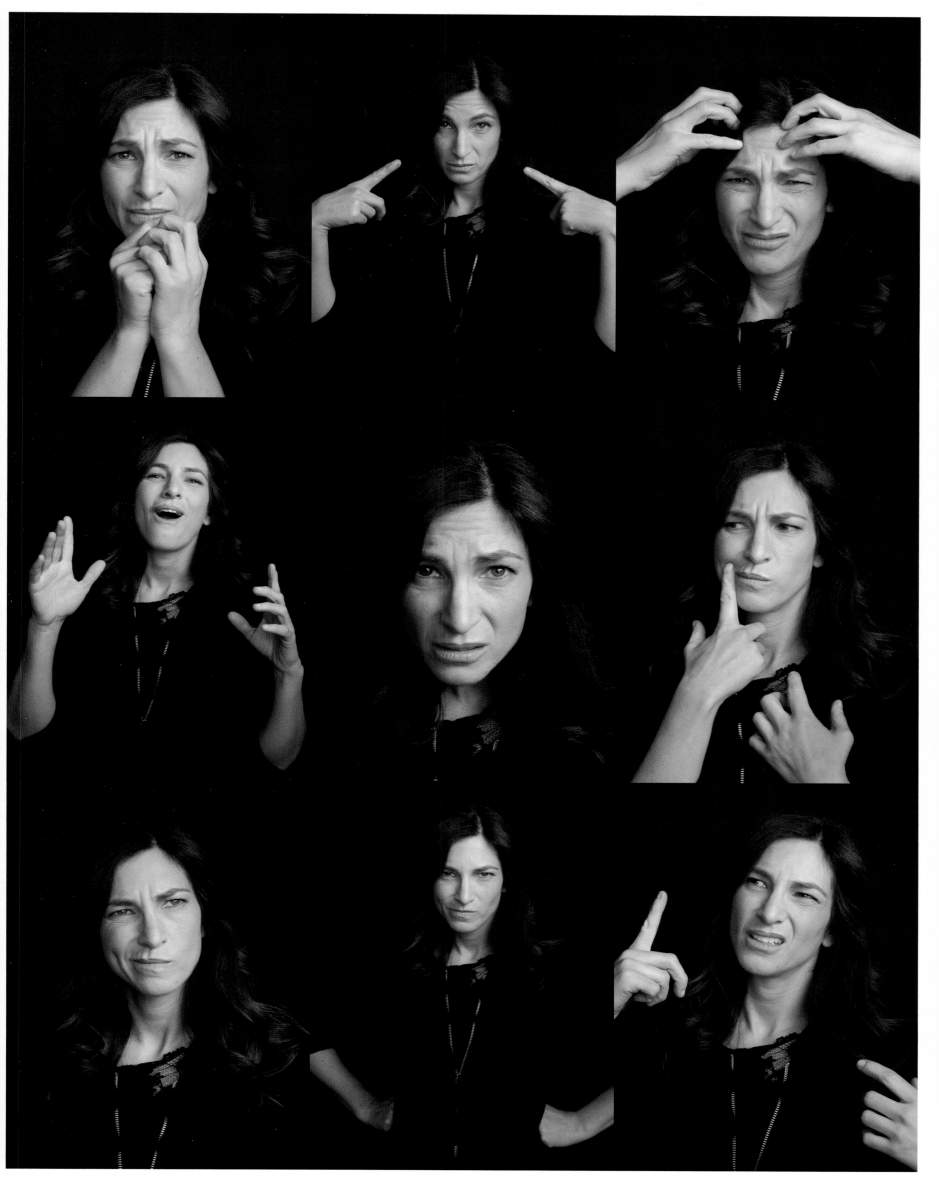

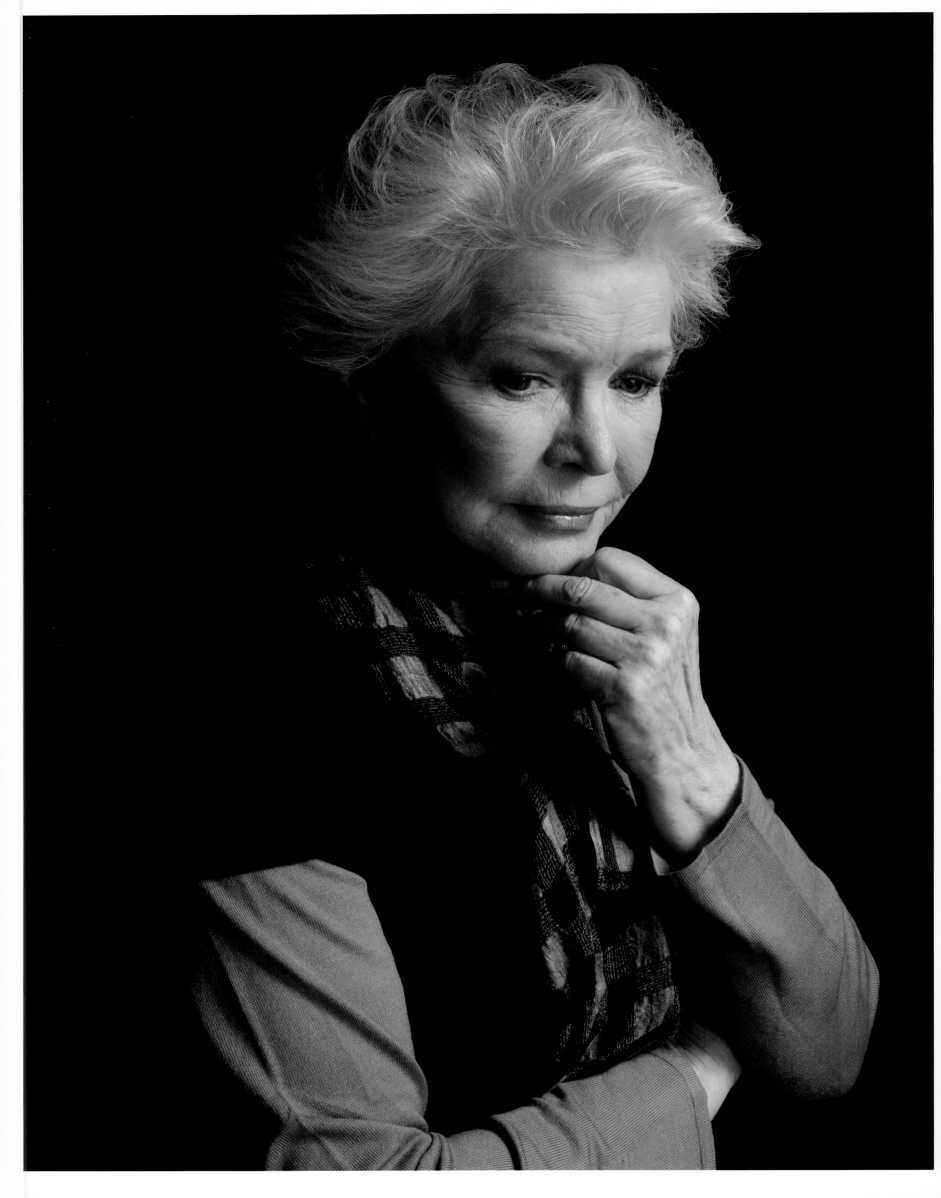

It is through the arts that the generations speak to each other. I've visited the Netherlands of the 17th century through the vision of Rembrandt, heard the cawing of the black crows flying over the cornfields of France as seen on Van Gogh blazing canvases. I've stood on the spot in Prague where Mozart stood when he first conducted the immortal "The Magic Flute."

I've sat in a theater in England listening to an informed audience chuckle at an actor's choice to play a particular moment which they can appreciate because they've seen ten or twelve other actors in the same Shakespearean role.

I can still remember the shock I felt the first time I saw Brando on the screen and knew I was seeing something more vital and real than I'd ever seen on any screen before. I've been thrilled by the extraordinary genius of Baryshnikov and been deepened by hours spent with Rilke's poetry and Emerson's Essays.

All of this has heightened my sensitivity, developed a sense of beauty, awakened my mind and deepened my appreciation of the human experience.

It is a shame that of all the civilized countries of the world, the United States supports the arts least of all. For instance the little country of Finland spends $98 per person for arts support while we spend only $6.00 per person.

We are cheating ourselves and our fellow Americans of the enrichment of our cultural heritage.

Ellen Burstyn

ELLEN **BURSTYN** / ACTRESS

To whom it may Concern:

Which came first ... Music or the dancer. Laughter or the comedian. The writer or the actor -- The canvas or the painter. The spirit or the religion.

Does it matter?

You enjoy both. And both enjoy being enjoyed. It is us that is I that is we, that is me!

*Eddie Griffin*

EDDIE **GRIFFIN** / ACTOR / COMEDIAN

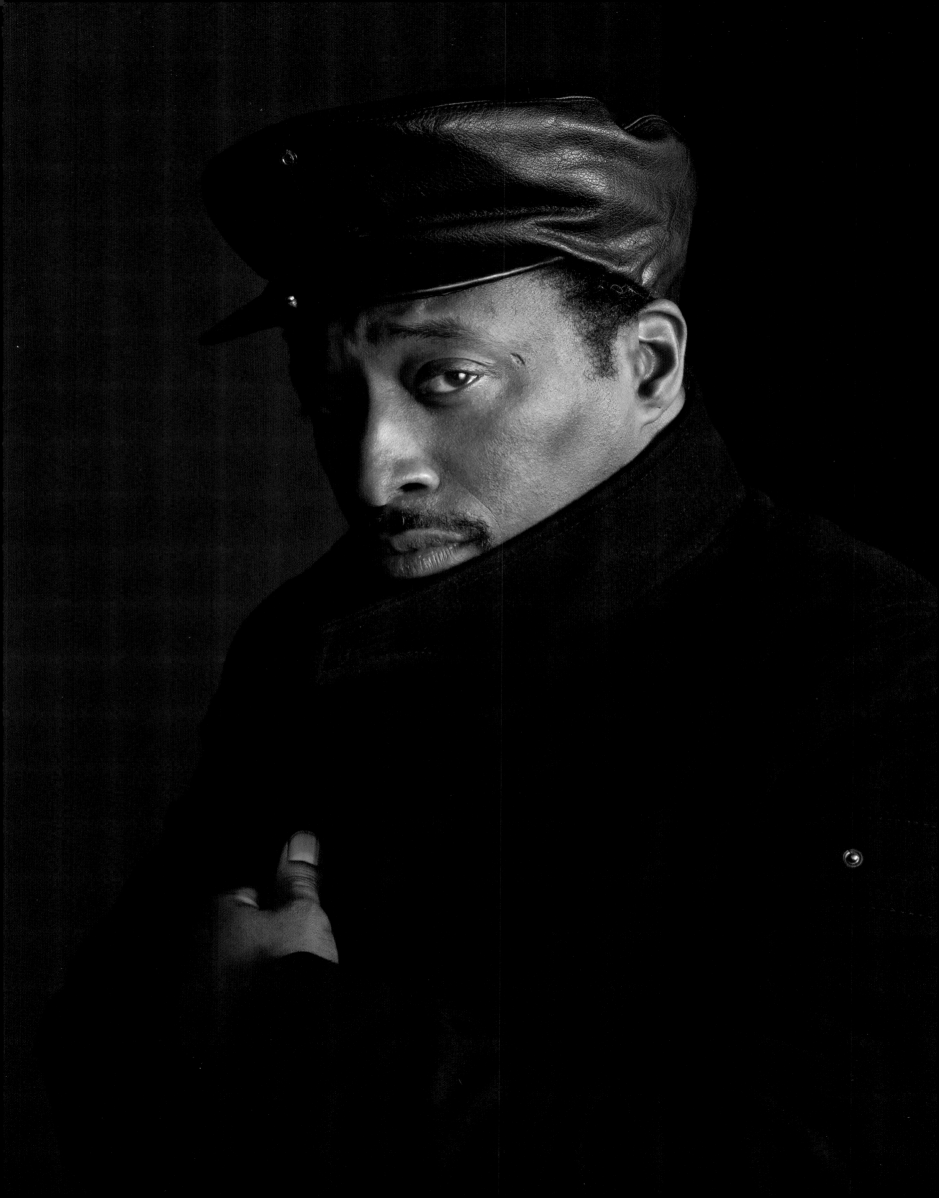

When you give a child a paintbrush, a camera, a pen, a stage, a microphone, you are empowering them with the ability to use their imagination to create a brighter future.

Art is powerful. Art is one of the most successful teaching methods. It strengthens problem solving and critical thinking skills. It teaches students to be more tolerant, and embrace their individuality.

The simple act of self-expression lays a foundation for children to grow up to be strong, self-possessed and tuned in to themselves and the world around them.

Art is all about taking big risks, making bold choices, and voicing your opinion. What better educational tool can you offer a child as they venture out into the world?

As Bertolt Brecht once said,

"Art is not a mirror held up to reality, but a hammer with which to shape it."

Long Live Arts Education!

♡ Camryn Manheim

CAMRYN **MANHEIM** / ACTRESS

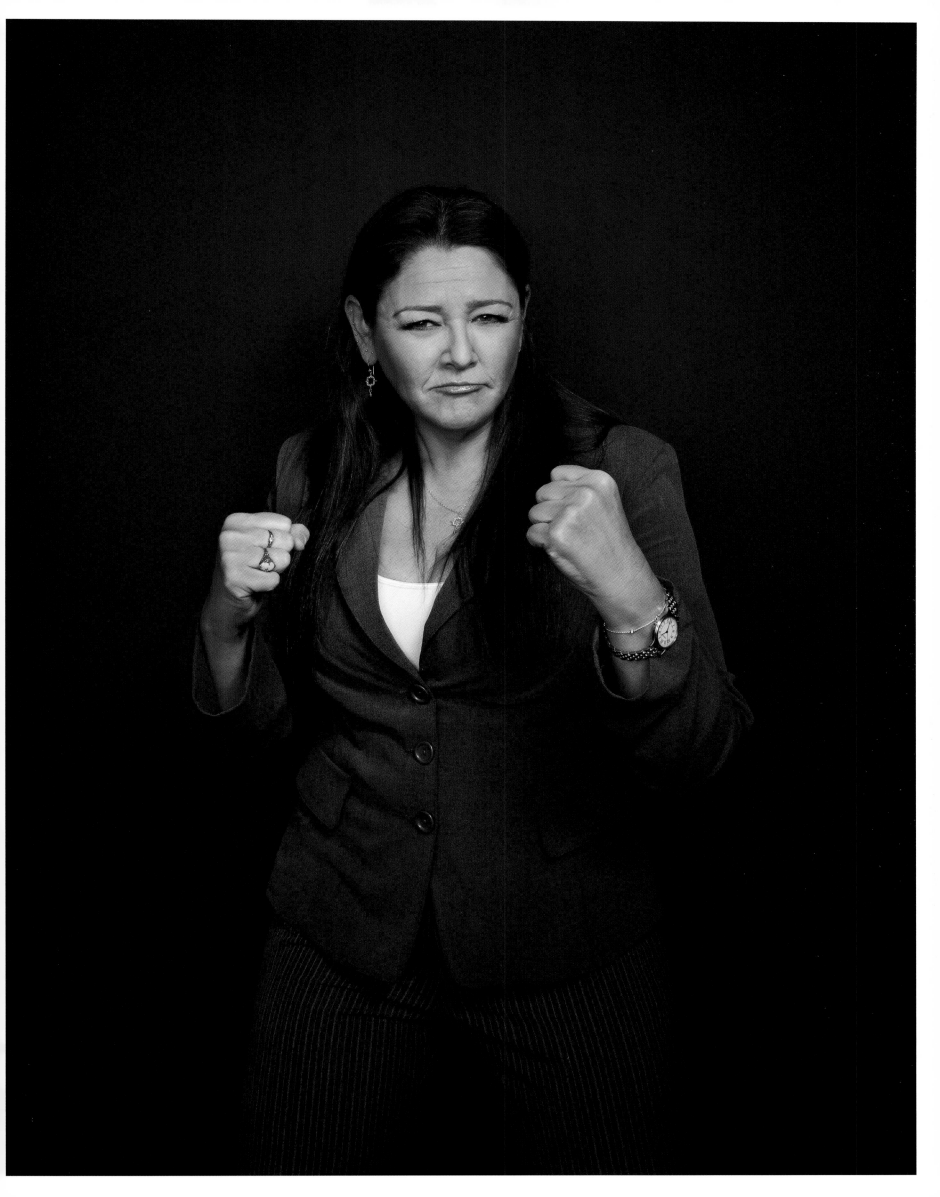

MUSIC SAVED MY LIFE,
ART LET ME LIVE IT.
AND THAT POTENT
HEADY MIX OF THE TWO,
THAT ELIXER OF SOUL
AND MAGIC HAS THE
POWER TO TRANSEND
TIME, LANGUAGE, CULTURE
AND ALL HUMAN UNDERSTANDING.
IT'S AS CLOSE AS I HAVE
EVER COME TO GOD
AND MAGIC.

PURE JOY, NO FILLER,

*Siedah Garrett*

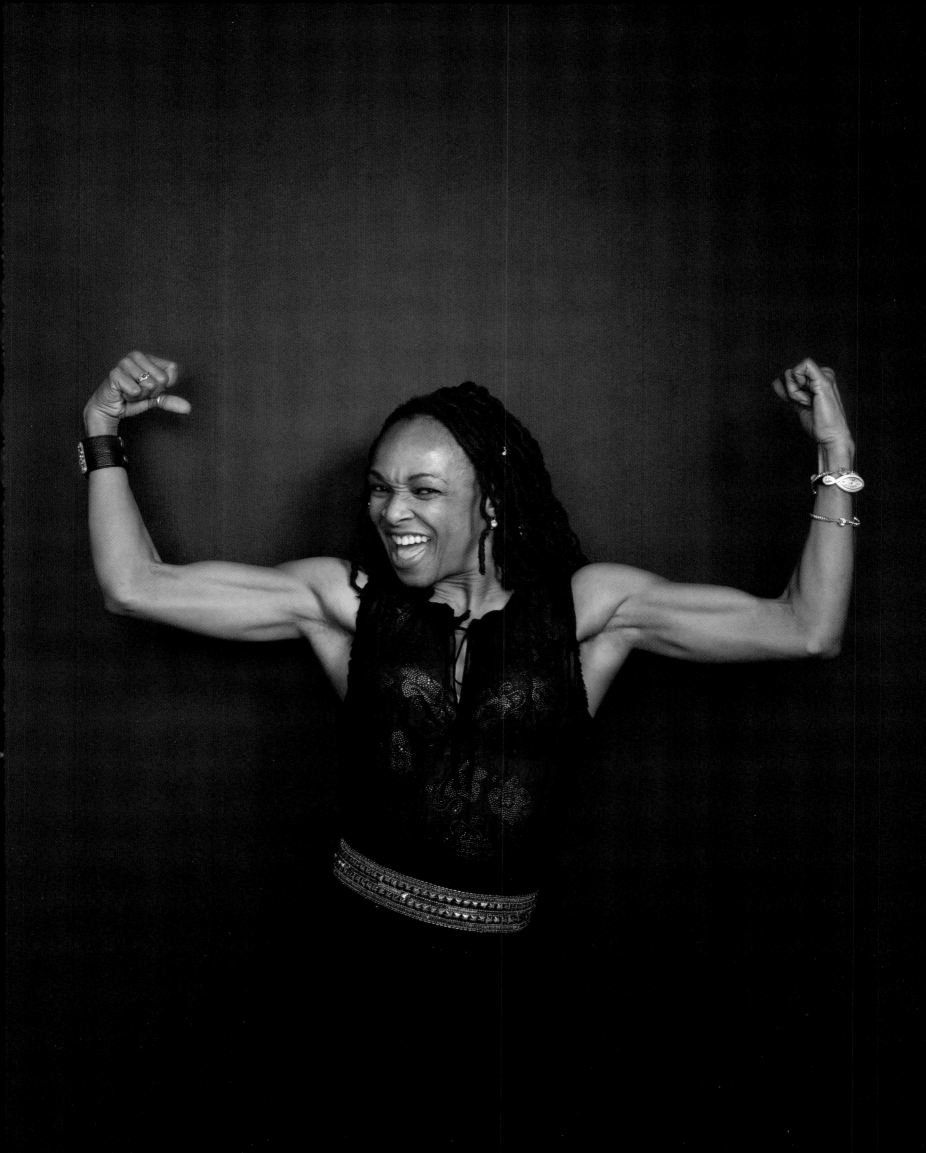

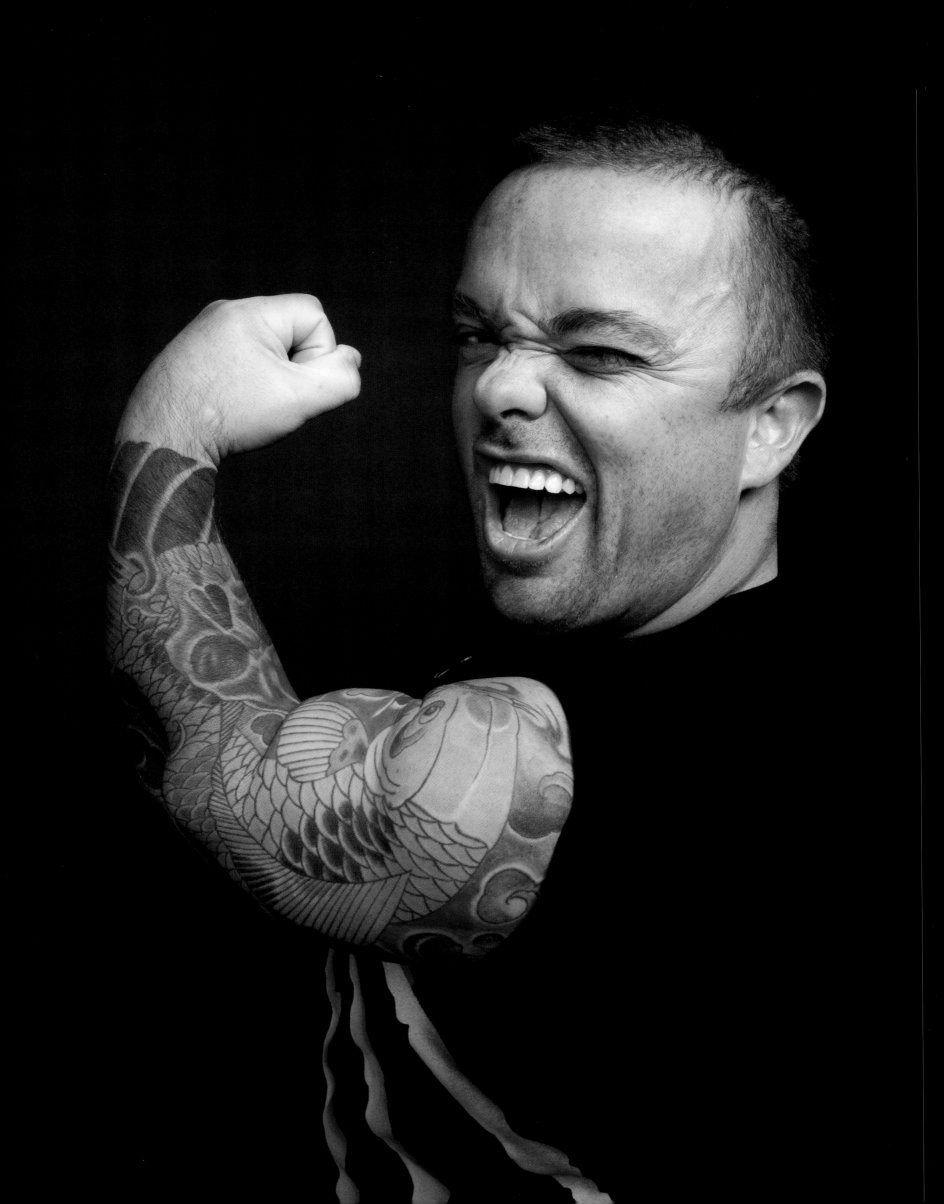

Art is Part of
EVERYTHING IN MY
LIFE!
From

T Shirts   SKATEBOARDS

TO THE INK
ON ME!

JASON **ACUÑA** / ACTOR

Growing up I grew fond of
movies at an early age. Growing
up in the Bronx I kinda stayed
to myself mainly because I
was afraid of getting in trouble.
Everyone I knew always got
in trouble and I know that
wasn't me. I wanted to be in
the films I watched or something
like it. I also loved music
and would immitate M.J.
so much so that I decided at an
early age I wanted to be
an entertainer and stayed
away from the street life.
which I felt saved my life
given where I grew up.
So I would say the Arts
is the soul through which I
will continue to shine my light.

Quinton
Aaron

QUINTON **AARON** / ACTOR

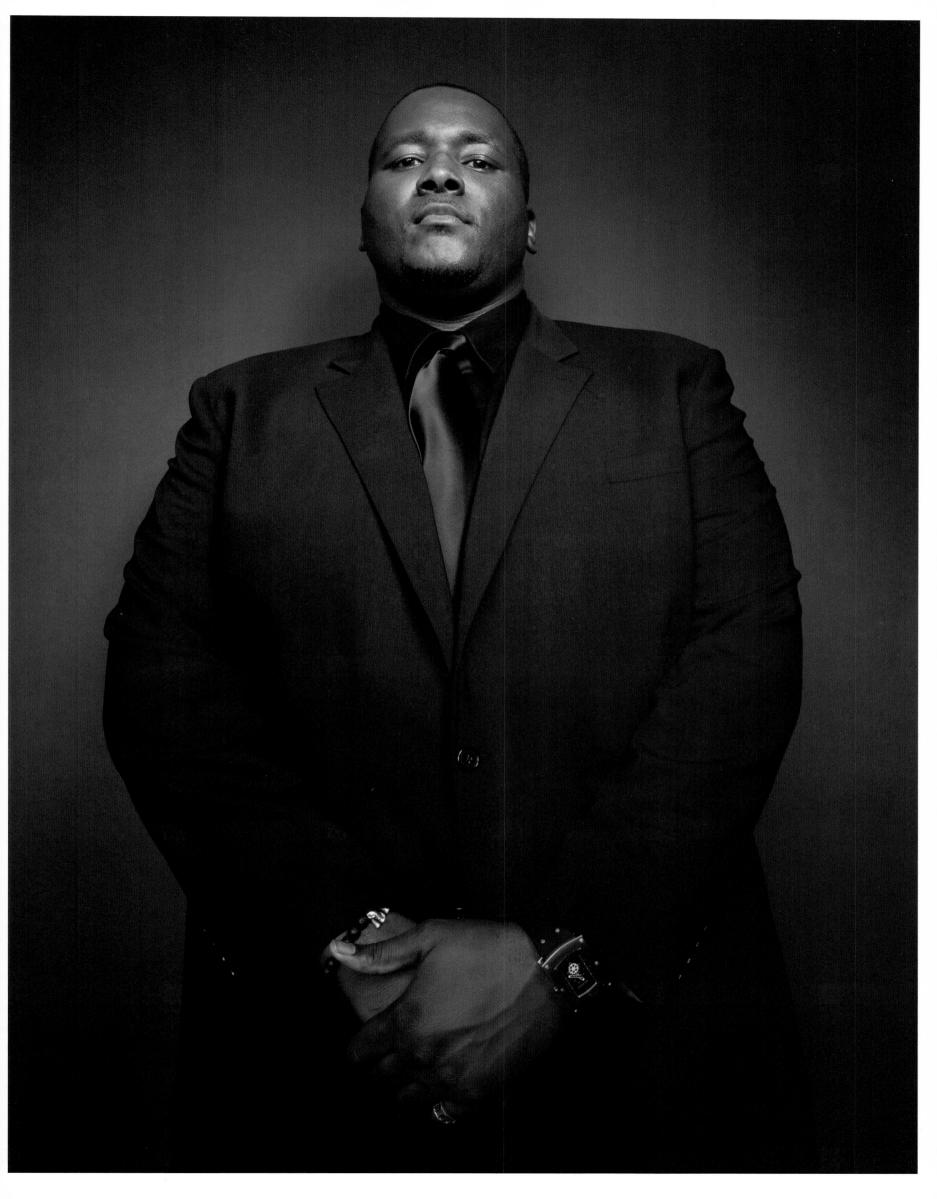

Life is The Sum TOTAL
of The Choices you MAKE...
I KNEW AT the Fresh
Age of 10 That I WANTED
To be AN ACTOR! AND, I've
Never Looked Back!

IT is, and will ALWAYS bE
About The WORK!

*Dennis Haysbert*

DENNIS **HAYSBERT** / ACTOR

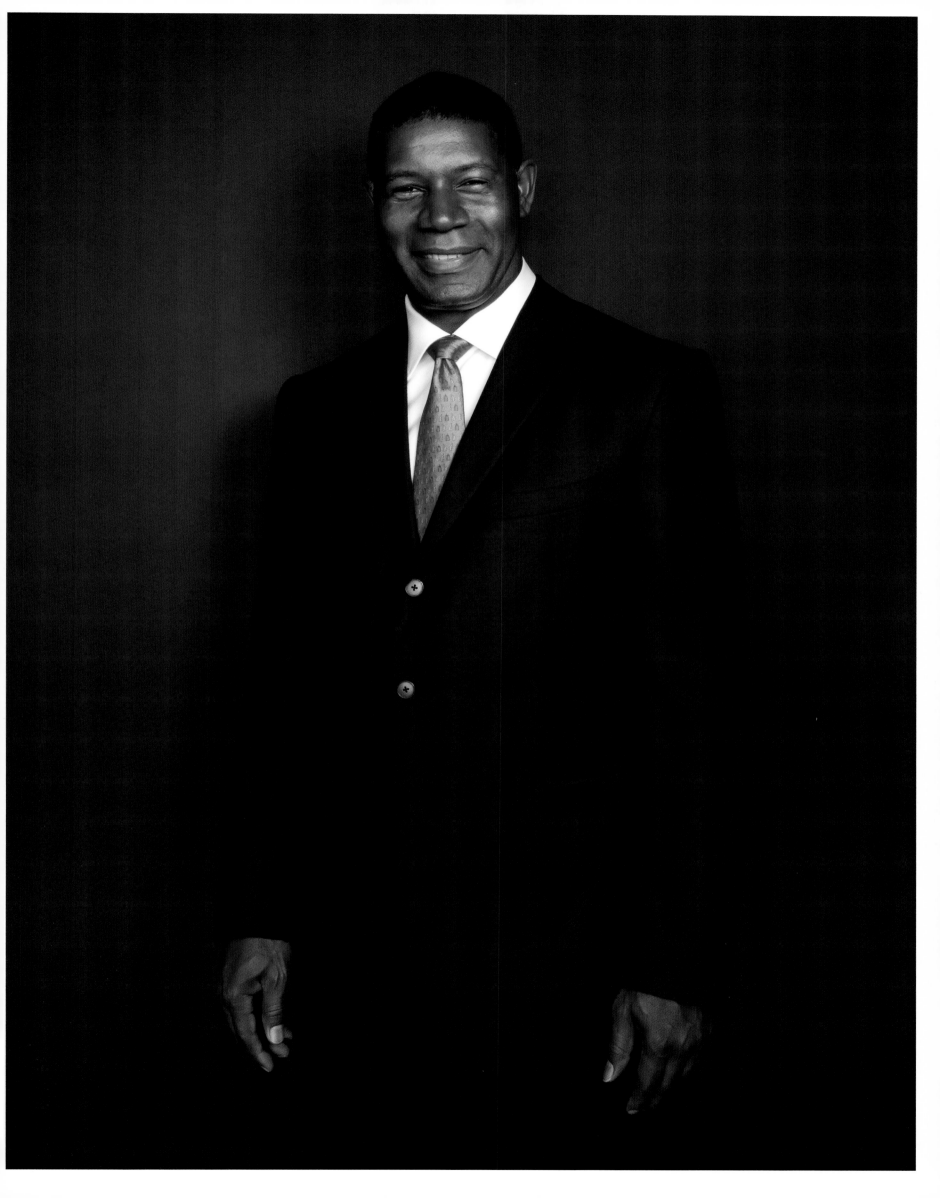

ART

FOR LOVE
FOR CONNECTION
FOR GIVING AND RECEIVING

AND TO KEEP THE CHILD
IN US ALIVE
     IT'S WHO WE ARE

*Rick Yune*

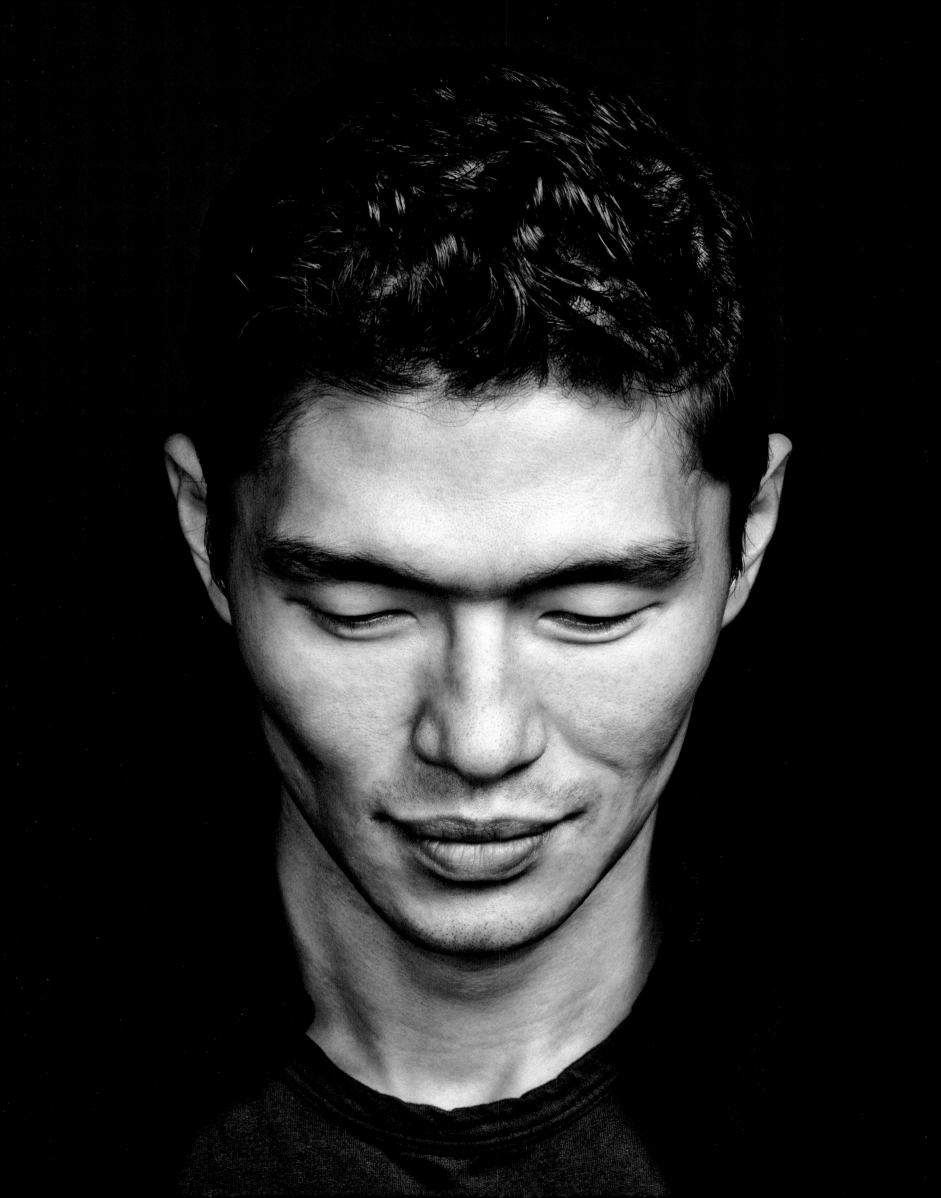

Maybe Art is the expression of the adventure of being alive?

It has certainly inspired me and given me courage in my own adventure.

Is that what it does for everyone?

TY **BURRELL** / ACTOR

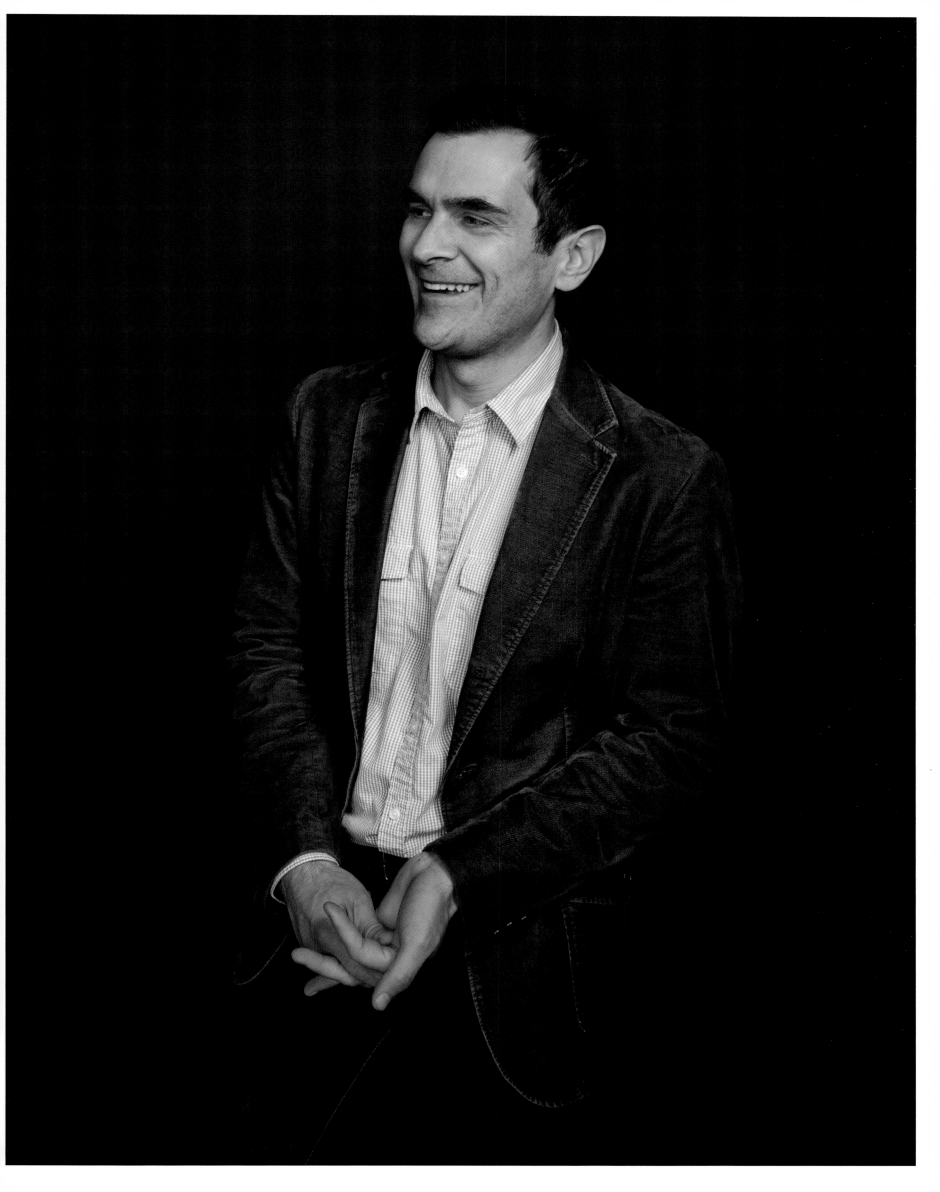

Art demands a connection. No matter how you like or don't like a painting, a piece of music, or a play, you react w/ your whole person - heart, soul, and brain. Science doesn't demand soul. Math doesn't require emotion. But the arts — you are involved. Even boredom, disgust, indifference. They are active reactions.

Art is sports for the soul

— Richard Kind

RICHARD **KIND** / ACTOR

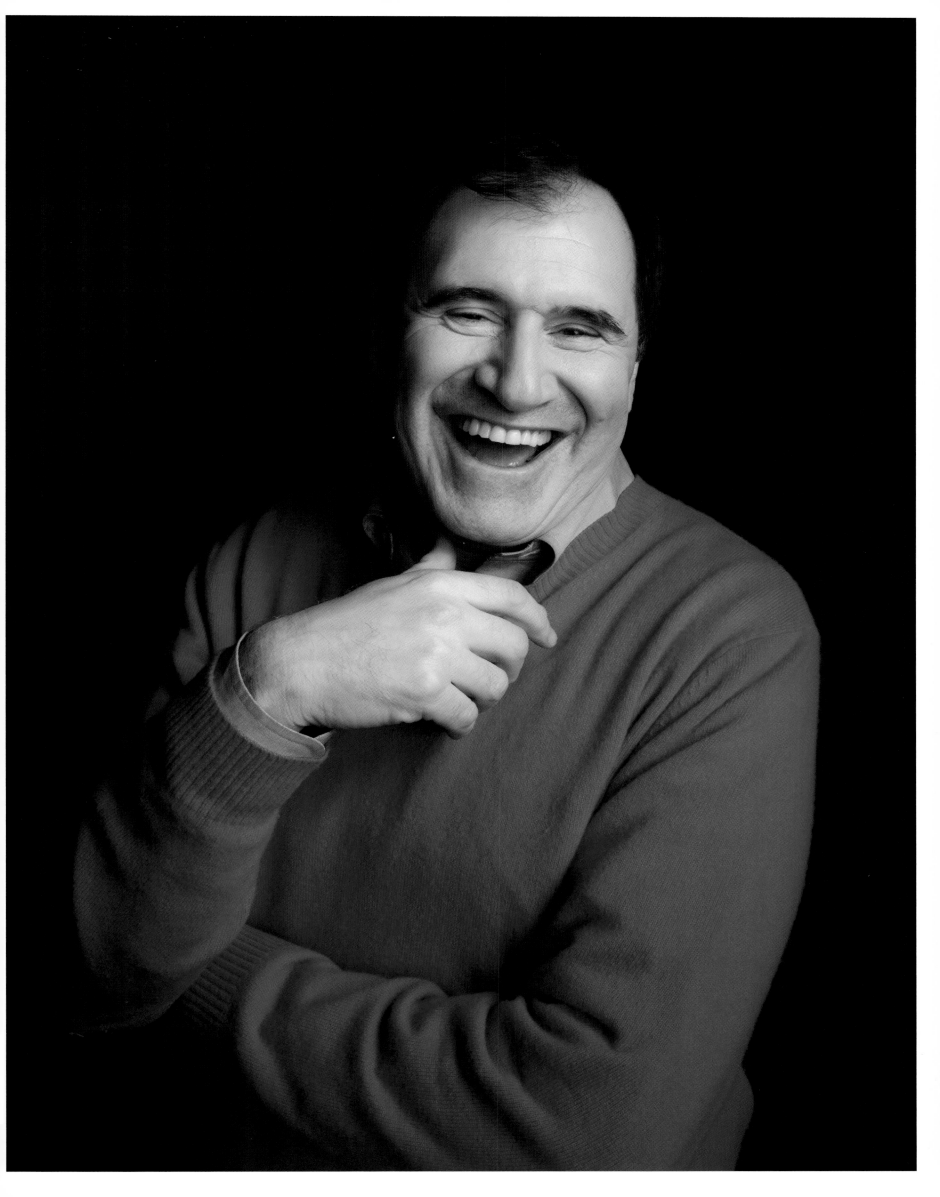

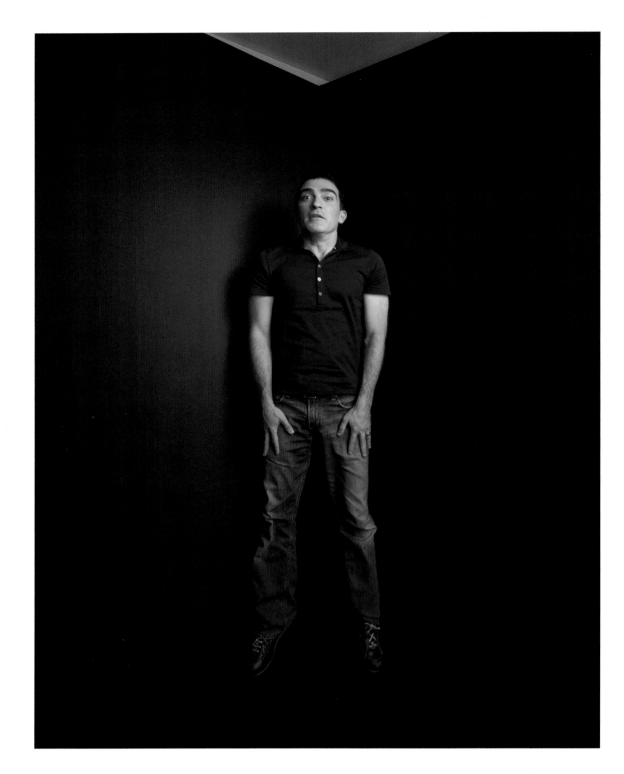

Art aligns us with
our innermost self.

—Patrick Fischler

PATRICK **FISCHLER** / ACTOR

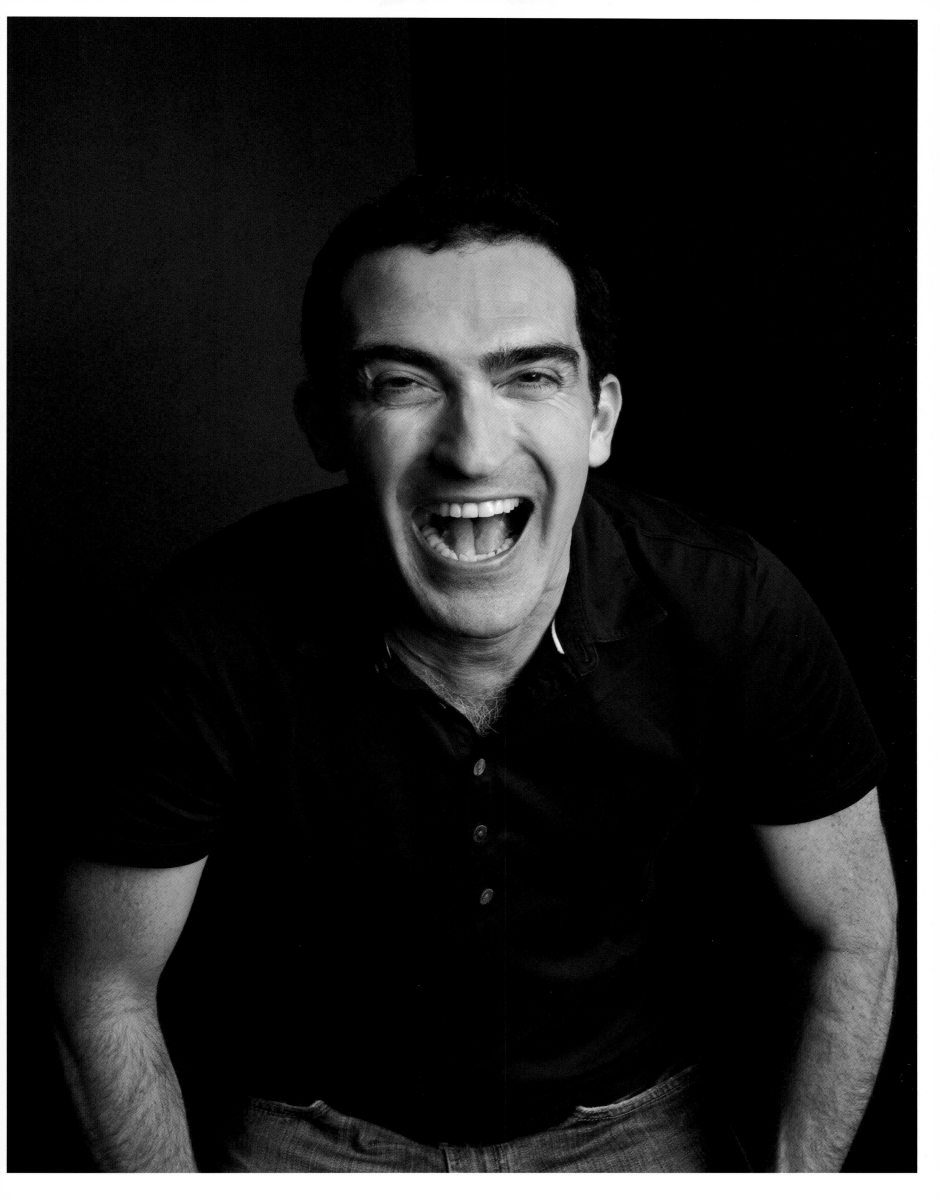

I would not be here today if Mrs Thompson, speech teacher at Washington Junior High in Ottumwa Iowa had not pulled me aside, after I'd acted out an assignment as Henry VIII of "Anne of 1000 Days" — given me a big hug (which I also loved because I was raised without a mother and she was a beautiful woman!)

And she said "You are good at this". "I've signed you up for the Drama Club."

Even though football players did not join the Drama Club I went... eventually winning state and Regional Competitions... which lead to today.

But it was that hug and "you're good" that changed my life.

Even though I was (a much thinner) Quarterback of the football team my coach, God Bless him, never wrapped his arms around me, pulled me into his ample breast and said "Arnold... you're good at this". That hug, that compliment, that moment changed the course of my life. Love

Tom Arnold

TOM **ARNOLD** / ACTOR / COMEDIAN

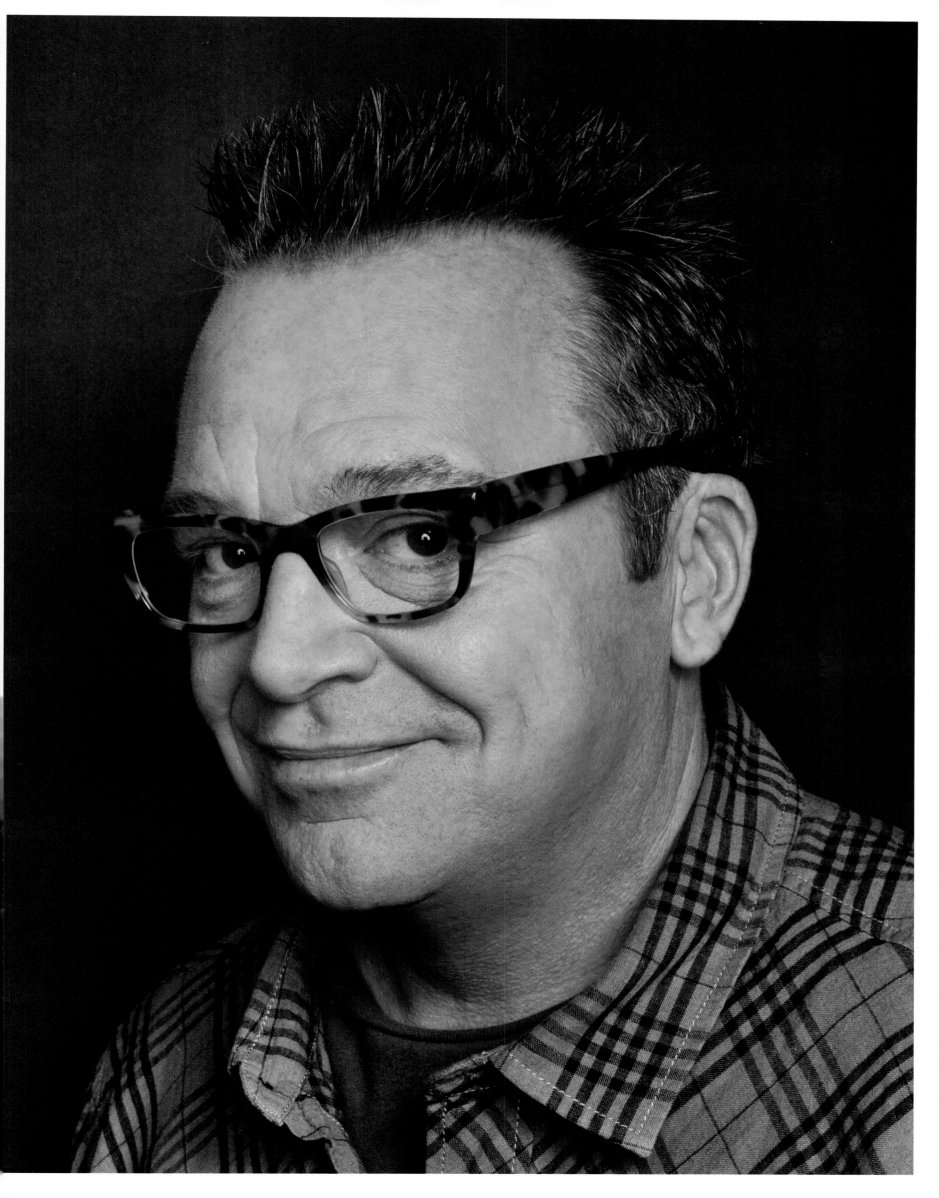

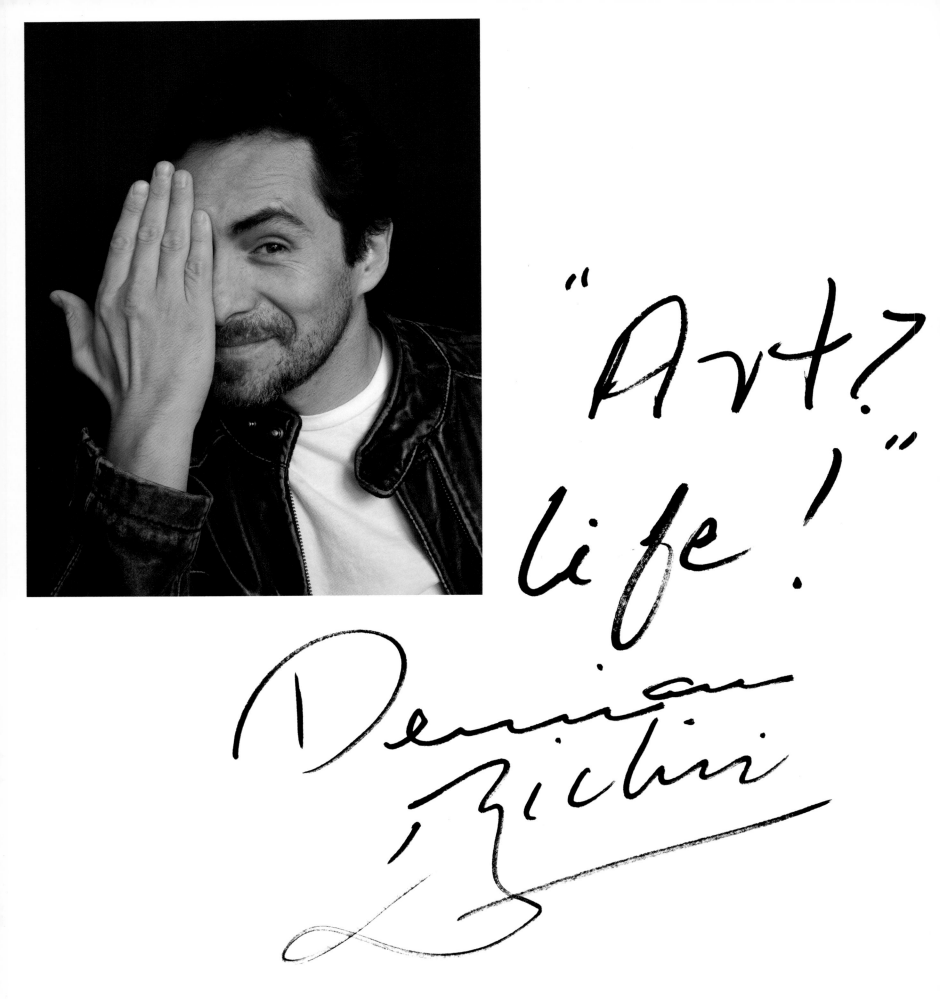

"Art?"
life!

Demián Bichir

DEMIÁN **BICHIR** / ACTOR

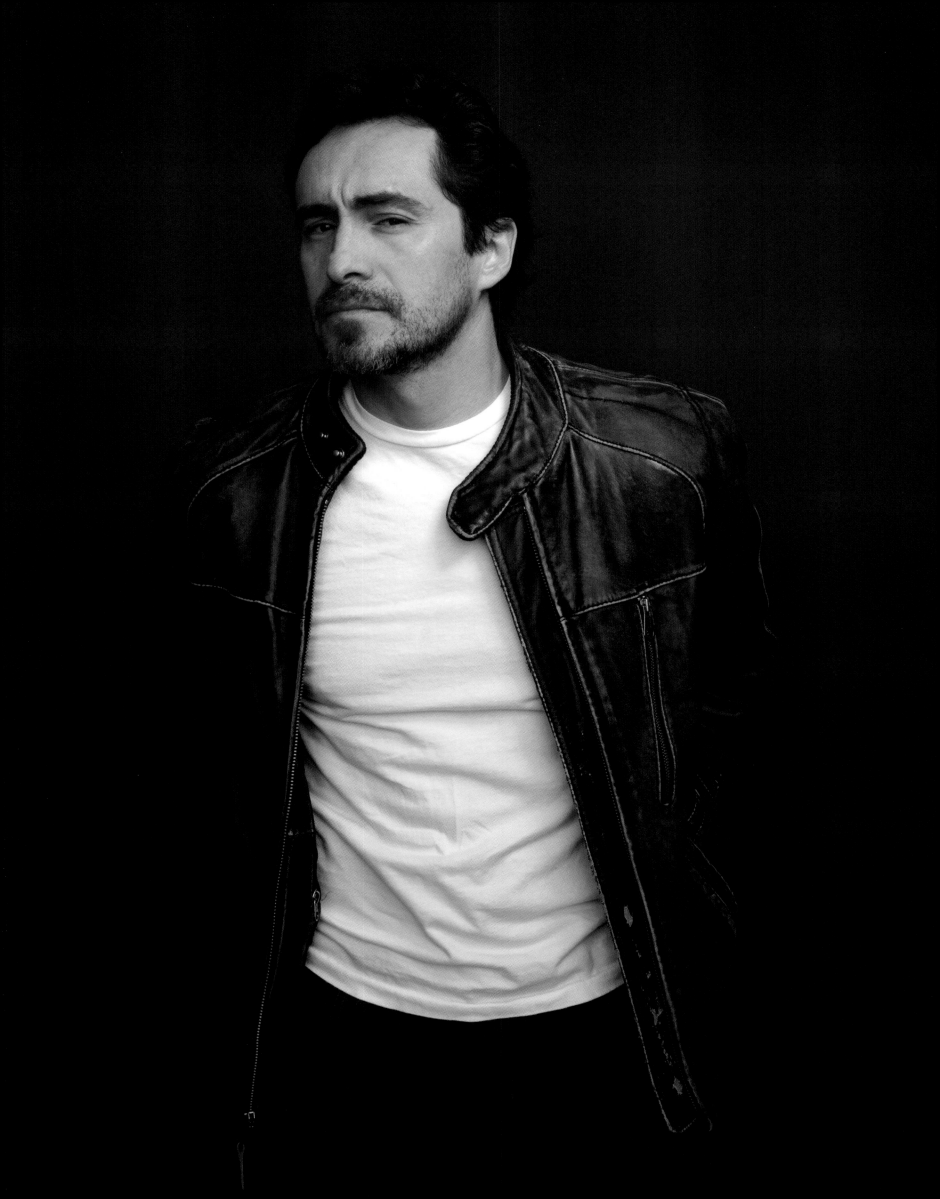

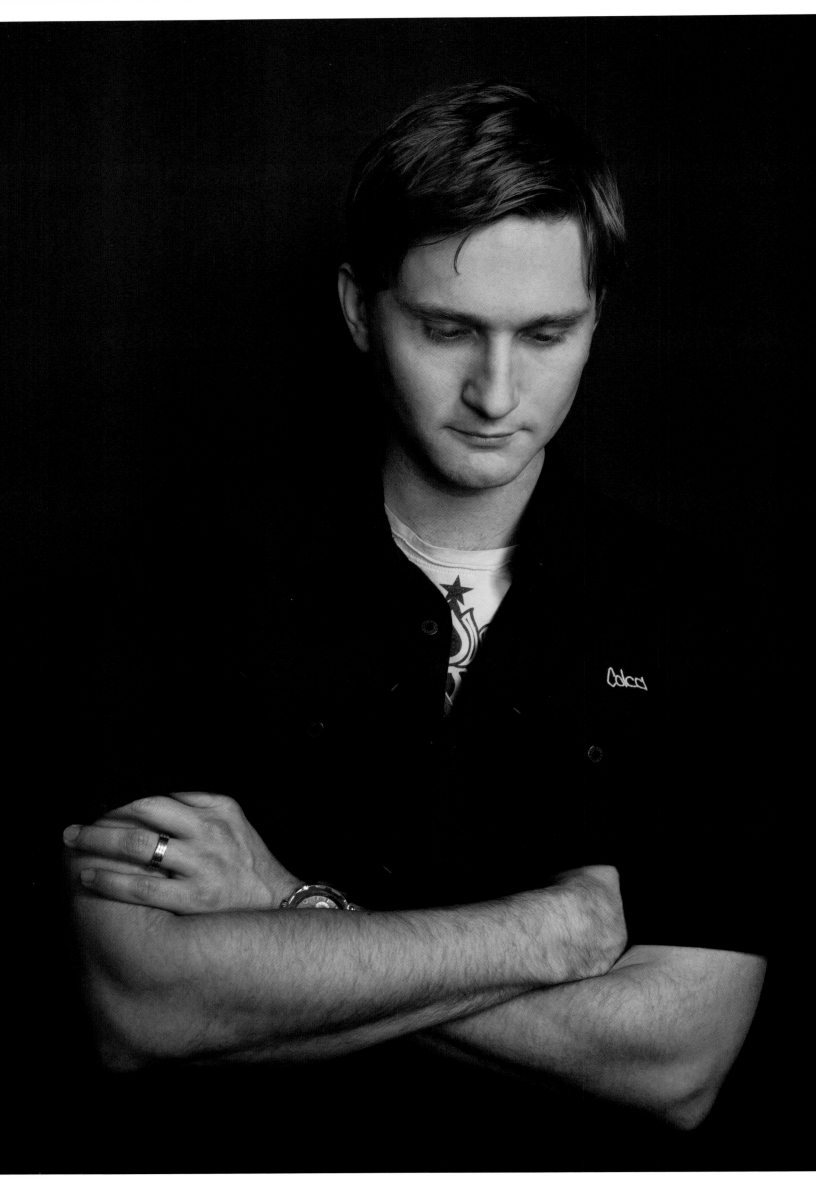

Art    Creates    Possibility.

*Aaron Staton* (signature)

AARON **STATON** / ACTOR

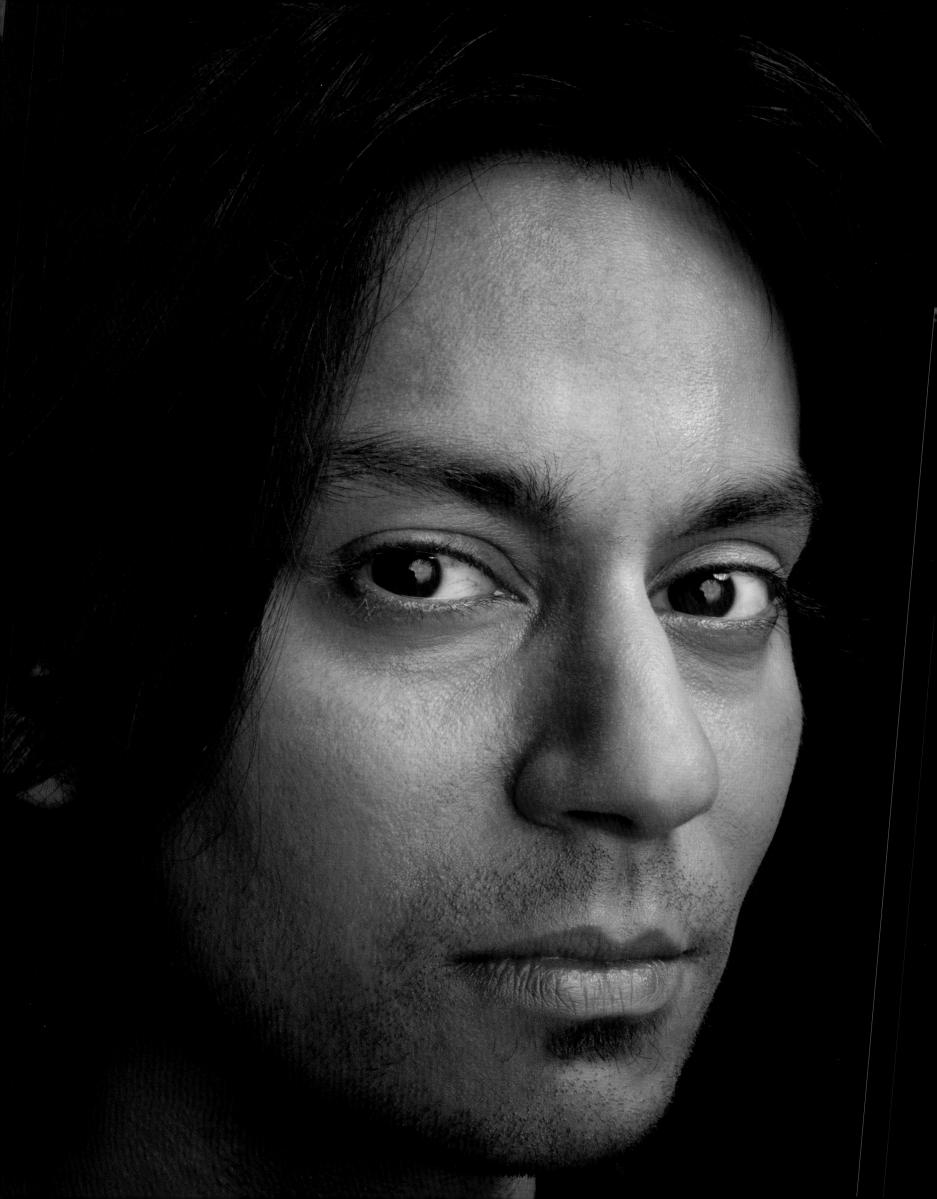

For me,
Art has meant everything.
I went to an all-arts highschool, and
the funding & support of that was
vital to how I see & feel the
world. We see ourselves through
art. And with that, we learn
about one another.

Vik Sahay

Without art we have no identity.
No reflection to look at, no inspiration,
no joy. We must continue to explore,
create and question!

Viva Art!

Pablo Schreiber

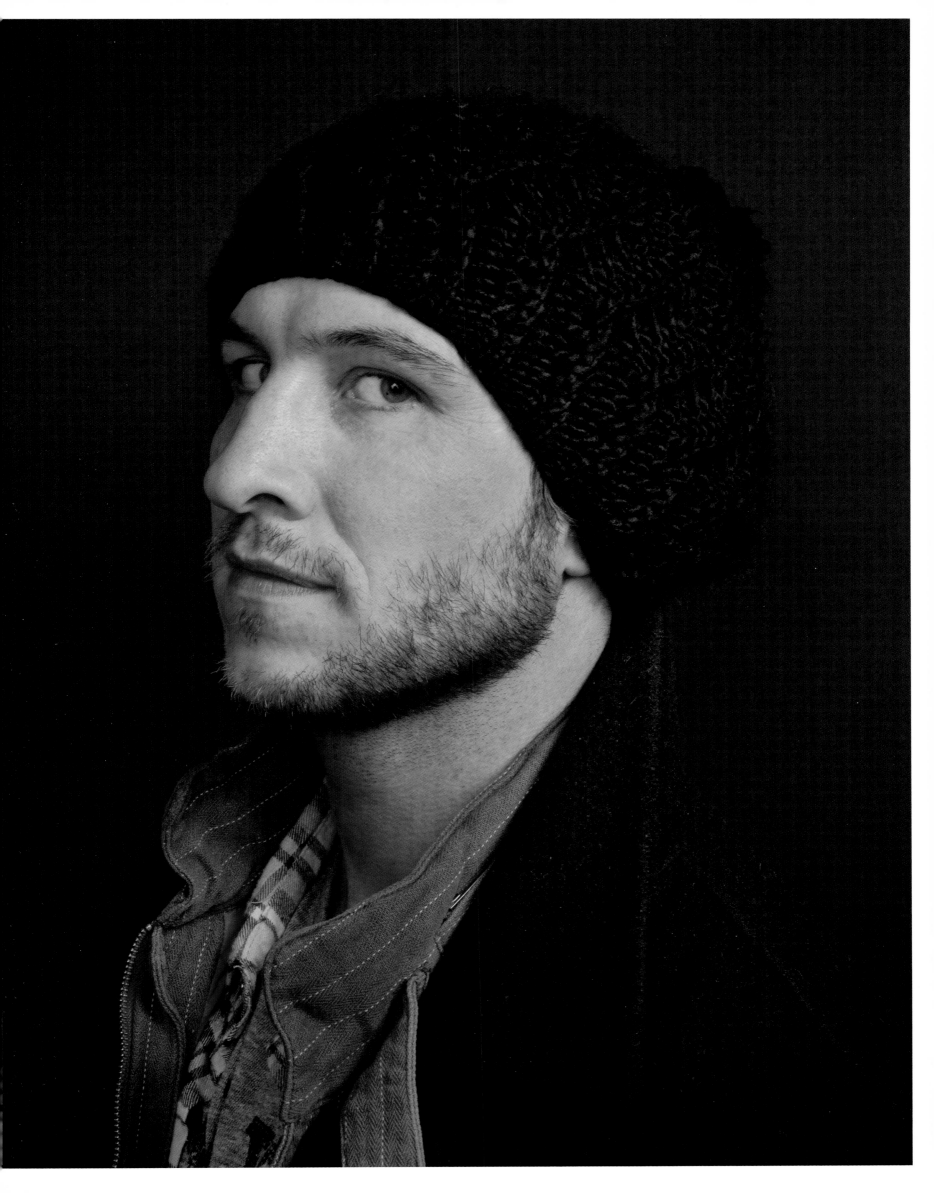

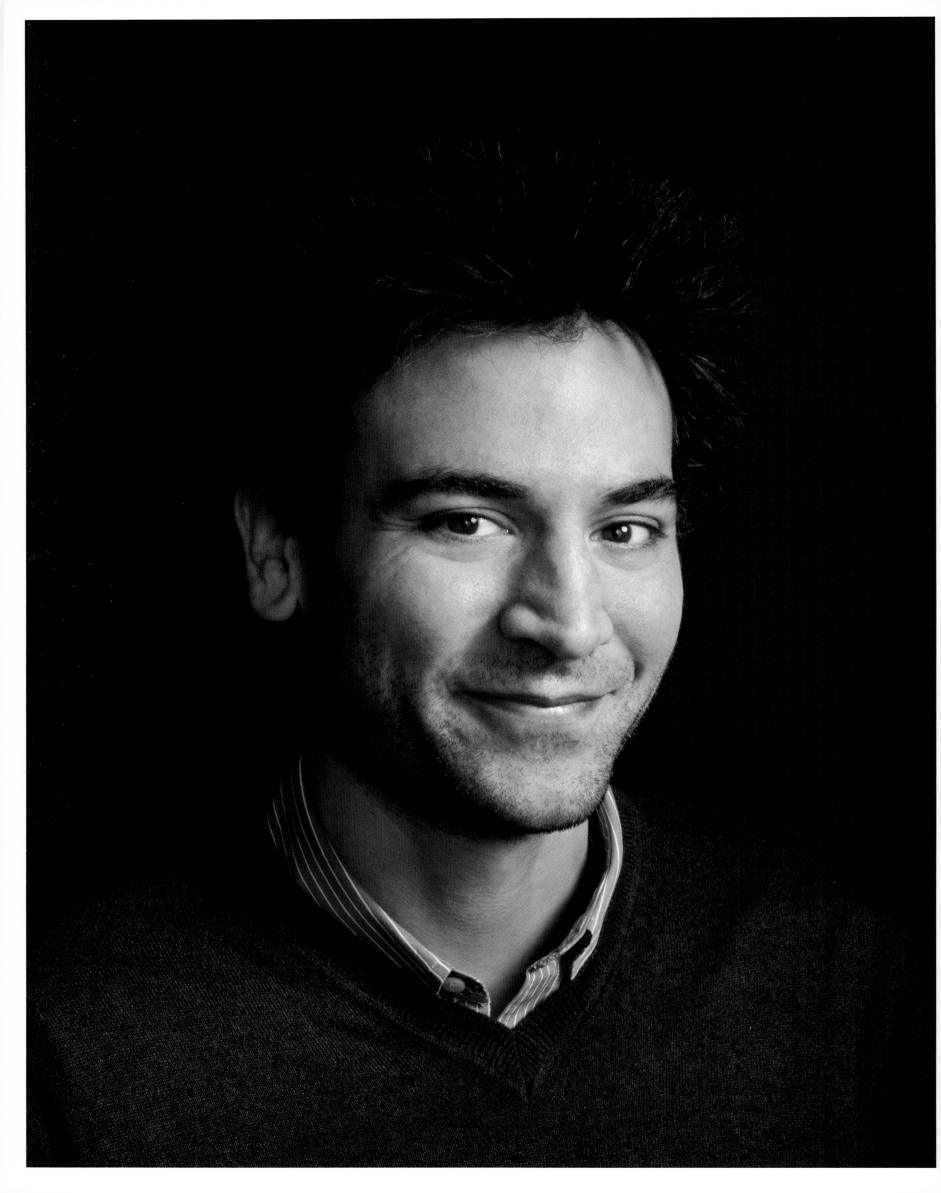

I was recently thinking about compassion, how difficult it is to step outside our own story lines and enter imaginatively into the circumstances of another. Are we all really, as David Foster Wallace said, marooned inside our own skulls? Here's maybe the best argument in defense of art: It grants us a window into experiences that are not directly our own, functioning (at its best moments) as a release on the pressure valve of our own relentless point of view. Suddenly the chasm between 'my story' and 'your story' is not so wide. Having spent some time outside ourselves, we can meet somewhere in the middle. It's not hyperbole, then, to say that art can save the world. In fact, a world without art would be a terrifying, and ultimately uninhabitable, place.

JOSH **RADNOR** / ACTOR

Art has been a window.

Through Art, my heart and mind have expanded beyond my initial perceptions and my investment in other systems of thought has multiplied.

Art has given me a rewarding and compassioned empathy for the eternal struggles and potential dignity intrinsic to the human condition.

*Matthew Settle*

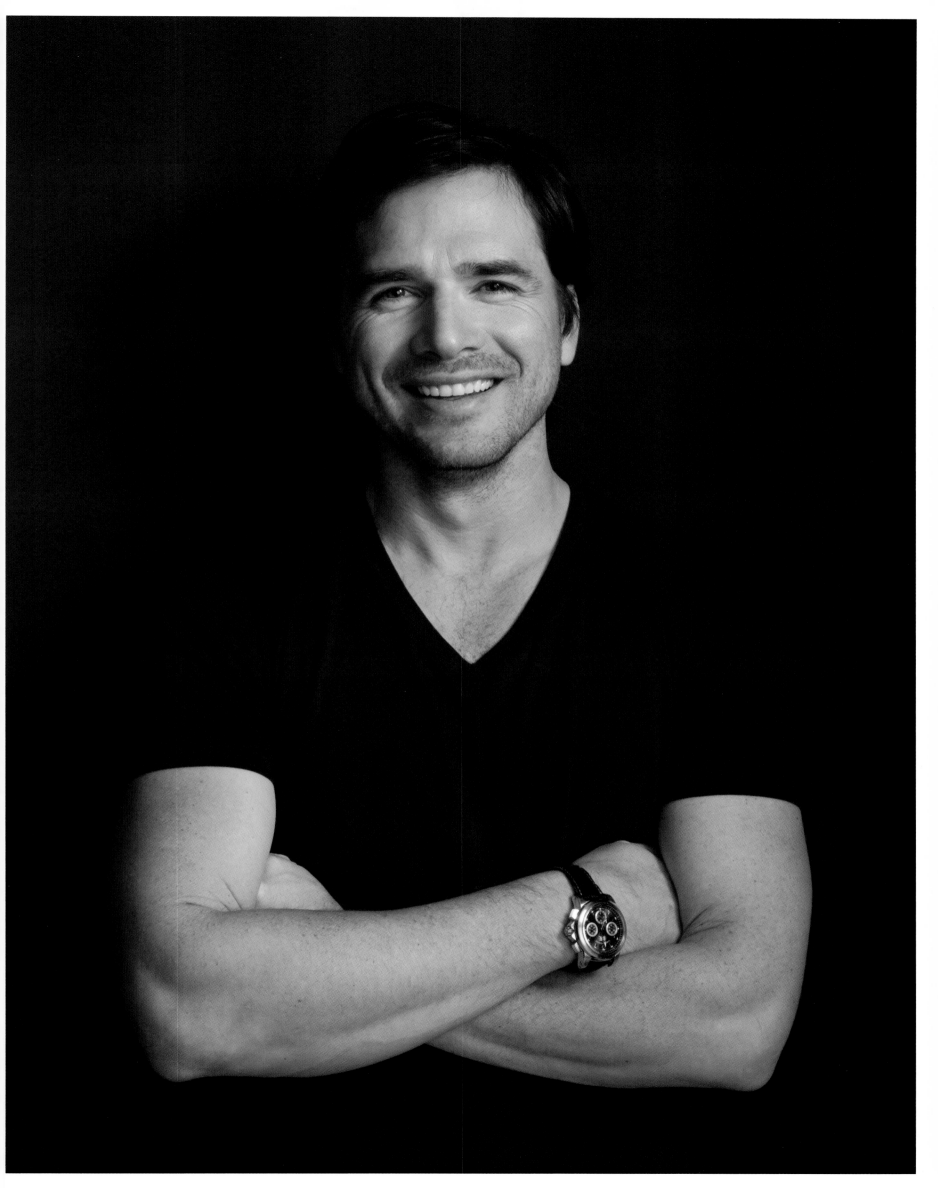

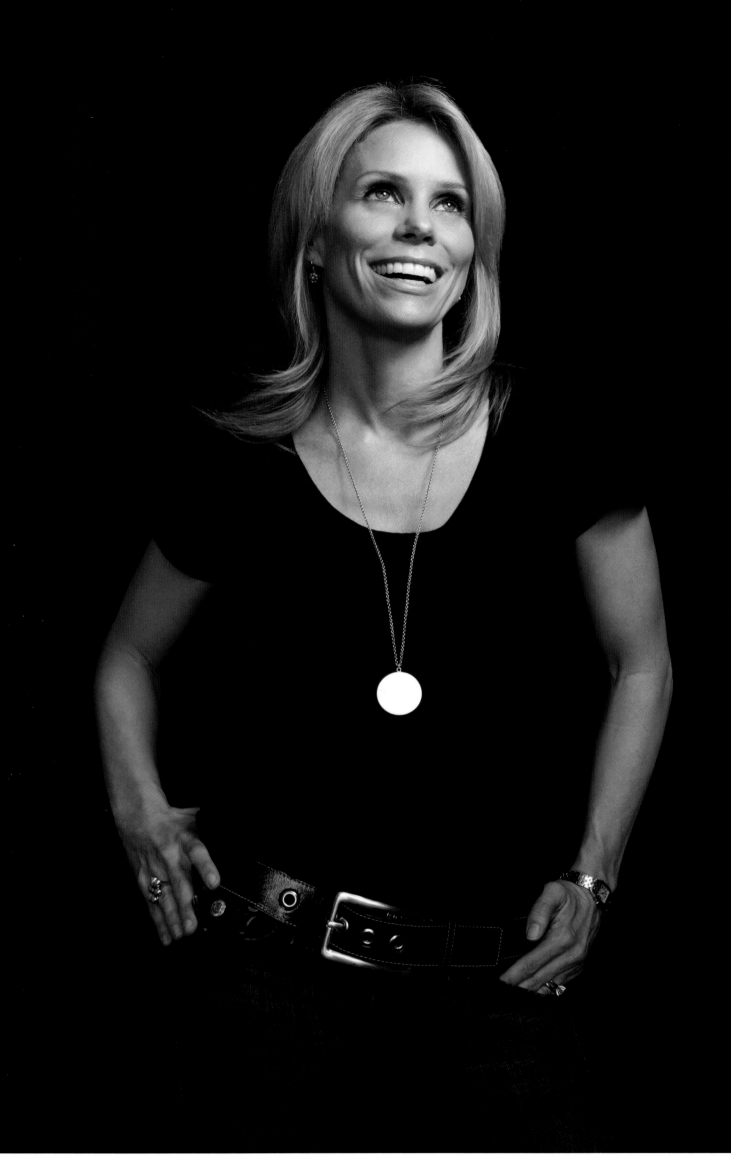

When I was growing up,
I didn't give a frog's fat ass
about school - but I LOVED
chorus and drama. So, I
showed up everyday. I graduated
and went on to become the
greatest brain surgeon this
world has ever known.

*Cheryl Hines*

CHERYL **HINES**

In so many ways, the arts represent the most important fabric of our lives. In children, it teaches patience, passion and dedication. And although every child may not become a musician or artist, the fundamentals of the arts will enrich their lives forever.

C Botti

CHRIS **BOTTI** / MUSICIAN

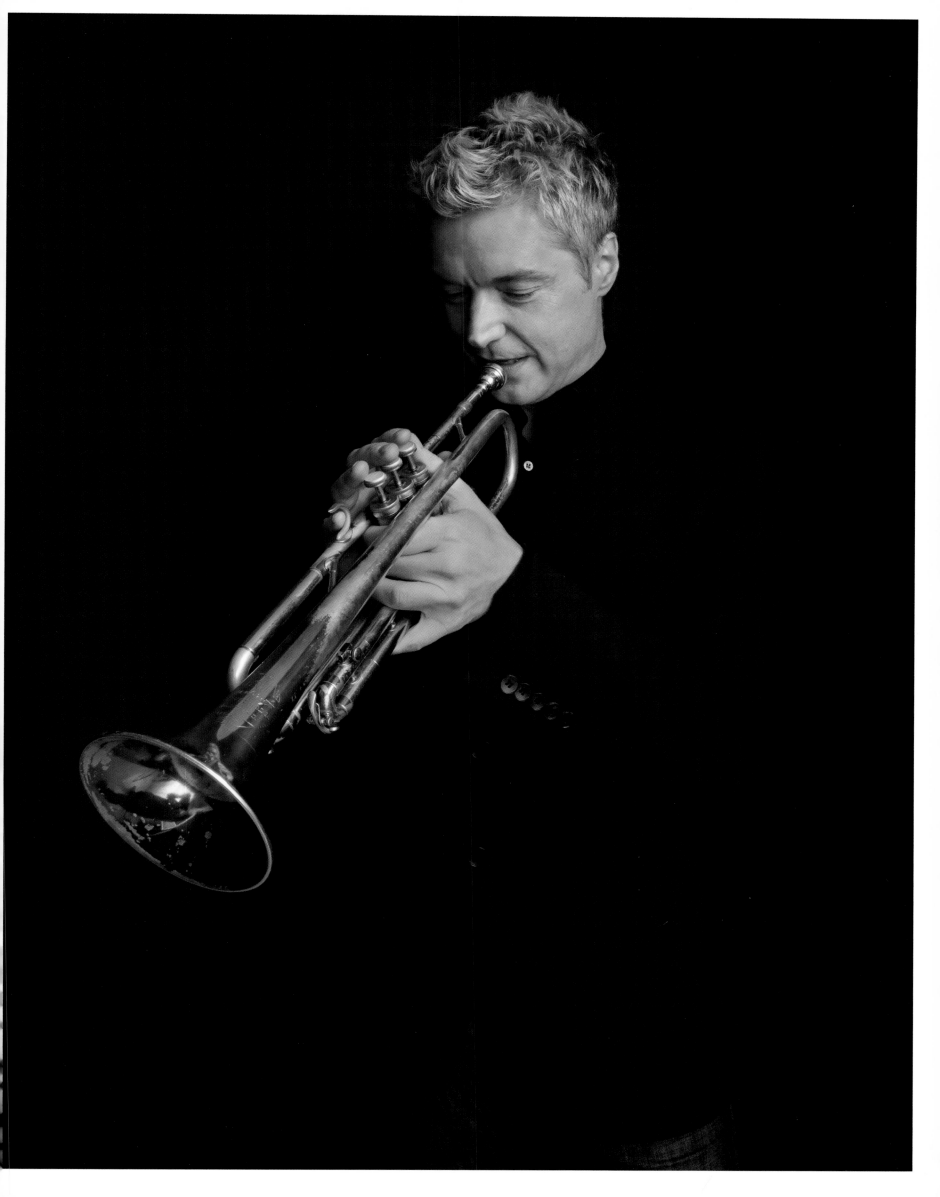

Find You

Find the Arts

Find the Arts

in

_You_!

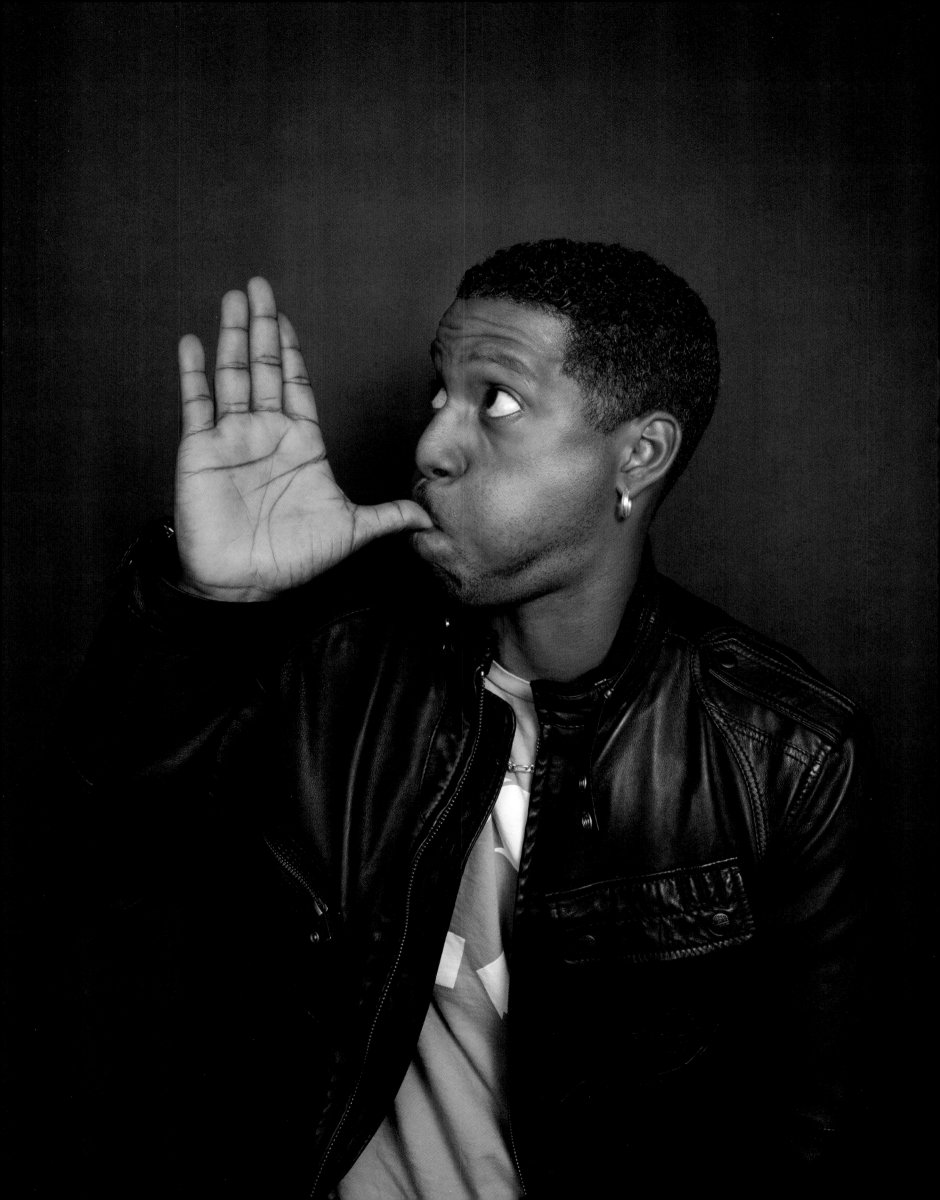

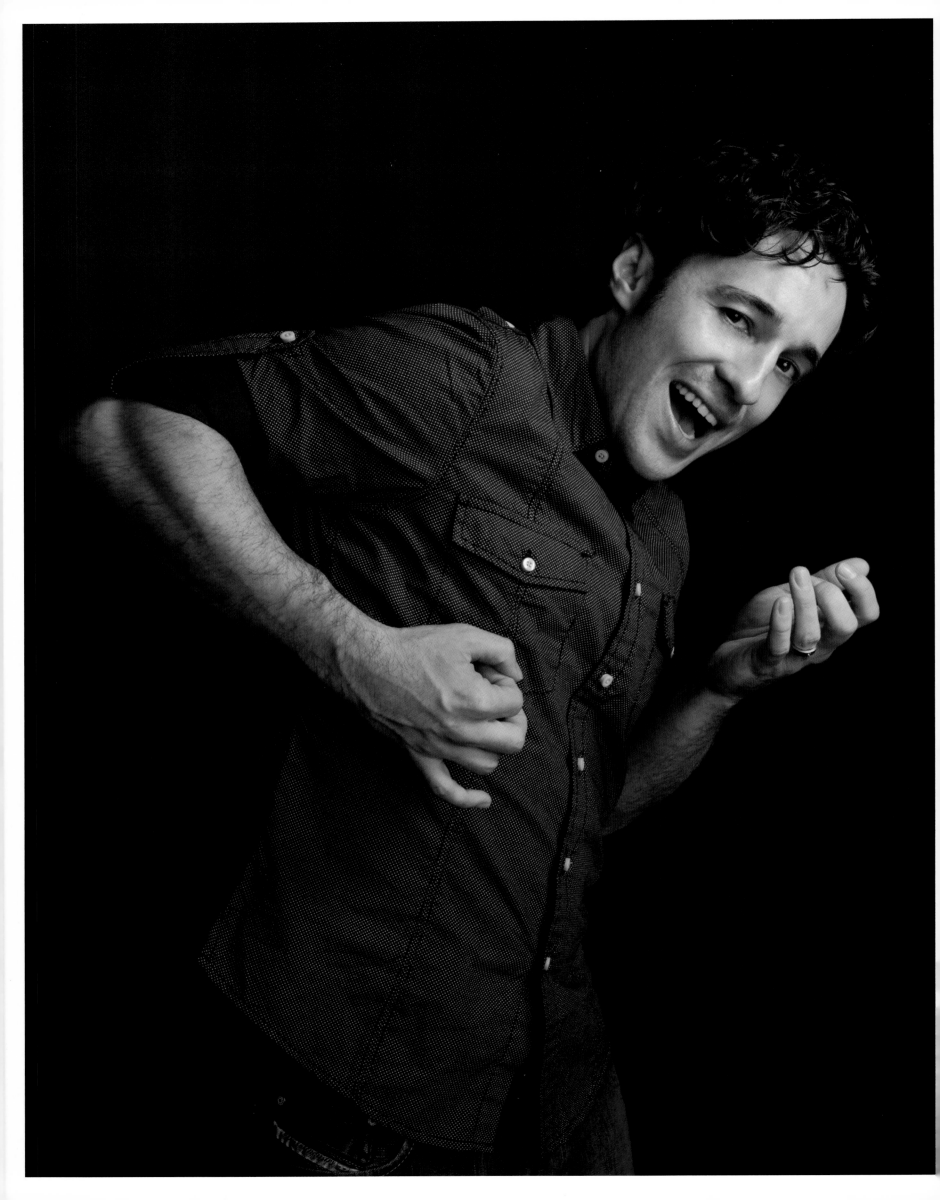

if we replaced guns
with guitars, then the
WORLD WOULD BE A CONCERT

this idea sounds silly but
we can do this on a small
scale.

Let's make sure we get
art back into the public
school system.

THOMAS IAN **NICHOLAS** / ACTOR / MUSICIAN

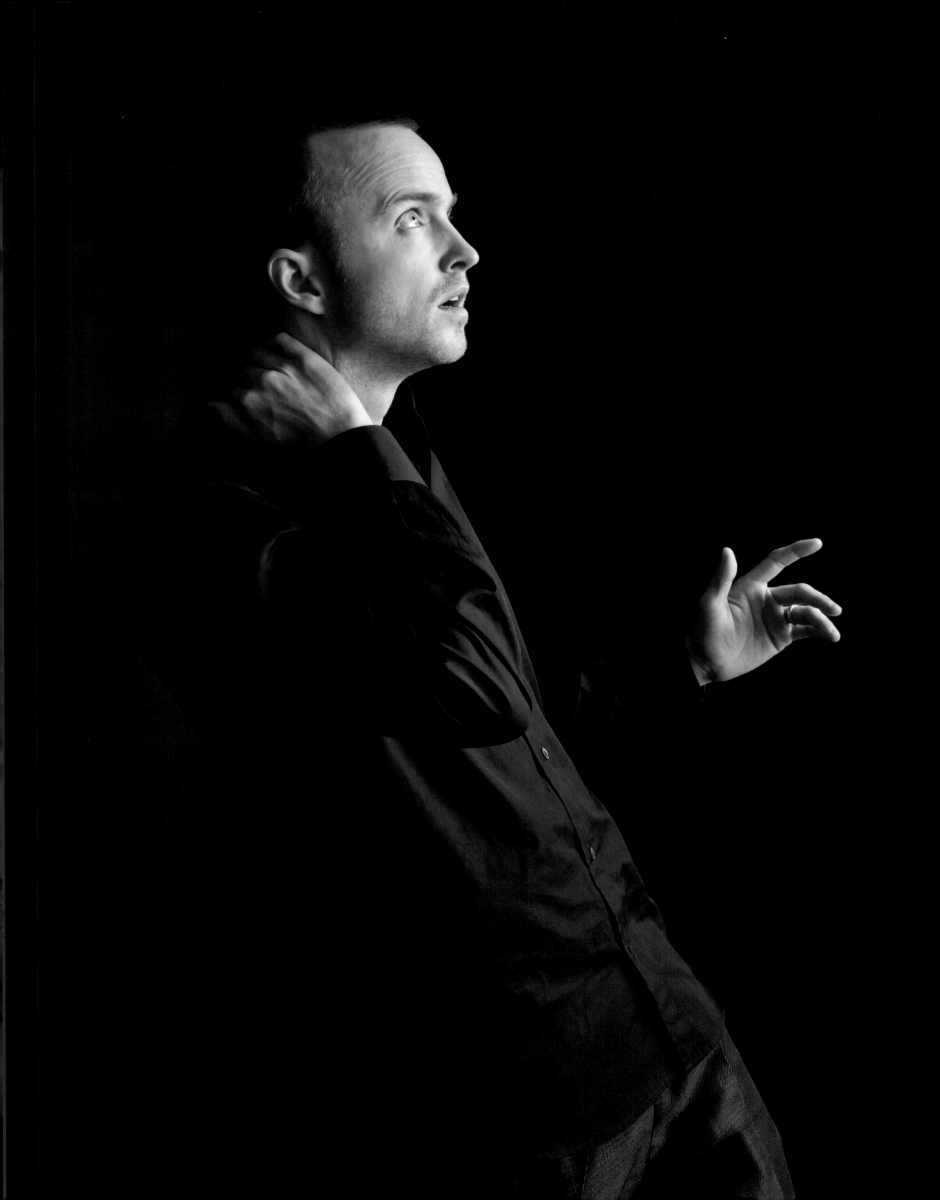

Art Allows you
to Express yourself in a
Very RAW WAY.
Art is Love
And Love is Beautiful.
Embrace Love.

A.P.

ART is LOVE

I'm a sucker for artists!

KEEP ART ALIVE

xx

*[signature]*

Sundance 2010

RICKI **LAKE** / ACTRESS

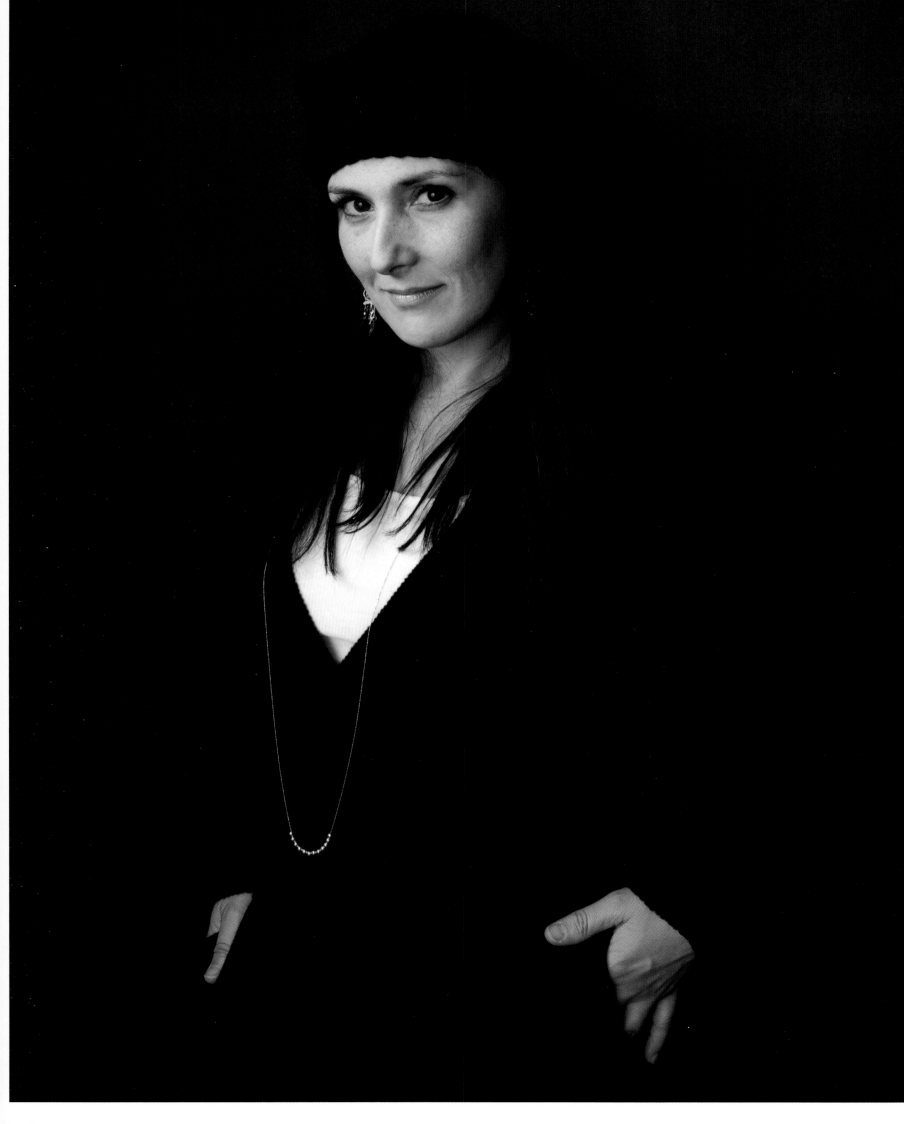

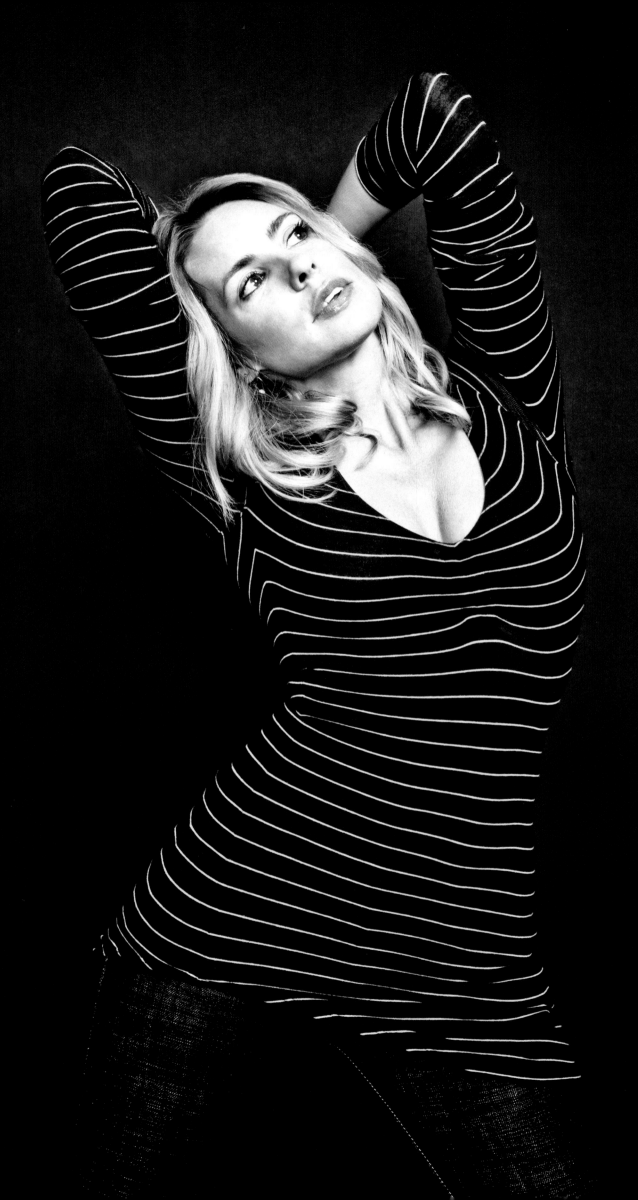

Art is the most truthful inspiration we have to exist.
Art's reflection connects us to the human spirit and is the key to our evolution.

Olivia d'Abo

OLIVIA **D'ABO** / ACTRESS / SINGER

REPRODUCTION is the ultimate act of Creativity

*Evan Handler*

EVAN **HANDLER** / ACTOR

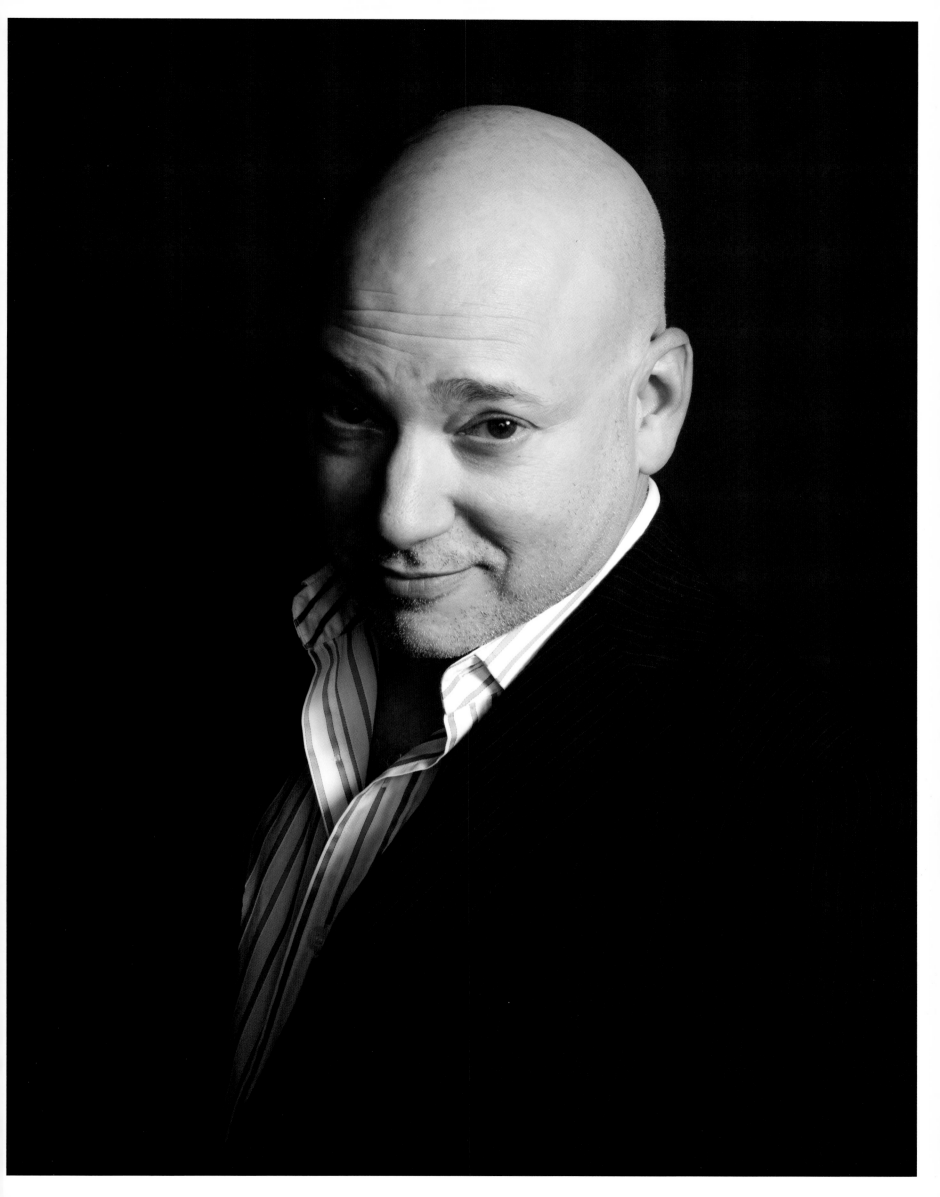

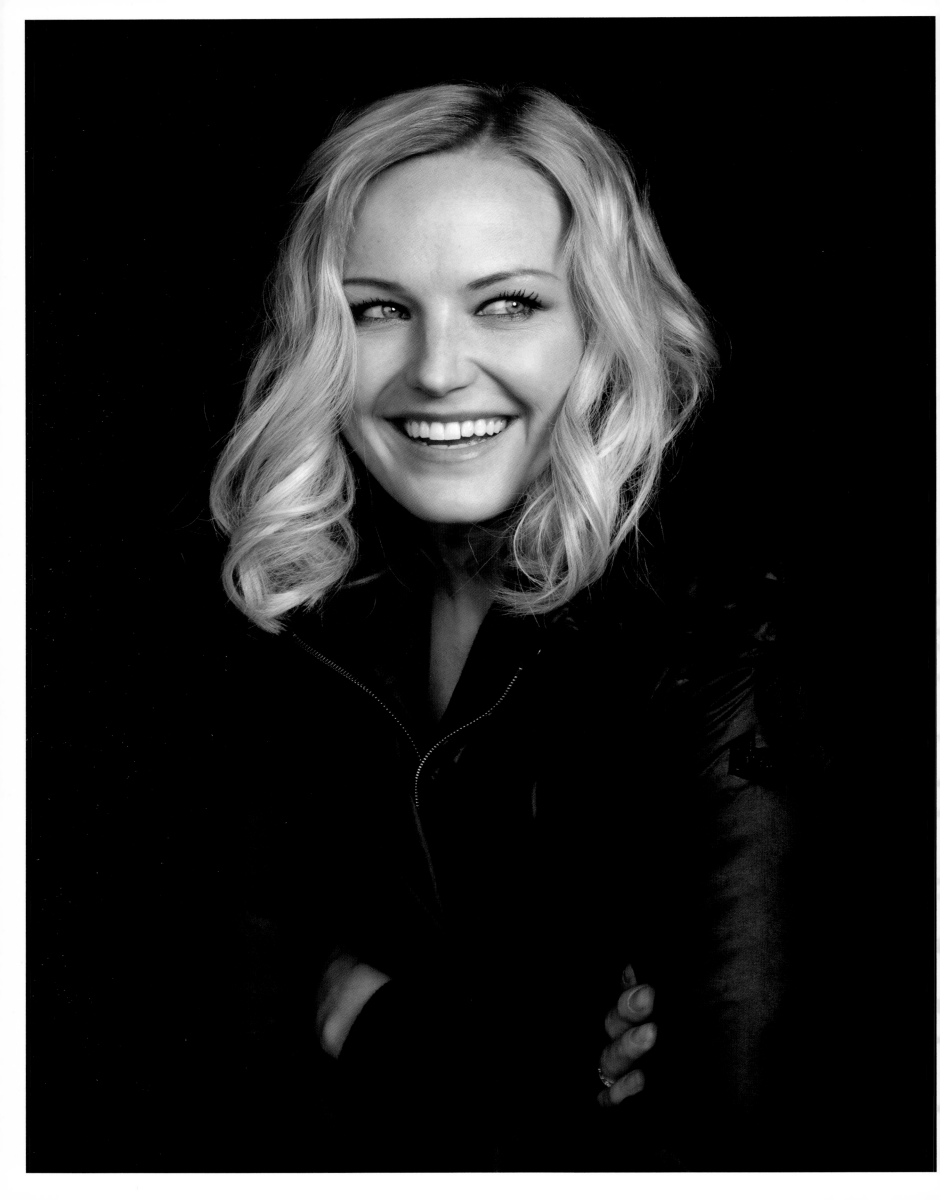

ART IS A CONSTANT STATE
OF CHANGE

ART IS EVERY SINGLE EMOTION

ART IS SUBJECTIVE

ART IS CHALLENGING

ART IS GROWTH

ART IS VULNERABLE

ART IS MAGIC !!

*Malin Akerman (signature)*

I went to high school
in Cicero Illinois, not
exactly the garden spot
of the country. You either
worked in the steel mill, became
a policeman, or got shot
by one. Prior to trying out
for the highschool production
of West Side Story on a dare,
I had seen one play in my
life and slept through it.
After the audition, I wanted
to be an actor more than
anything else in my life.
I haven't looked back since.
The Theatre Department at
that school didn't enhance
my life, they gave me a
life. I take full responsibility
for whatever man I have become,
but I give complete credit to
an exposure to the arts for
whatever artist I've become.

Joe Mantegna

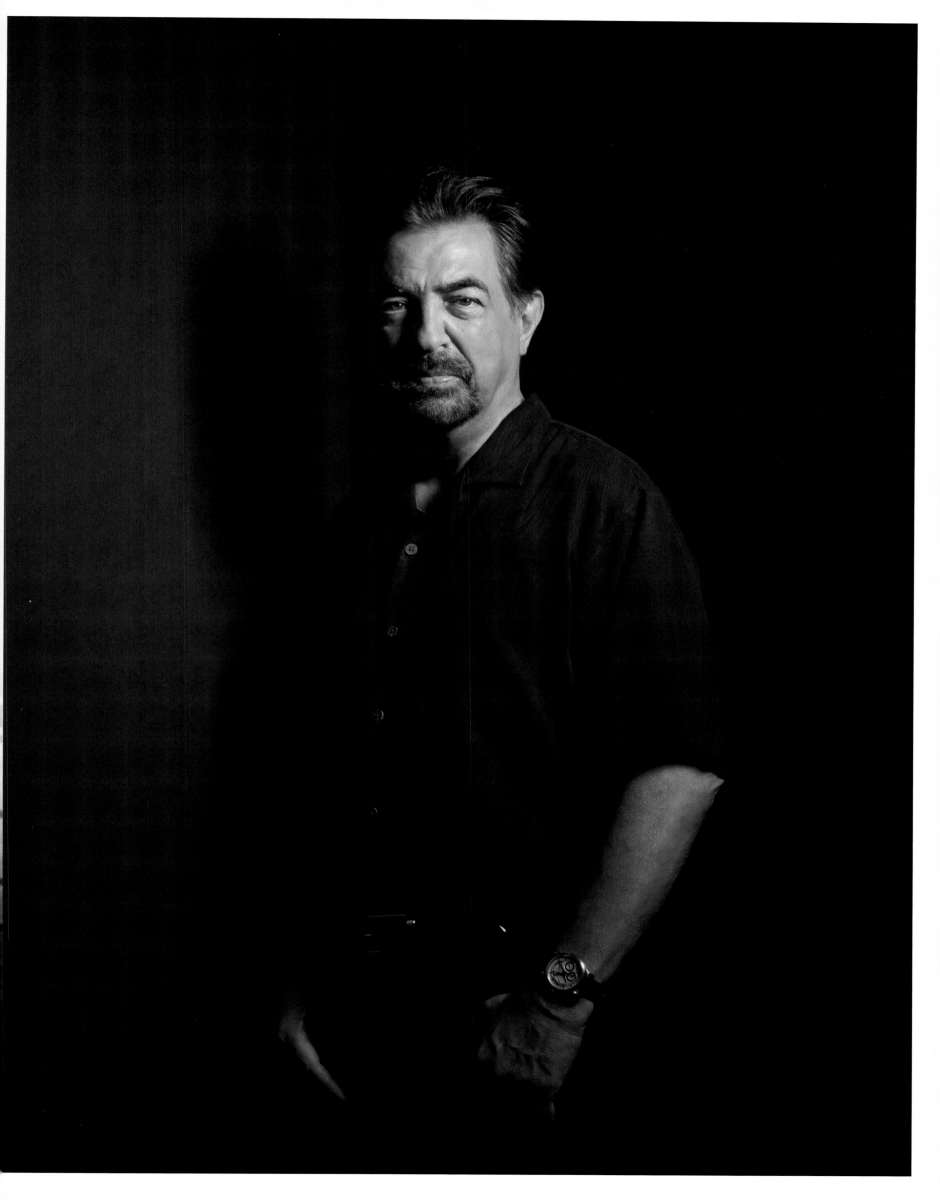

Art saves people. I'm a prime example. You have to express yourself. It's spiritual. If you believe in God, then you believe in Art.

*Michael Shannon*

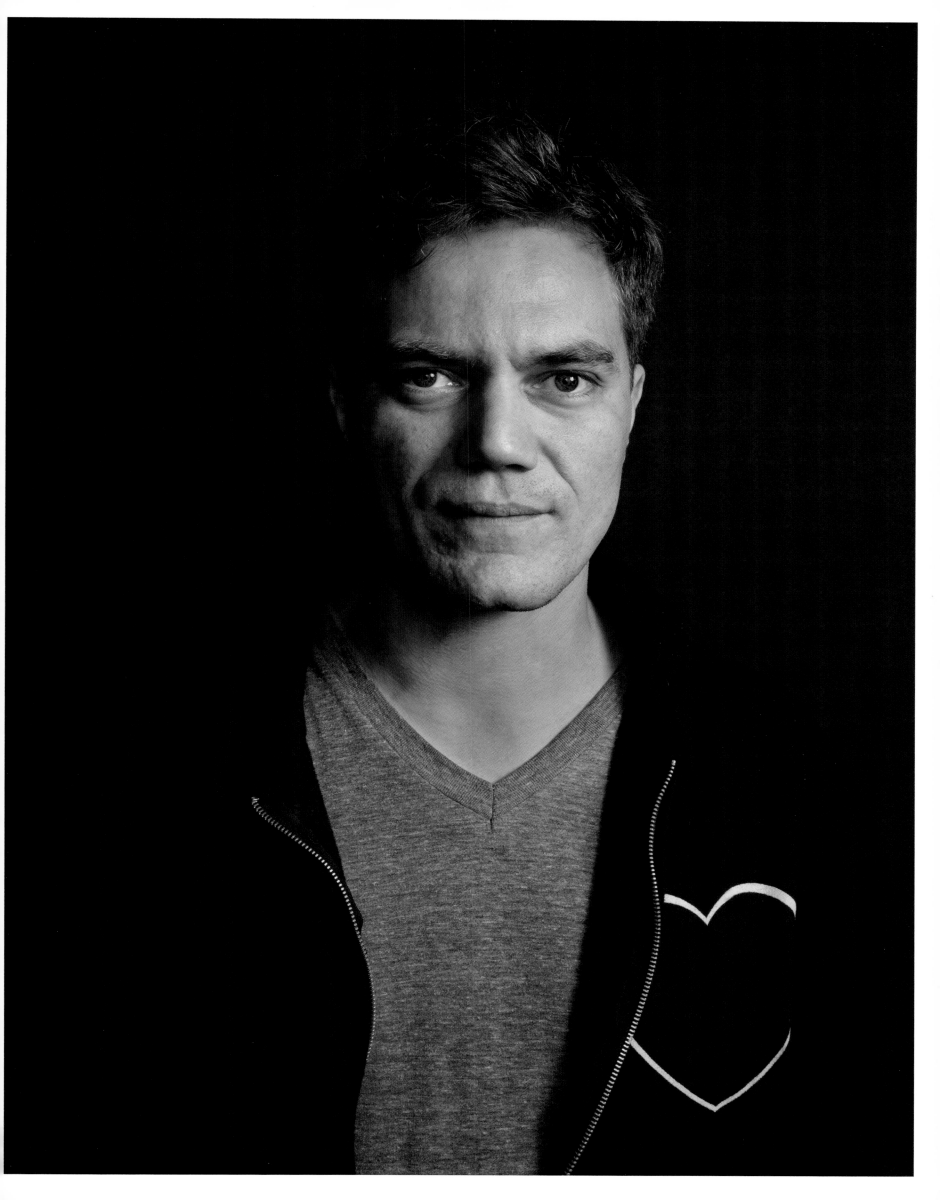

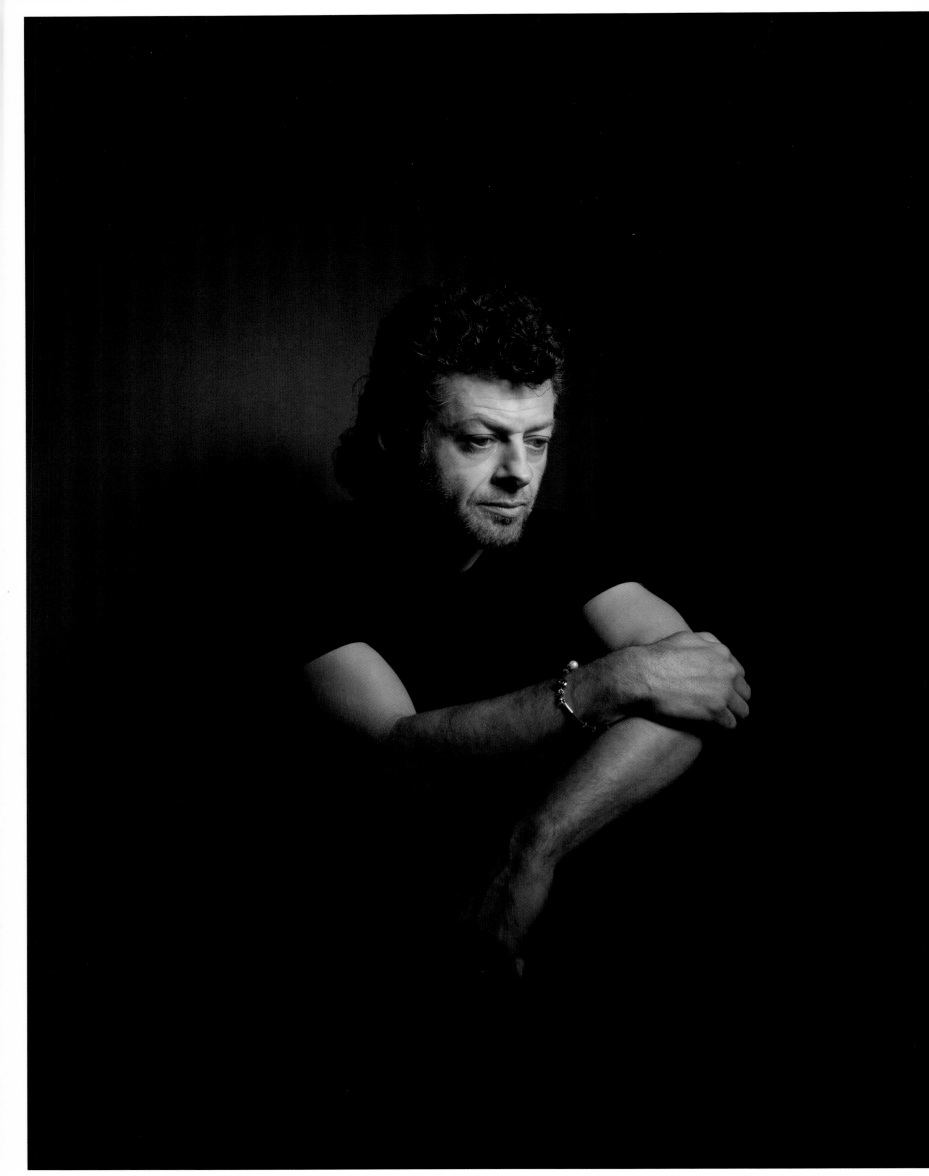

Once upon a time,

there was a young thoughtful, Playful
chaotic, willfull, naughty, passionate.
excited, impetuous, soulful emotional
and above all honest young person
called Art.

He was beloved by all, because whoever
he played with felt free and
incredibly unselfconcious.

His elder brother, Reality, was in
contrast a harsh critic, who liked
nothing better than ensuring that things
were done correctly, according the "rules,"
and reminding everyone he met that
life, when all's said and done, is pretty
pointless.

Over the years, he became fiercely jealous of Art,
and persuaded people that he was a
waste of time, and that no-one should
bother playing with him. For a while it
worked, and Art got lonley, sick and
almost died... But as Art gasped his
last breath. he held a small Mirror.
up to Reality's face ...who saw how miserable
he'd become. He was reminded how
much he'd loved his younger brother, and
felt terrible for trying to crush him —

so he gave him the kiss of life, and fill his lungs with

up to his old tricks, Making life just that little bit
more worth living

The End by Andy Serkis

ANDY **SERKIS** / ACTOR

"With just a little bit of encouragement, the arts can turn a young life from ordinary to extraordinary."

*signature*

JUSTIN **BARTHA** / ACTOR

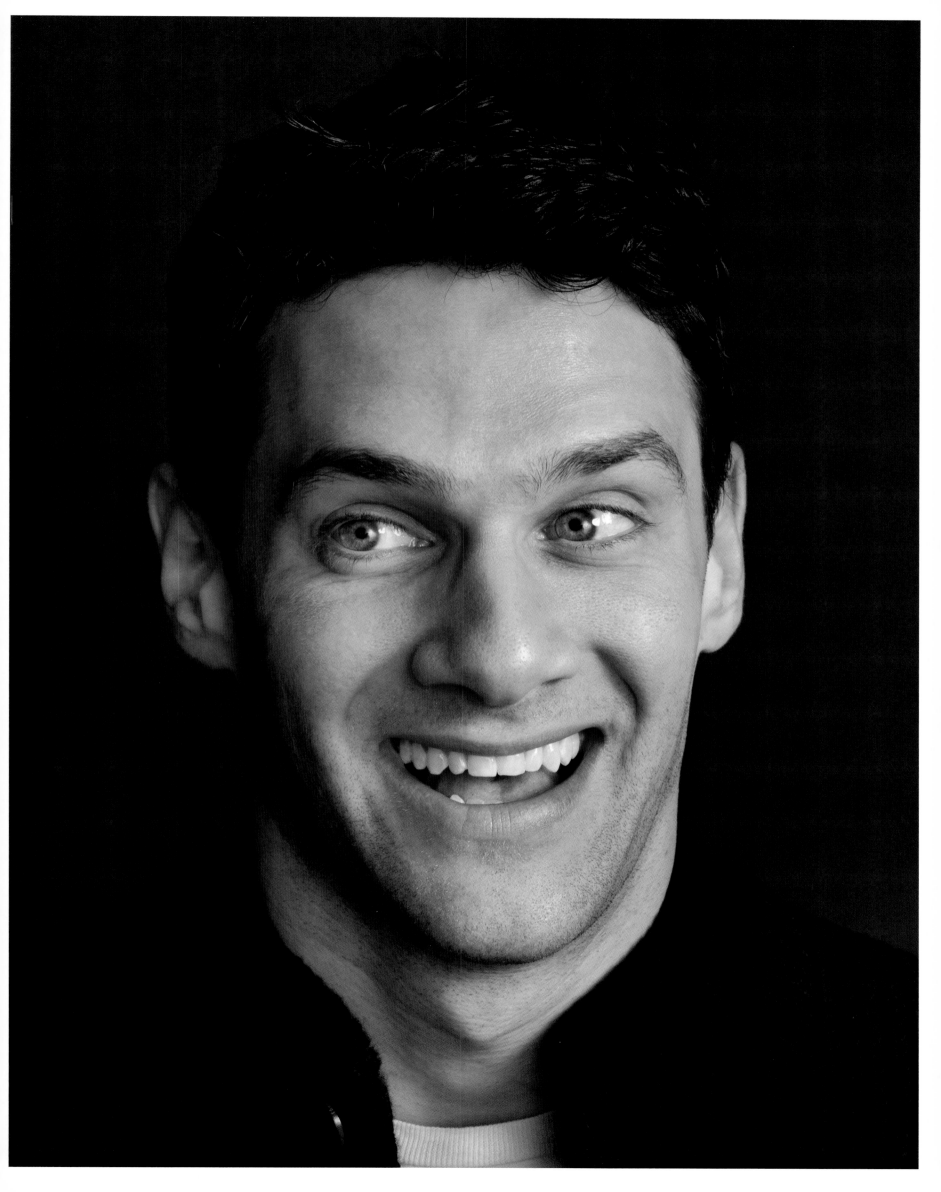

The Arts saved my life +
gave me Direction...

as a child I could do it all the
world was my playground but
focus eluded me... until I
met my 10th grade art teacher
she saw potential + new what
I was capable of... she took the
time to look past my wild side
+ find my Inner Spirit since
that time I've become a world
renowned stylist, Actor + Designer
I've written 2 books been able
to reach millions of people around
the world through all my artistic
endeavors... a mind is a terrible
thing to waste + fortunatly for
me... I haven't wasted a moment
since... Inspiration + Beauty are
every where i look...

XO
Phillip
Bloch...

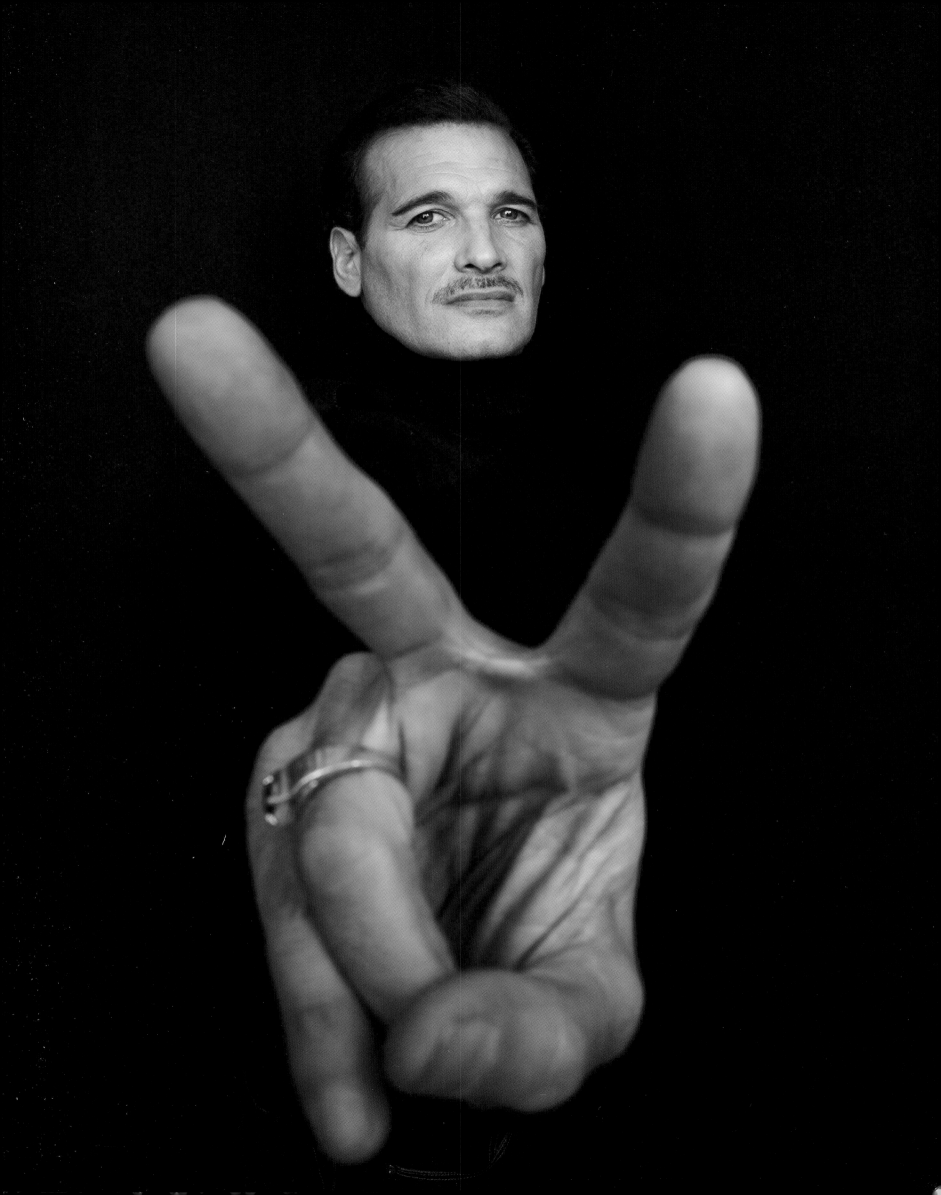

I have seen an erosion of our society as a whole - in some instances I attribute this to the neglect of the arts in schools. There is nothing more universal to Man's spirit to express - It begins and ends with - Music - Dance - Literature - Theater - Painting - When I was a child the arts were integral to the education of my generation - Please support a Renaissance for the arts -

Robert Davi

ROBERT DAVI / ACTOR

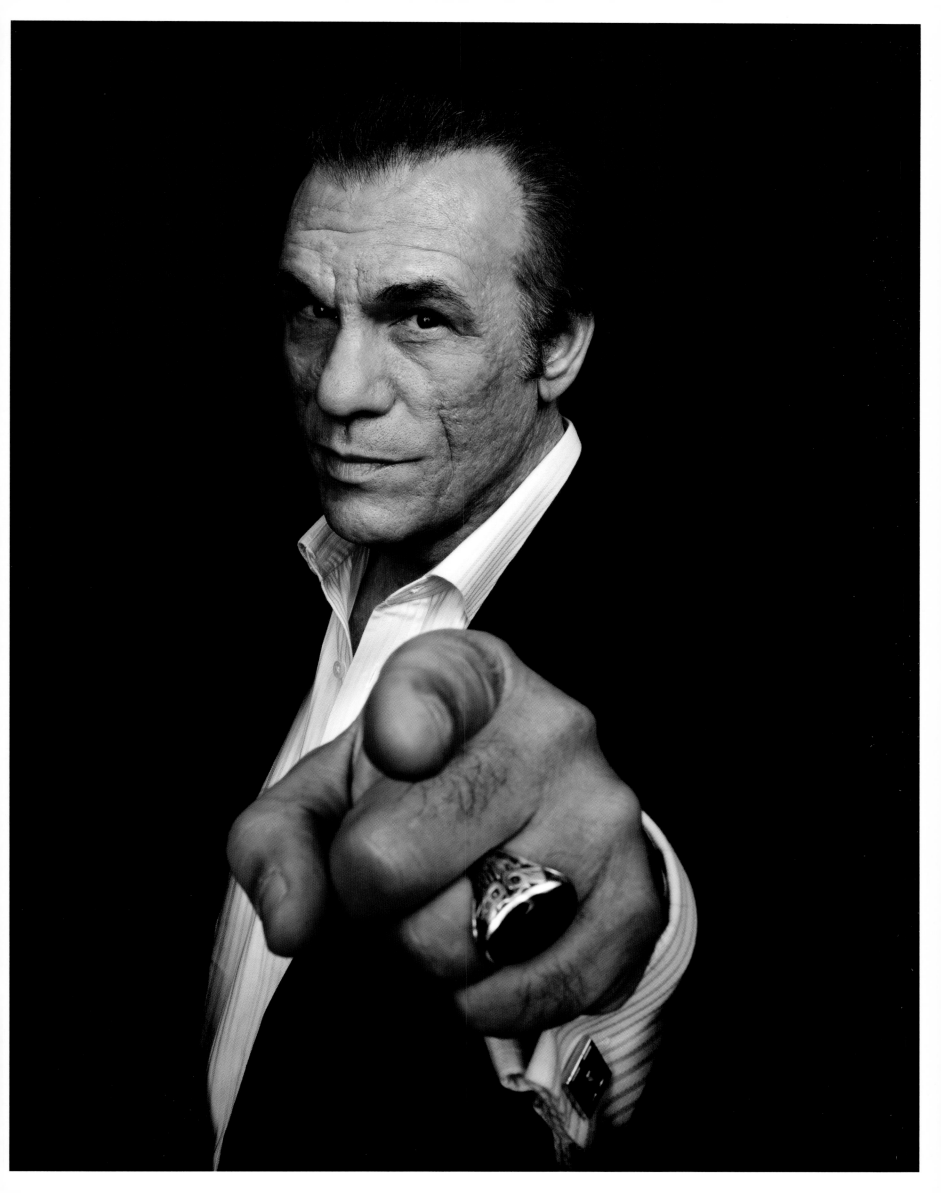

A = Art

R = Reveals

T = Truth

The arts are the connective tissue that binds humanity; allows us to celebrate our differences, individuality; unique qualities as human beings.

— Brian White

BRIAN J. **WHITE** / ACTOR

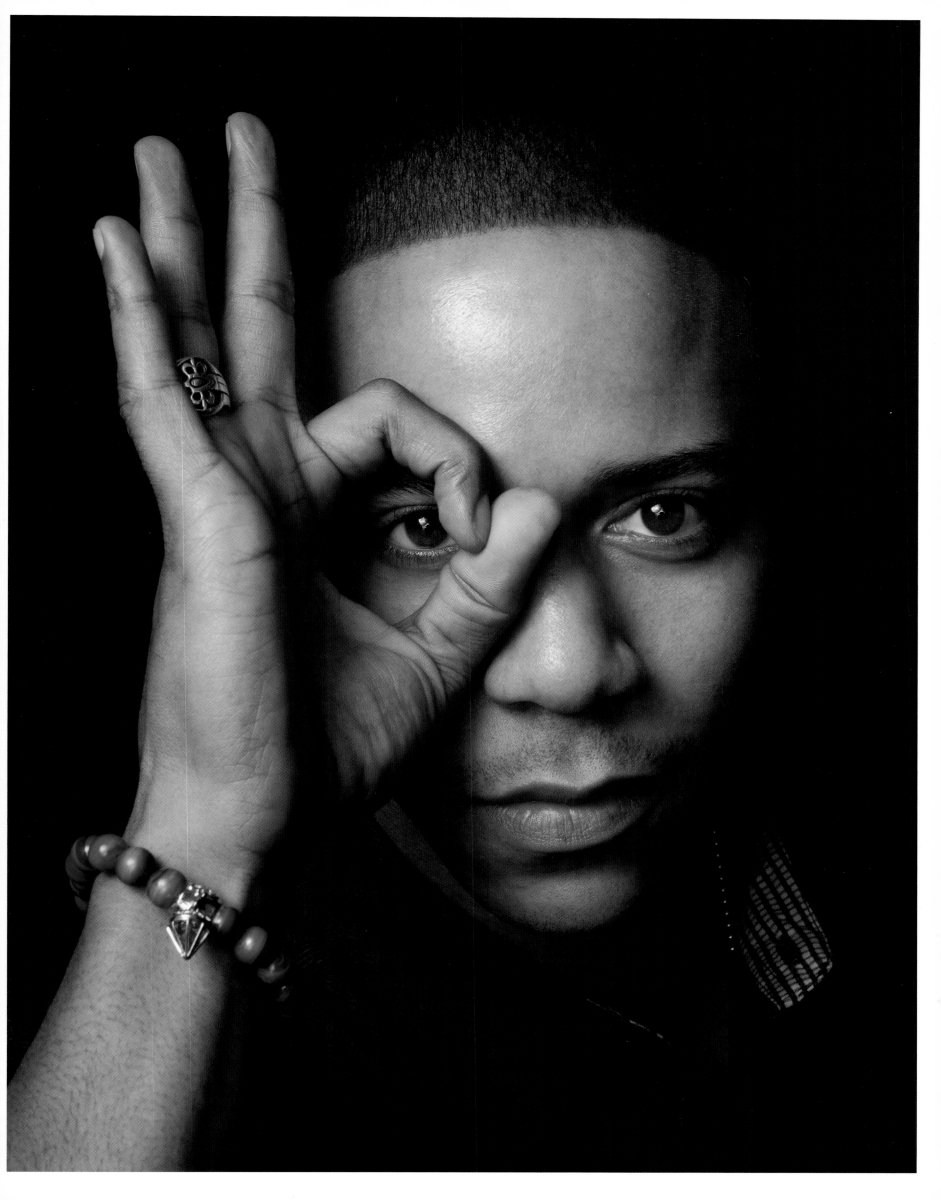

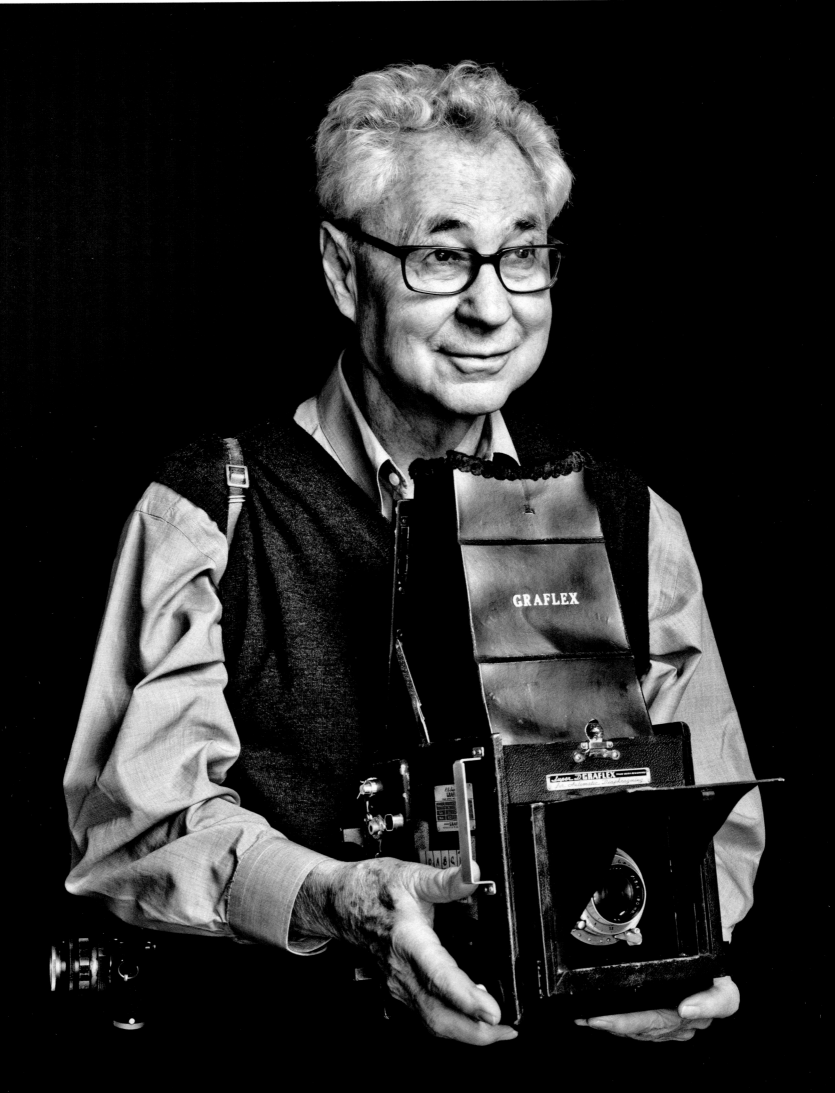

Art is smart
liquor is
quicker

Elliott Erwitt

thanks to Peter DeVries

ELLIOTT **ERWITT** / PHOTOGRAPHER / FILM MAKER

# CREDITS

All the stars in this book look their best thanks to the hair and makeup artists who lent their talents to this book. Our deepest thanks go to Edward Tricomi and Joel Warren for their incredible support of this project from the very start, and for coordinating this massive project with artists from the Warren-Tricomi hair and makeup team.

We also wish to thank hair and makeup artists Amy Hollier, Audra Holcombe, Audrey Rae Boyd, Christiane Gendrey, Fazia Ali, Jacklyn Pezzotta Gray, Jessica Nalley, Jillian Halouska, John Paul Hamilton, Julie Harris, Kyung Chon, Kamille Nielson, Kristoff Ball, Ky Walker, Lena Palm, Liza Coggins, Martin Pretorius, Michele Shakeshaft, Mimi Tran, Reanna Garcia, Riley Knoxx, Ronnie Blush, Sam Fine, Sarah Uslan, Sukran Shuki Almac, Ted Gibson and Whitney Olson.

Thanks to Al Silvestri for getting this all started, and to Georgi Page for keeping the wheels moving. To Benoit Lagarde of Splashlight Studios, digital tech Matthew Schulert, Matt Hege of The Broadway Channel. To Stuart Smith for his design concept. To David Manning and Gia Valintina of A-List Communications, and Nanette Lepore for her style. To Lynn Scaglione and Annie Andres; and David Parmeter. And to our publisher, Dorothée Walliser, who green-lit this book out of her belief in the power of the arts.

Thanks to The Creative Coalition's team led by Barb Horvath along with John Hook, Mark Sobel, Dennis St. Rose, Liviya Kraemer, Risa Kotek and Sarah Lueck. Thank you, Michael Frankfurt, Mark Merriman, and Frankfurt, Kurnit, Klein & Selz.

Thanks to Snehal Patel, Duggal, Kari Feinstein, Mike McGuiness, Feinstein McGuiness Public Relations, Heather Holland, Jenna Sarti, Erik Bright, Prodigy Public Relations, Sheryl Tyrol, Allison Leffingwell, Kim Morgan, Angela Gioielli, Jimmy Floyd, Jacob Gitzis, Henry Eschelman, Rembrandt Flores, Jane Ubell, Pauli Orchan, Conair, W Los Angeles-Westwood, and Hyundai Genesis.

This book would not have been possible without the generous support of Sony. Our thanks to Steve Sommers, Kristen Elder, Mark Weir, El-Deane Naude, Bob Tubbs and Kayla Lindquist for their tremendous support of and belief in this project.

About this book:

20 shoot days
246 celebrities
30 hair and makeup artists
25,657 photographs
Camera: Sony a900
Lenses: Sony CZ 24-70/2.8 and Sony CZ 85/1.4

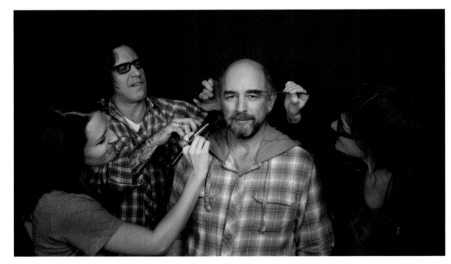

WARREN·TRICOMI®

# ART &